THE HOLMES MANUAL

THE HOLMES MANUAL

Expert Answers to Your Most Common
Home Maintenance Questions

MIKE HOLMES

Collins

The Holmes Manual
Copyright © 2014 Restovate Ltd. All rights reserved.

Published by Collins, an imprint of HarperCollins Publishers Ltd

First Canadian edition

No part of this book may be used or reproduced in any manner
whatsoever without the prior written permission of the publisher,
except in the case of brief quotations embodied in reviews.

HarperCollins books may be purchased for educational, business,
or sales promotional use through our Special Markets Department.

HarperCollins Publishers Ltd
2 Bloor Street East, 20th Floor
Toronto, Ontario, Canada
M4W 1A8

www.harpercollins.ca

Library and Archives Canada Cataloguing in Publication information is avail-
able upon request

ISBN 978-1-44342-237-6

Printed and bound in Canada

Photographs by Alex Schuldtz
Illustrations by Kevin Prendergast

Contents

Introduction . 1

1 Exteriors and Attics. 5

2 Windows, Doors, Walls, and Floors 67

3 Lighting, Electrical, and Plumbing. 99

4 Kitchens and Bathrooms . 129

5 Heating, Ventilation, Cooling, and Insulation 153

6 Basements and Foundations . 189

7 Materials and Finishes . 235

8 Household Hazards and Pests. 253

Index. 273

Acknowledgements .285

THE HOLMES MANUAL

Introduction

Most of the renovations we do involve fixing something that's broken. Disaster is the starting point and our job is to make it right. Maybe the homeowners didn't see the signs. Maybe a bad inspector or contractor told them that there was nothing seriously wrong or that a Band-Aid solution would do the trick. By the time the homeowners called someone in, the problem was much harder to fix and more expensive. *The Holmes Manual* is all about how you can see the red flags sooner, take control, and save yourself a big headache—and a lot of time and money. It's about understanding how your house works and how to maintain it, and how you can protect your investment so your house outlasts you. If you don't take proper care of your house, it will deteriorate quickly. There's a lot you can do to slow that down. It's all about making smart choices, and asking the right questions is a great first step.

In *The Holmes Manual* I answer common questions sent to me by homeowners, including:

How many roof vents should I have?

Should a brick house be waterproofed or sealed?

Why do some floorboards creak when I walk over them, and how can I fix them?

What do we need to consider when replacing old windows?

Are skylights a good idea?

What do we need to know about recessed lighting?

What is the life expectancy of plumbing?

What should I do to maintain my sump pump?

How should I look after my septic system?

What kind of grout should I use around my bathtub?

How much insulation should I have in my attic, and what kind is best?

How often should I have the ducts cleaned?

How can we prevent air leaks?

Can I paint my concrete basement floor or lay down carpet?

What kind of ceiling is best in a basement?

Should I buy "green" paints?

How can I tell if our house has mold?

Taking care of your house can seem difficult, but it's not. Learning what you can do—and more important, why you should do it—is more than half the battle. Think of your house as a human body, with a structure that holds everything up, like your bones; an HVAC that keeps air flowing, like your lungs; and so on. It's a complex system, but there are simple steps to take so that everything runs smoothly. You look after your body, you get regular medical and dental checkups, and you eat right and exercise. That's because you've learned that if you look after your health you'll have a better quality of life and maybe even live longer.

It's the same with your home: when you maintain your house, it's less likely you'll have problems down the road. Knowing what to look out for can save you time and money and worry. I believe your house should outlast you, and it can if you take care of it.

Why not do what you can now to save yourself the hassle later? Use the best technologies and materials you can afford and look at repairs as opportunities to make things better before they have the chance to get really bad. Nothing lasts forever. Everything breaks down eventually. A house is no exception. But you do have the power to extend the life of your house. This book gives you the tools and knowledge to do that. Take care of your house, and it will take care of you.

1

Exteriors and Attics

I'm starting with the outside of your home because, to me, this is very important. Too many times, I have witnessed people who buy a new home and right away start saving money for a new kitchen without paying any attention to the outside of the house. Why would you do a kitchen when there's a chance the exterior of your home will leak and ruin all that investment?

Start at the top. Most of us never look at our roofs. Out of sight, out of mind. We tend to walk around inside our homes and assume (or maybe hope) that everything is fine up on the roof. I'm telling you now that you need to pay attention to your roof and your attic. Don't wait until problems happen. By the time you notice the roof is leaking, water will have broken into your home and done too much damage. Always work from your outside in, not your inside out.

The number one job of your exterior is to keep water out of the house. The better we can keep water out, the better off we'll be. It's not just the cost of insurance or the cost of cleaning up after a flood, it's also the cost of our family's health. Moisture can lead to mold, which can make your indoor air hazardous; you breathe in those mold spores. It's true: indoor air is more polluted than the air outside because of the mistakes we make or maintenance we ignore around the house.

Next, people should get to know their attics. Go up into the attic in the spring and the winter to take a look. Make sure you don't see any signs of water coming in. You don't want to see frost buildup in your sheathing in the winter because it means your attic is not breathing. This could lead to mold and rot. Mold needs organic matter and moisture. Anything organic is like a steak buffet for mold; in the attic, that buffet is your wood framing. If you've got a poorly ventilated attic, you're going to get condensation in summer and frost (frozen condensation) in winter—there's your other food group: moisture.

Like so many parts of your home, your attic needs to breathe. What is the best breathing system you can have for your attic? A good ventilation system. This will give you excellent air movement: fresh air in through soffit vents, stale air out at the top through ridge vents or roof vents.

You also need to make sure the walls can breathe behind the exterior cladding. That's why building codes for newer brick houses require an air space behind the brick veneer. Both stucco and brick veneers also require a drainage plane. The ability for air movement helps water to evaporate instead of penetrating your home.

I'd like to see better products used on each and every home. I'd like to see moisture-resistant, mold-resistant sheathing on the outside of our homes, such as one of the colored, coated lumber products. These products act as a barrier when it comes to moisture. Your second line of defense would be a high-quality building wrap—installed properly, right down to the seams—to allow water to weep down and away from the house. This is the more important layer. It is both moisture-resistant and water-vapor-resistant, and it lets water weep as well as evaporate.

The point is your home is not all about looks. I don't really care what finish you have: it's whatever is beneath your cladding that really matters. You

have to have the right products in the right order to protect your home. Why? Because water will penetrate almost every single exterior clad. Making sure your home is wrapped properly will make sure that the water runs out, not in.

I get huge scary icicles and ice dams on my roof every winter. Permanent fixes will have to wait until spring, but I'm not sure what I should do—if anything—about removing an existing dam. What do you recommend?

Some people think icicles look nice in the winter, but I'm with you—those giants *are* scary. People have died from icicles falling from the roof. Plus, icicles can be a sign of an ice dam. If you ignore an ice dam, you could be looking at big problems.

An ice dam is a ridge of ice that forms at the edge of a roof and prevents melting snow from draining away properly through your gutters and downspouts. An ice dam forms from snow on the roof. The snow starts to melt—either from the heat of the sun or from heat escaping from the attic. The water flows down the roof under the snow and refreezes when it reaches an unheated portion of the roof—usually at the eaves—where it starts to build into an ice dam. The ice dam—fed by the melting snow above it—grows through a cycle of freezing and thawing and can get very thick. It can also spill over your eaves and form those icicles you're seeing.

Ice dams can also form in houses that have complicated roof designs, especially around skylights. Skylights have less insulation around them, and they allow for more heat to escape.

Since water is prevented from flowing down to the gutters, it will eventually back up, finding its way under the shingles and into the attic. A thick ice dam can damage roof flashing, fascia, and soffits. It can even shift vent stacks and create gaps that allow water into the roof. That water can flow into exterior wall cavities and end up in your basement, or it can leak into your home and cause damage to walls, ceilings, and insulation. All that from icicles.

If your ice dam is causing water to leak into the home, you'll want to deal with it now. Otherwise, wait until spring to deal with the problem (but keep an eye on things—you don't want any water damage to your interior). You might be tempted to slap down some heating cables in your gutter and along the roof edge.

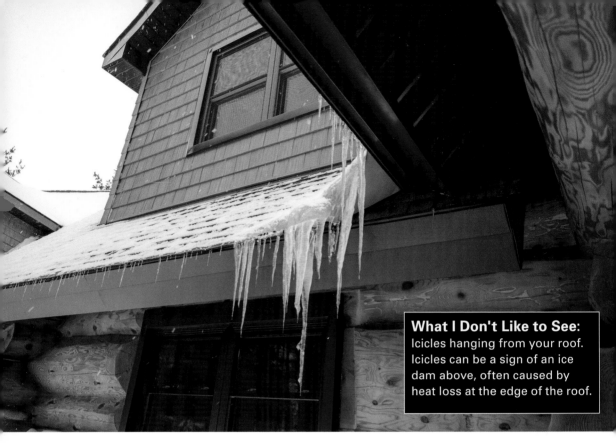

They work, but I think they're a waste of energy—you're better off spending money to fix the problem that caused the ice dam in the first place.

You can also buy a roof shovel that you use from the ground to keep the snow off the eaves. You'll have to use it every time it snows, just like shoveling your driveway, but the snow won't build up and you'll prevent ice dams. Just remember that shoveling your roof may also damage your shingles, which can reduce the lifespan of your roof.

I don't recommend you rush up onto your roof and try to chip away the ice. It's dangerous for you and your shingles. You or your ladder can slip, and removing ice from a sloped roof can release chunks of ice higher up that can slide down on top of you, tearing shingles along the way. If you have to remove an ice dam, have it done by a professional with proper equipment and training.

In the spring, fix the problem that's causing the ice to melt on your roof. Ice dams are usually your home's way of showing you that you're losing heat near the roof. Most often, this is caused by poor insulation or ventilation.

You want your home to be warm, but you have to think of your attic as a cold zone, which means the attic temperature should be the same as the outside air. Keep it well ventilated and

you'll keep the exterior of your roof uniformly cold. If your roof stays cold, the snow won't melt and contribute to the ice dam. Make sure you have enough roof vents and that they aren't covered by insulation on the inside or snow buildup on the outside. Have another look at both the insulation and the vapor barrier between your living space and attic. Insulation is one thing—and very important—but air movement through a poor vapor barrier is something that needs to be addressed.

One thing that could be adding heat—even if your attic is properly vented and insulated—is lighting. I don't recommend using recessed lights in ceilings below an attic space. Recessed light fixtures in that space will give off heat, which you don't want in a cold zone. Also, recessed lights aren't perfectly sealed. They have holes in them, which also allow warm, moist air from the room below to pass into the cold zone. That will lead to condensation, which can cause water damage on the ceiling below and promote the growth of mold. The heat loss can also melt the snow cover on your roof from below, which will then refreeze when the lights go off. Now do you see why I don't like recessed lights below attics?

Ice also accumulates on low-sloped roofs because these roofs are particularly difficult to insulate and ventilate—there just isn't much room for insulation or air movement. Ice dams can be chronic on these roofs.

Another problem may be gutters clogged with leaves and other debris. If you didn't get around to cleaning them out in the fall, water will back up under the shingles and cause ice damming and water damage to the sheathing under the shingles in winter. With every freeze–thaw, the cycle repeats.

Is it ever acceptable to roof over existing shingles?

I understand why people are tempted to lay a new roof over old asphalt shingles: it's faster and cheaper. Sure, you'll save a few bucks on removal and dumping, and minimum code allows for two layers in regions without severe hail (three used to be acceptable by code). But this is something I'm totally against. Never ever install a new shingled roof over top of an existing one. Why? Because you don't know what the structure is like underneath. The existing shingles may have damaged the sheathing—it may be rotten, it may be moldy. We need to pay attention. So always, always strip your roof every time it needs reshingling.

Use Ice and Water Shield on the Whole Roof

Next time you need to replace your roof, it's worth going beyond minimum code. Minimum code typically requires the installation of roofing underlayment—also known as roofing felt, tar paper, or asphalt paper—over the entire roof. This asphalt-coated felt helps protect the roof's deck—the plywood sheathing underneath—from wind-driven rain. Well, I'm not into minimum code because that paper is riddled with holes after the shingles are nailed onto the sheathing. Every one of those nails is an invitation for water to trickle down into your attic.

Where there is a risk of ice damming at the eaves, minimum code also requires a self-adhering, polymer-modified bitumen like Grace Ice and Water Shield to be installed along the lowest portion of the roof, close to the eaves. But I'm a big fan of using ice and water shield over the whole roof as a secondary waterproof layer to seal around the nails better than paper. Unlike asphalt paper, a product like Grace Ice and Water Shield is a rubberized adhesive membrane that goes on under shingles. If water ever leaks down to this layer of sheathing, it is absolutely watertight. It prevents moisture from creeping into your home and protects you against ice dams backing up under your shingles.

If your roof is done properly now, you'll save money in the future. Water will not infiltrate your home or attic and cause you issues down the road. This is another case where I don't think minimum code goes far enough, and where I think a few hundred extra dollars is worth the money.

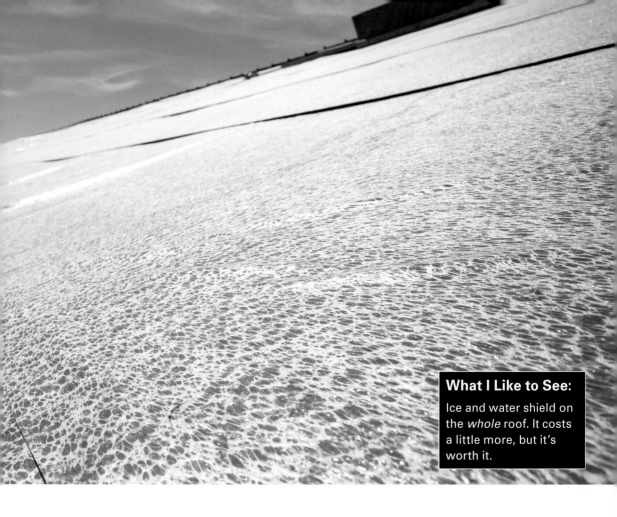

What I Like to See:

Ice and water shield on the *whole* roof. It costs a little more, but it's worth it.

Five Reasons to Strip Old Shingles . . .

1. Your roofer needs to remove the old roofing to see the condition of the plywood sheathing underneath. Any weak or rotting boards can be replaced.

2. Stripping the old shingles allows you to put up a new water and ice shield over the whole roof, not just along the edges.

3. Putting up an extra layer of shingles adds a huge load to the roof structure.

4. Moisture can seep down between layers, causing the wood beneath the shingles to rot.

5. Laying shingles on top of old ones may void the warranty on the new shingles—call the manufacturer to find out. (And remember to keep the bag the shingles were packaged in: that's your warranty.)

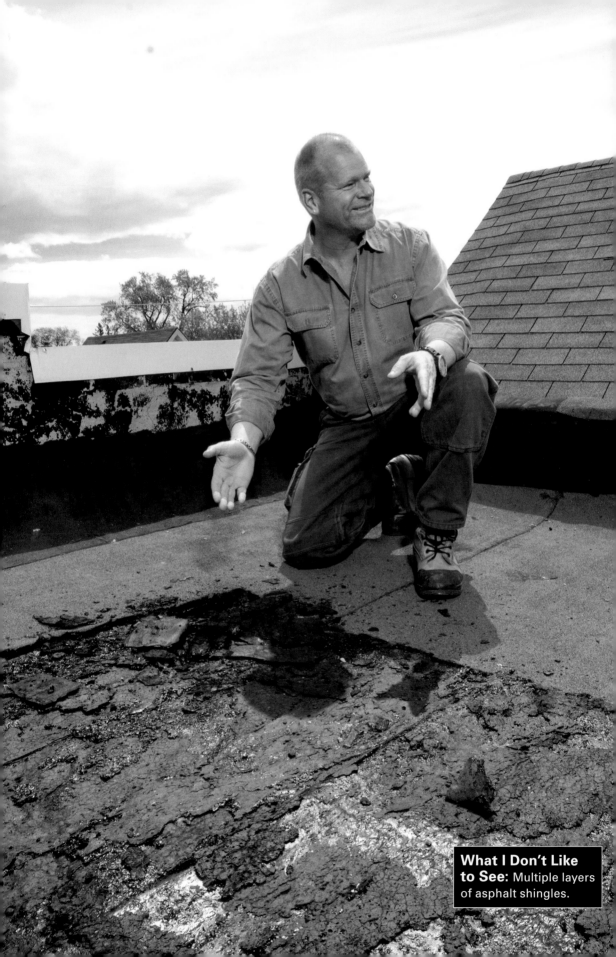

What I Don't Like to See: Multiple layers of asphalt shingles.

What do you think of metal roofs versus traditional asphalt shingles? And if we go with metal, how do we choose the right type?

I don't like asphalt shingles, period: they're not environmentally friendly, they contribute to urban heat islands, and they don't last as long as other roofs.

I'll tell you what I think of metal—I think it's the best product on the market (I also love a flat green roof). A metal roof is relatively lightweight, extremely durable and fire-resistant, and it should last up to fifty years. Metal roofs cost about three times the price of asphalt roofs, but they'll last about three times as long. If you're planning to move in a few years, you won't get your investment back, but metal is a triple threat if you're staying put: it raises your property value, reduces maintenance, and lowers your energy bills. Here's what you need to know.

Environmental impact

Most metal roofing is almost 100% recyclable. Plus, most new metal roofs are made with partly recycled material. Since metal roofs last much longer than asphalt shingles, they need replacing less often, which keeps tons of used roofing material out of our landfills.

Noise

Don't worry that a metal roof will be noisy when it rains—it's not like living inside a drum. A properly installed metal roof is no louder than any other roof. If the metal shingles have been mounted properly by a professional—using built-up 2 × 4 strapping to help

Where to Recycle Asphalt Shingles

Millions of tons of shingles are dumped in North American landfills each year. They take up to 300 years to decompose. Fortunately, some smart roofing and recycling companies are doing something to divert these toxic shingles from landfill: shingle recycling. Drop sites have been set up in various states and provinces to recycle asphalt shingles and make them back into something useful—which is a good thing, in my books. The shingles are shredded and added to roads and bike trails. Check ShingleRecycling.org or GreenShingle.com, or search "shingle recycling" online to see if there's a company doing it near you.

You might hear that metal roofing is heavier than asphalt shingles so you'll need a stronger structure, but that's not true.

with venting and breathability, or over a well-insulated attic space—the noise is controlled.

Durability

A metal roof should last at least three times longer than a regular asphalt shingle roof—that means fifty years compared with an average life span of fifteen years for an asphalt roof. I don't care if your shingle warranty says thirty years: in all my experience, I've never seen asphalt shingles last that long. They begin to break down as soon as they're exposed to sun and weather. Asphalt shingles and cedar shakes are also easy to tear off, so it's no problem for squirrels and raccoons to get into your attic.

Plus, metal is tested for the wind—up to 200 miles an hour in most cases. An asphalt roof would never last through severe storms. And the metal won't attract lightning either: if a metal roof is struck by lightning, the roof will conduct the charge and disperse it.

Fire resistance

Now if you think about fires, moving from one home to another, they are usually caused by the embers, flying through the air when the first house is on fire. A spark lands on the asphalt shingle and burns the house from the top down. With a metal roof, this will not happen. Metal gives you a huge advantage for insurance, and you'll be much safer from nearby fires.

Weight

Some people think a metal roof will weigh too much or that you'll have to re-support the roof to carry it. The truth is your roofers will thank you: metal roofs weigh less than asphalt roofs. Since metal doesn't absorb moisture, its weight stays the same in both dry and wet weather—unlike cedar shakes and clay or concrete tiles, which need the roof to be reinforced to provide extra support.

Just don't believe it if anyone suggests that because metal roofs are so lightweight you can put them over old asphalt shingles to save the expense of tearing off the old roof. They may even play the environmental card and tell you that it's a good idea to keep the old shingles on and go over them. Don't do it. I always recommend you tear off old shingles and inspect your roof deck before re-covering.

Materials

Today's metal roofs are made from galvanized aluminum, steel, or copper. Galvanized steel is the most popular, and it can be coated to prevent

Comparing Roofing

No matter what you choose—fiberglass, metal, asphalt, whatever—always choose a high-quality product. It's better to have high-quality asphalt shingles than low-quality fiberglass or cedar shingles. And make sure you get a pro to install your roofing properly. You can have the best-quality shingle, but if it's installed wrong, it won't last. If you do it right, you do it once.

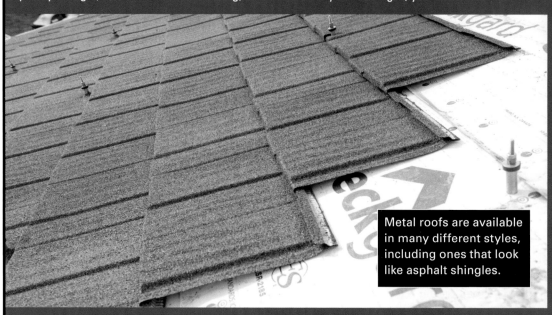

Metal roofs are available in many different styles, including ones that look like asphalt shingles.

The right way to install a slate roof, with coated sheathing and copper nails.

Material	Durability	Cost	Eco-friendliness	Good to Know
Asphalt shingle	Low to medium; lasts 15 to 20 years	Low to medium	Low; difficult to recycle, so millions of tons end up in landfill each year	Also called organic shingles because they're nonsynthetic. But don't be fooled: these are the same old paper-and-petroleum–based asphalt shingles
Fiberglass shingle	Medium; lasts 20 to 25 years; better durability than others in warm climates due to increased heat resistance	Low to medium	Low; same as asphalt	Made of similar materials as asphalt shingles but with a layer of synthetic glass fiber, which makes them more water- and heat-resistant
Cedar shingle	Low; lasts 10 to 15 years; high-quality can last 30 to 40 years. Not good for solid roof deck; you need proper spacing to allow shingles to dry (air movement)	High	High; recyclable and made from renewable, domestic wood	Porous (absorbs up to 10 lb./sq. ft. of moisture), so you must confirm your roof can handle the extra load
Clay, concrete, slate tile	High; can last 50 years or more	High	High	Clay tile is brittle so may break easily if a branch falls on the roof; fireproof; porous and heavy, so you must confirm that your roof can support the load
Metal	High; can last 50 years or more	Moderate to high	High; up to 100% recyclable; some metal roofing is made with recycled materials	Fireproof, windproof, lightweight, and durable

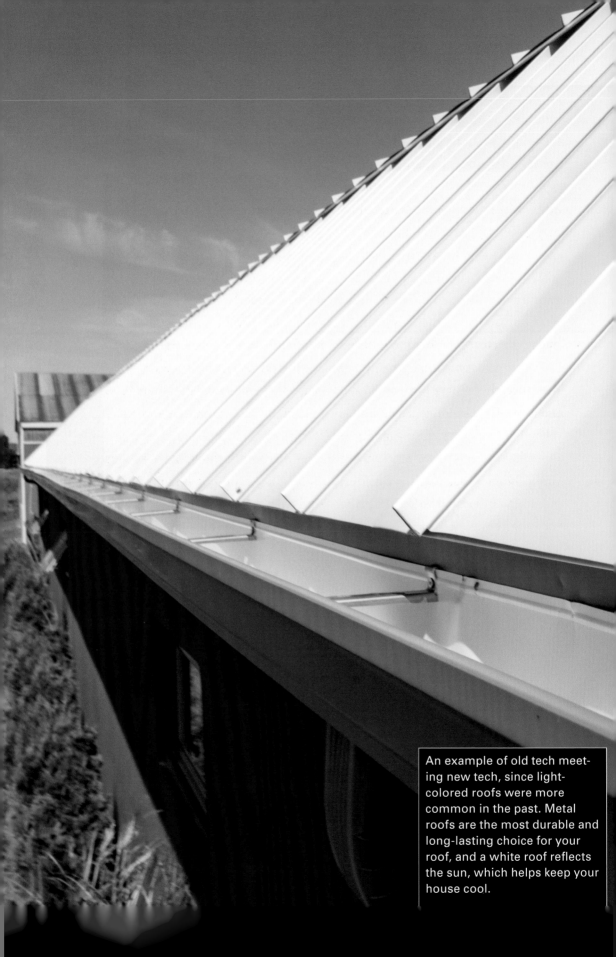

An example of old tech meeting new tech, since light-colored roofs were more common in the past. Metal roofs are the most durable and long-lasting choice for your roof, and a white roof reflects the sun, which helps keep your house cool.

corrosion. Stainless steel will cost more, but it won't corrode. Aluminum is extremely lightweight and rust-free, but it needs a finish. Along with copper, aluminum is better in coastal areas where steel would rust, but both may dent in a hailstorm. Copper will cost you, but it won't rust, peel, or scratch, and it acquires a soft verdigris patina over time.

Consider the thickness of the metal, which commonly ranges from 24- to 29-gauge material. The higher the gauge, the thinner the metal—and the lower the price tag. Thickness is related to longevity and the ability of the metal to keep its form, so choose carefully and check with your local building department to see what the code specifies.

Coatings

High-tech coatings on your metal roof reflect light and heat, and are UV resistant, which can help slash your home's energy consumption by up to 30%.

Look and style

Think beyond a garden shed's corrugated tin roof: metal can be formed and textured to resemble other materials, like wood shingles or slate. Some manufacturers offer twenty-plus shapes and thirty-odd colors. My favorite, and I think the best product out there, is Decra. It's well made and it looks like an asphalt shingle.

Do houses with metal roofs need gutters if they've already got good drainage around the house?

I think gutters are always a good idea—no matter what kind of roof you've got. (Good call on the metal.) Roof and gutters are related but separate. You may have good drainage around your foundation, but you need gutters and downpipes to carry water farther away.

Every house should have gutters along the bottom of every roofline. And each gutter needs a downspout to drain the collected water away from the roof. You never want a downspout to drain water directly onto a lower-level roof because this water and ice will cause excessive wear to the shingles and roof deck underneath the shingles. Downspouts should always drain into a lower roof's gutter. You also don't want a downspout to drain directly into the weeping tiles belowground or near the foundation. It makes no sense to put additional load on your weeping tiles—especially if they are old or in poor condition. In either case, there is water coming into

the house at the roof or foundation level. Not a good thing.

We've got some great mature trees on our property, but cleaning leaves and needles out of my gutters is a pain. What can I do to keep them out?

You're right on two counts: you need to keep your gutters clear, which means cleaning them out at least every spring and fall; and yes, it's a pain, but it's essential. If water backs up due to clogged gutters, you may get water leaking into the house. If you've got stagnant water up there, it can build up and allow mosquitoes to breed and grasses and weeds to grow right there in the gutter. If leaves and debris hang around too long, they'll speed up the corrosion process. Clogs can also cause water to back up under your shingles. If you live in a cool climate, you could end up with ice dams and water damage to the roof deck in winter.

If that kind of ongoing maintenance isn't for you, look into a leaf-proof cover for your gutters. I endorse Smart Screen (TheSmartScreen.com), which is perforated to allow water through but not leaves and debris. Well, you might get a few needles that dive in straight through the holes, but those will get washed away by the flow of

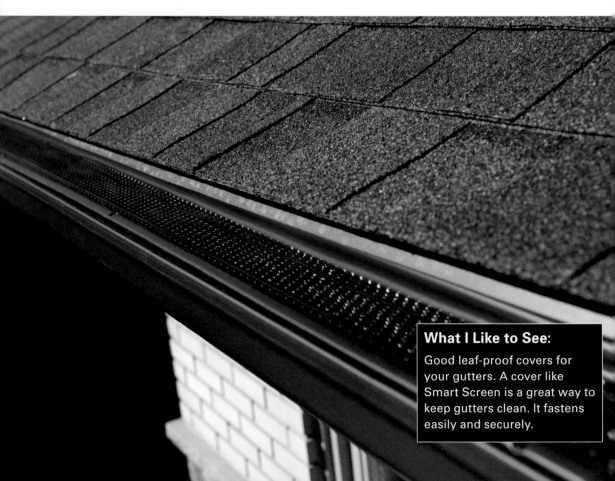

What I Like to See:
Good leaf-proof covers for your gutters. A cover like Smart Screen is a great way to keep gutters clean. It fastens easily and securely.

water. What I like about Smart Screen is it's made of heavy-duty aluminum and it fastens easily and securely.

What size downspouts and gutters should I have on my home?

I've said this about a thousand times, but I don't mind saying it again: water is your home's enemy. You need to control it and keep it away from every part of your house, from roof to foundation. Your gutters and downspouts are an important part of that protection.

Your gutters, also known as eaves troughs, collect water that comes off your roof and divert it through downspouts to the ground and away from your house's foundation walls. Make sure the downspouts release the water as far from your foundation as possible— at least 6 feet past the area of backfilled, uncompacted soil. If not, you're pouring water down to your footings. Without good gutters, rain falls right off the edge of your roof and pools along the drip line all around your house. You'll get seepage into your basement, mud splashing up on your house causing discoloration and staining, and possible structural damage to the outside walls and foundation over time.

Standard gutters are 4 inches wide, but this is one of those cases where size matters: small gutters and downspouts may not be able to handle the capacity of a heavy rain. Think about it: if you have a gutter that runs the length of your house— maybe 30 feet or more—and there is only one downspout at the corner that collects water from two sides, that's a huge amount of flow in a rainstorm. If the water spills over the edges and falls next to your foundation, it defeats the purpose of the gutter system in the first place. I recommend 6-inch gutters with a bigger downspout.

As for materials, plastic is cheaper, but aluminum is the industry standard for gutters. It never rusts, unlike steel, and it's weather resistant. It's stronger than plastic and will last longer since plastic will degrade when exposed to UV. Have them made so they're good and solid: that means they should be seamless and made with thick-gauge aluminum. The thicker the gauge, the longer they'll last. When gutters are built in sections, they have seams. Seams mean the potential for leaks. That's why I only recommend seamless gutters.

Professionals use a forming machine to construct seamless gutters. They're custom-sized to fit the length of any roof. It's the only way a gutter should be done, and it's the only way

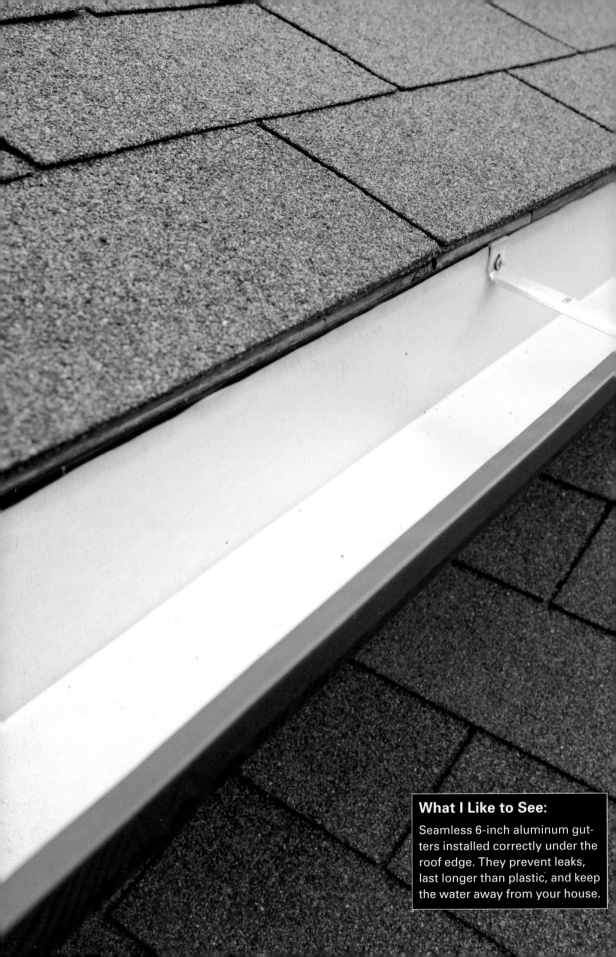

What I Like to See:

Seamless 6-inch aluminum gutters installed correctly under the roof edge. They prevent leaks, last longer than plastic, and keep the water away from your house.

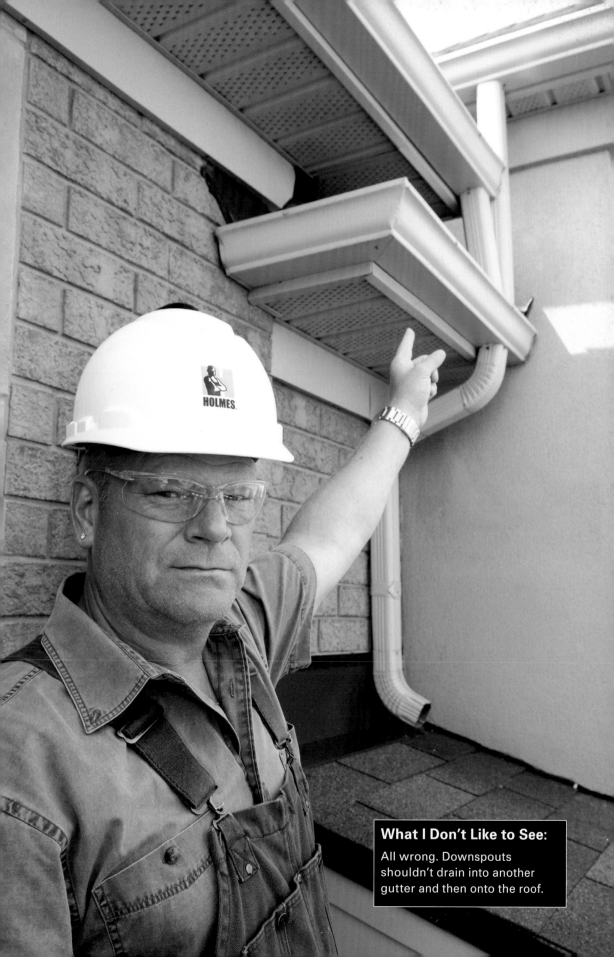

What I Don't Like to See:

All wrong. Downspouts shouldn't drain into another gutter and then onto the roof.

to prevent leaks. Professionals also make sure the entire gutter is pitched correctly. Otherwise, water is going to gather and it won't drain properly. You don't want something you're going to need to replace after the first winter. Talk to a good roofing contractor about how to incorporate gutters that work as well as your metal roof does.

Why are my roof shingles curling?

If you're looking at shingles that are curling or buckling at the edges, you're looking at a roof that's waving red flags. By the time you see that flag, your roof is telling you it doesn't have much life left.

Buckling and curling may be signs of natural wear and tear. You can also look for exposed bare patches on asphalt shingles, which gradually lose their granules over time, or large deposits of granules in your gutters. All these changes could be signaling poor ventilation in your attic, where rising heat often accumulates. If that heat gets trapped because you don't have a well-ventilated attic, it can warm up the roof, causing asphalt shingles to stiffen up and age more quickly.

A poorly ventilated attic can also cause another big problem for your roof: ice dams. When warm air from the home leaks into the attic and melts the ice on your roof, the water trickles down towards the eaves, where it refreezes and builds up. The buildup of ice can cause moisture to back up below the shingles, causing damage to the shingles and the roof deck below. (Take a look at pages 7–9 for more on preventing ice dams.)

If you're comfortable with heights, I recommend you take a ladder and some binoculars and inspect your roof at least every spring and fall so you can spot problems before they grow big enough to damage your house. If you see torn or missing shingles, or buckling in the middle of the shingle or curling along the edges, it may be time to reshingle. I'd call in the pros.

How many roof vents should I have? I notice only two vents on my roof, and other homes around me have five to six. Do I need more?

Most people care more about a roof's shingles, but it's a good thing you're picking up on the vents. Attics and roofs need to breathe or they'll decay quickly. If yours isn't adequately vented, you'll get serious problems—like mold or rot—from any moisture or water vapor that can't escape the space. A lot of moisture from everyday living—from showers, laundry, doing the dishes,

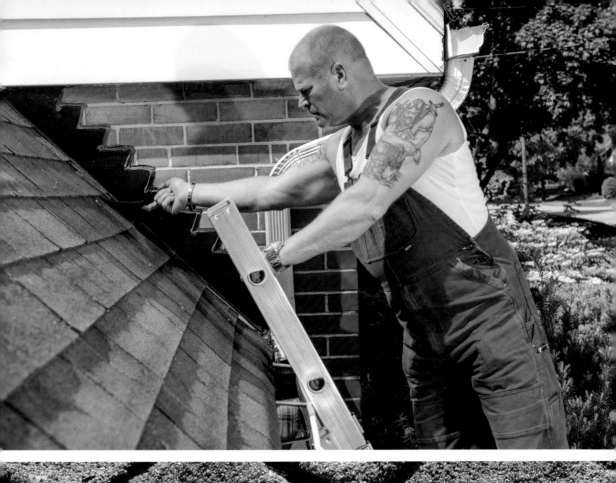

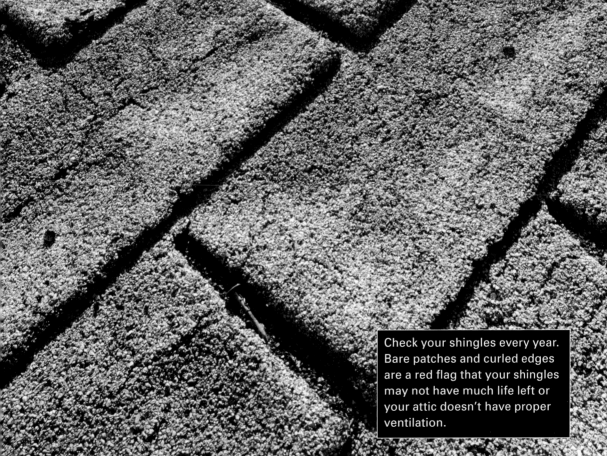

Check your shingles every year. Bare patches and curled edges are a red flag that your shingles may not have much life left or your attic doesn't have proper ventilation.

ROOF VENTS

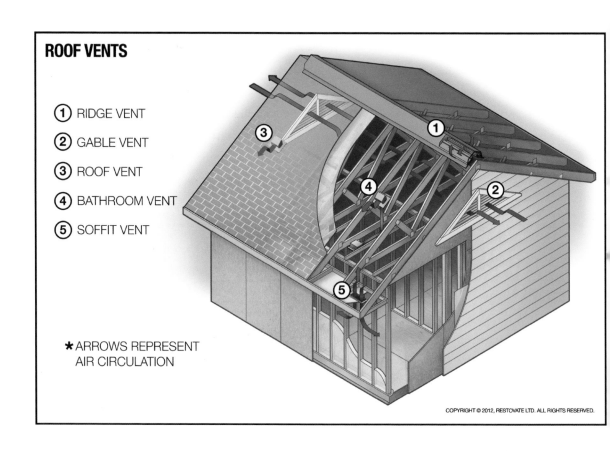

1. RIDGE VENT
2. GABLE VENT
3. ROOF VENT
4. BATHROOM VENT
5. SOFFIT VENT

*ARROWS REPRESENT
AIR CIRCULATION

even breathing—will rise into the attic along with the warm air that carries it up. Once there, you'll get condensation.

Condensation can soak your attic insulation, making it useless. In winter, the warm, moist air sneaks into the attic, where it's cold or freezing, and frost forms on the underside of the roof. Sometimes homeowners have what they think is a leak in the roof, because there's moisture or staining on the ceiling of the room below. There may be mold on the underside of the roof sheathing, rafters, or trusses. Over time, the plywood sheathing may rot out altogether.

A good attic is properly sealed off from the living space (with vapor barrier, insulation, and caulking) to keep warm air and humidity from getting into the attic and causing mold and other problems. Unless it's a finished attic, you want yours to be a cold zone and it needs to be ventilated.

To figure out if you have enough ventilation, you need to know the horizontal area of your attic. If there are separate attics or attic spaces separated by over-framing (the practice of building roof sections over sheathed roof sections below), each must be considered separately. With the least analysis, building codes simply require 1 square foot of vent opening for every 150 square feet of attic area. Exceptions to this standard allow less venting—1:300—in cold climates when there is a vapor retarder installed on the ceiling of the room below the attic. Venting can also be reduced if there is a relatively even distribution of vents low, at the soffits, and high, near the peak of the attic. There are specific details to these exceptions so, unless verified, just stick to 1:150.

Not all roof vents are built the same, and the requirement is for "free area" of ventilation. Metal or wood louvers reduce the actual free area of soffit vents, and 12-inch rooftop vents are 12 inches round, approximately ¾ of a square foot. Err on the side of more ventilation and you're going to cover these concerns.

If you only have two vents for the entire roof, you likely don't have enough. Check with a professional roofer to have more installed, and make sure your vents have screens to keep critters from getting inside. Also make sure they aren't covered by insulation, and inspect them regularly to make sure they aren't blocked by a bird's nest.

If you're having condensation problems in the attic, adding more ventilation might not be the answer. The most important thing to do to prevent problems is to properly seal

the attic from the home below, which will prevent air movement between the warm and cold zones of your house. If you prevent the warm, moist air from flowing into the attic, where it will inevitably condense, you likely won't see problems with moisture and mold. Check with a professional roofer.

What type of roof vents do you recommend?

Getting roof vents is a start for good attic ventilation. The most common type of roof vent is square like a box, with one open side that faces the ground. The vent is usually color-coordinated with the roof but still visible. The seal around it is critical, as is the quality of the vent itself. Get good ones, not the cheap ones that squirrels can literally bite into to get inside your attic; they like a nice indoor space as much as we do. These square vents are the bare minimum. There are better vents on the market.

The number one way to go would be to use ridge vents, which run along the peak of the roof. This style of vent has a specific free area per linear foot, so the geometry of your roof must provide a long enough ridge to do the job. I also like gable vents, which are louvered units set high up on the wall at either end of a peaked roof. Either of

these types of vent will give you 100% air movement to your attic to exhaust hot air in summer and cool air in winter. Like any vent, gable vents have to be sealed correctly around the edges, but because they're on a vertical surface and don't require perforating the roof, they're less likely to let in moisture.

As well as roof vents, you need perforated soffit vents. Soffits are the narrow horizontal sections under the roof eaves. Cooler air pulled in through the soffits warms up, picks up moisture and rises out through the roof vents. You don't need fans— it's a process that occurs naturally. Older soffits were made of wood, while modern soffits are either aluminum or vinyl, with perforations that allow for ventilation. Even when there are other roof vents, soffit vents are critical to give enough airflow to keep attics dry. Just remember not to cover up any of your vents with insulation.

The turbine vent has been a big product for years now. It spins and pulls air from the attic and out of your home. But too many times I've seen homeowners use a turbine vent while they have existing roof attic vents. This is an absolute no-no because a turbine vent is powerful enough to pull air through roof vents—the path of least resistance—instead of

Comparing Roofing Vents

Type	Pros	Cons	Good to Know
Box-style vent	Typical/standard roof vent	Ineffective if installed too low on the roof	The number of vents you'll need depends on the size of your attic and the amount of air leakage
Soffit vent	Perforations in vinyl or aluminum soffits allow air into the attic	Can get blocked by insulation inside the attic or be painted over	Install airflow baffles to keep opening clear
Ridge vent	Run along peak of roof to allow continuous air movement/exhaust, which provides better airflow at the very top of the roof because heat rises	More labor-intensive and expensive to install	Opening at roof peak must be cut according to manufacturer's recommendation
Gable vent	Vertical, so good at keeping out moisture	Less air circulation than soffit venting; gable vents need wind; if there isn't any wind, or if it changes direction, the gable vent won't work	Should be installed if soffit venting is missing; some older homes have undersized or missing soffits

from your soffit. You need to have air movement from bottom to top so your attic can breathe.

I checked inside the attic last winter and saw the entire underside of the roof coated with a layer of ice. What causes that? Is it dangerous?

Your attic is supposed to be a cold zone, but you absolutely don't want layers of frost forming. That tells me moisture is building up because your attic may not be ventilated properly. If you live in a cooler climate, frost will develop when warm, moist air rises up from the living space below and condenses when it meets the cold underside of the roof. If your attic can't breathe properly, that water vapor has nowhere to escape. When it gets trapped, it won't take long before you've got mildew,

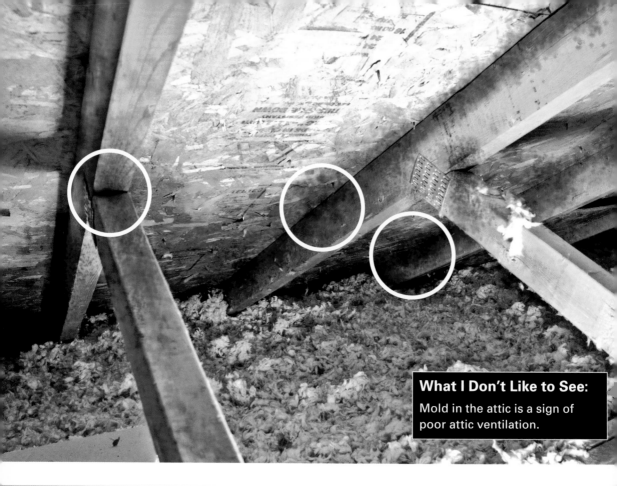

What I Don't Like to See:
Mold in the attic is a sign of poor attic ventilation.

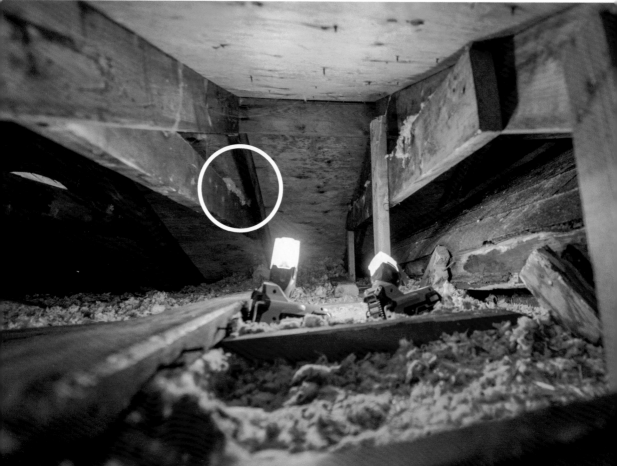

then mold; then the wood will start to rot. I've heard of homeowners who notice a leak or a stain on the ceiling of the room below the attic, which they assume is from a leak in the roof. It's probably not the shingles—it's probably poor ventilation. And no, this isn't just a northern problem: building code in the southern United States requires attics to be ventilated so they can handle the extreme heat.

Get your flashlight and go up to your attic (you should have access to any attic with a ceiling taller than 30 inches—that's code). First, make sure the vents are open, not blocked. Ideally, your soffit vents will have baffles (long, rigid plastic or Styrofoam vents) that direct air from the outside into the attic, up over the insulation and out through the roof vents. You should be able to see daylight through the soffit vents—this will tell you that they're not blocked by insulation. A general rule of thumb is to have one soffit vent for every four bays (a bay is the space between rafters).

What do you smell up there? If everything has been done right and is working the way it should, you should feel and smell fresh air in the attic, not mildew, mold, or rot. Look at the insulation too. Insulation should be dry with absolutely no dampness, and you need to see R-30 to R-49 across the entire attic floor, depending on your climate zone. The colder your region, the more insulation you should expect. If your attic insulation gets wet, it won't work and needs to be replaced.

Next, you need to make sure your attic is sealed. You want vapor barriers in the attic to be continuous and well sealed. They should be installed on the warm side of the insulation—next to the attic floor (which is actually the ceiling of the room below). Some insulation batts have a facing that acts as a vapor barrier; the batts should be installed with the facing towards the occupied part of the house, not towards the attic.

Make sure no air is leaking into the attic from the house. That sometimes happens around the attic hatch, the plumbing stacks, and ceiling light fixtures that enter the attic. These should all be sealed off to prevent warm air from flowing up. Dirty insulation in certain areas shows you have air movement, which isn't good. And make sure no bathroom fans, dryer vents, or range hoods are venting into the attic.

I want to put a floor in the attic. How will that affect the insulation I've got in there?

The good news is insulation isn't your

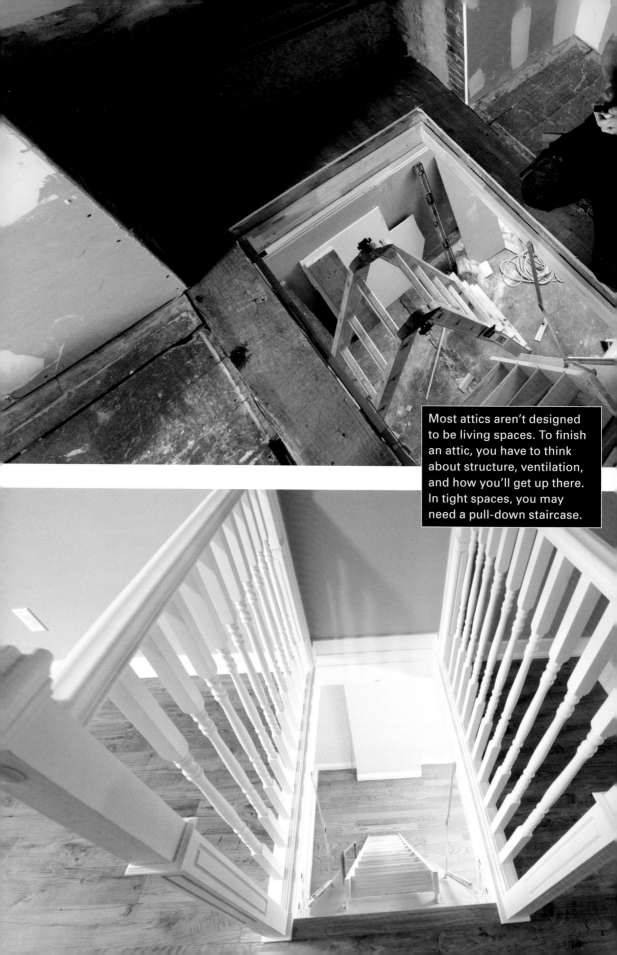

Most attics aren't designed to be living spaces. To finish an attic, you have to think about structure, ventilation, and how you'll get up there. In tight spaces, you may need a pull-down staircase.

biggest concern in this situation. Do you want the bad news? I don't recommend you install a floor in your attic.

Attic conversions are complicated because that space was never intended as living space. The attic's job is to be a buffer between the warm living areas of the house and the outdoors. We use a vapor barrier and insulation on the attic floor to keep warm, moist air from entering the attic. (Warm air will always move up.) Attics need plenty of ventilation to keep the air at the same temperature as the outdoors. That is how you keep your roof healthy and free from the condensation that causes wood and shingles to rot.

When the attic is converted from a cold zone to a warm zone intended for living, you have to consider insulation, ventilation, and protecting the roof from moisture. When you finish an attic, you're essentially creating a cathedral ceiling, with a very small space between the roof and the finished ceiling—not enough space for insulation and proper airflow.

Turning an attic into a living space may require changes to the roof and electrical, and will absolutely require changes to the structure of your home. Most homes weren't designed to support a room in the attic. It's not simply a case of sheeting over floor joists and building a couple of walls. Many old attics have "floors" that are built of 2 × 4s. That means they were designed to support the ceiling below it and to act as structural support for the roof, but not as a floor for walking on. They have to be beefed up to at least 2 × 6s to carry the weight load to the outside walls.

Have you thought about stairs to the attic? Do they need to be installed? If you've got a staircase that isn't original to the house, how do you know if the stairs are supported properly?

Then there's ductwork. Depending on the space, you may need more than one register for warm air and one cold return to balance heat. And does the furnace have the capacity to heat this additional space?

Many people want skylights in a finished attic, or they enlarge an existing window. In both cases, this is structural. Those windows need to be properly framed and installed. And of course you'll need permits and a very knowledgeable and experienced contractor to do all this.

If you're thinking of adding a floor so you can use the attic for storage, you can see it's a big job that involves permits, engineering, and money. I'd suggest finding another place in the home to store your stuff.

I want to put spray-foam insulation in the attic, but I've heard that roof sheathing needs to breathe. How can the sheathing breathe if we've spray-foamed the underside?

Good call on the spray-foam insulation. High-density polyurethane, or two-pound closed-cell spray-foam, has the highest R-value per inch of any insulation and it doesn't need a vapor barrier, depending on local building codes.

There are "hot roofs" and "cold roofs." Most typical homes have a cold roof where the attic space is a cold zone—it's sealed off from the rest of the house and it's basically the same temperature as outside. For these attic spaces, people typically use blown-in insulation on the attic floor. You need ventilation through the soffits and roof vents; that will help preserve your attic. Make sure the amount meets local code requirements.

Hot roofs apply to "cathedral ceilings." Because there isn't an attic space, the roof must be insulated, like in my new garage. That's when spray-foam is applied to the underside of the roof. Some municipalities don't allow hot roofs (or a conditioned attic), so you have to check with local authorities. When doing a hot roof/cathedral ceiling, you also need to make sure your roof framing leaves enough space for the right thickness of spray-foam to be applied. This gives you the R-value you need with the spray-foam. Two-pound closed-cell spray-foam provides an air and vapor barrier. So if it's installed to the correct depths, you do not need additional ventilation or need to worry about the roof sheathing breathing.

Which is better: vinyl, aluminum, or cement siding?

Once upon a time, siding was called clapboard and it was made of wood. In the '6os, aluminum siding became the new standard. It was textured to imitate traditional clapboard, but it was supposed to be more durable and maintenance-free than wood, which had to be painted every few years. It was also cheaper. Aluminum isn't perfect, of course: it dents and scratches. In some high-end neighborhoods, it's seen as outdated and it doesn't add value to your home. I'm not a fan of aluminum siding—there are better products out there.

Then came vinyl. It's been around since the '6os too, but it started getting more attention over the next decade or two. Now it's the most popular exterior finish for new homes, where it's often used with brick veneer to keep building costs down. On the downside, it can crack and mold, especially near

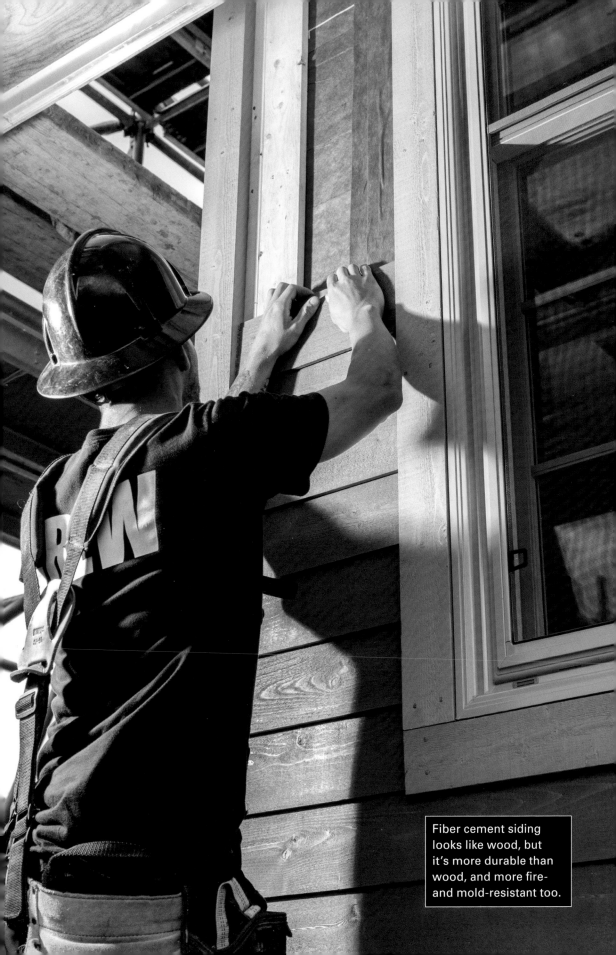

Fiber cement siding looks like wood, but it's more durable than wood, and more fire- and mold-resistant too.

Comparing Sidings

Material	Durability	Maintenance	Cost
Aluminum siding	Relatively durable but dents easily and finish will wear off over time	Low: may need washing to remove dirt	Low to moderate
Vinyl siding	Relatively durable but prone to denting, cracking, and mold near ground level	Low: may need washing to remove dirt	Low
Painted wood (clapboard) or stained wood siding (horizontal or vertical)	Lasts for many years if well maintained	Painted wood requires scraping and repainting every 2 to 5 years; stained wood requires restaining every 5 to 15 years	Moderate to high
Fiber cement board siding	Extremely durable	Must be repainted or stained as needed	Moderate to high

the ground. Vinyl isn't my preferred exterior cladding for a house. It's not environmentally friendly and it's a big fire hazard. In under five minutes, flames can spread from one vinyl-clad house to another just 6 feet away. Imagine how fast those flames would spread in a subdivision if all homes were clad in vinyl.

The newest siding on the block is fiber cement board, and I'm impressed with what I'm seeing so far. It looks like wood, but it's actually a mixture of cement, sand, and cellulose fibers. It won't rot, crack, or burn; it lasts for years; and it's excellent at keeping water out of your home. It needs paint, but it holds paint better than most wood siding and it's designed to stand up to extreme climates. It's more difficult to cut and work with, and it takes longer to install than vinyl or aluminum, so you'll need a pro. Fiber cement siding is also expensive.

All siding is fairly watertight if a professional contractor installs it correctly, but it will leak at corners and around windows if it's done wrong. Fortunately, it's fairly easy to fix: corners should be caulked and window trim

may need to be replaced. Whatever you do, don't go and put new siding over old stuff (that applies for flooring and roofing too). You might be covering up big problems with moisture or rot when you should be fixing them instead.

Is it possible to put new stucco over existing exterior stucco?

Done right, stucco looks great and can provide extra insulation. Done poorly, it cracks and falls apart. I'm guessing yours is crumbling, and you want to have it look like new. But you don't want to slap fresh stucco on top of old stuff. Here's why:

Stucco is a mixture of Portland cement, sand, lime, and water. It's just like brick, mortar, and concrete in that it's porous, so it absorbs water. It will repel rain for some time but can eventually become saturated to the point where moisture can reach the backside of the stucco, where it hits the house wrap. As long as the house wrap was properly installed, your house is protected. If it was not, moisture can reach the wood framing and start to rot or mold. That means this finish is most durable in dry climates like the southern United States, where the temperature is fairly constant, or at least constantly above freezing. That's the big problem with stucco: it doesn't work well in every environment and it will shrink and

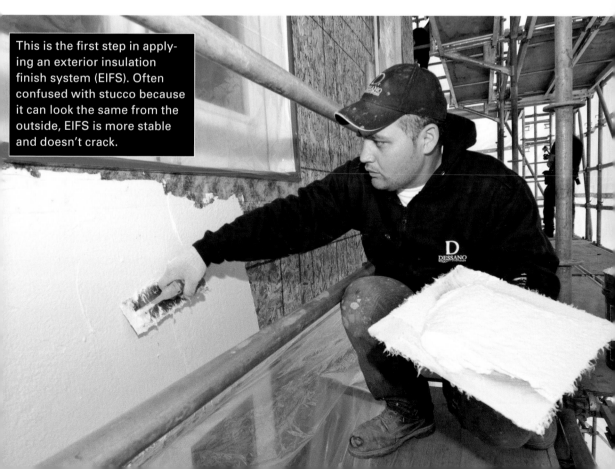

This is the first step in applying an exterior insulation finish system (EIFS). Often confused with stucco because it can look the same from the outside, EIFS is more stable and doesn't crack.

The 50-Year Stucco Solution

I'm a fan of the newer and better options on the market for "stuccos" such as Jewelstone from DuRock, which is an acrylic modified-cement–based coating applied over rigid foam exterior insulation. What I like about this synthetic is it bonds to almost any surface, and it really works. It's 100% watertight and fire-rated, is stronger than concrete, withstands freeze–thaw cycles, and it can be finished to look like stone, slate, tile, brick—you name it.

crack just like any concrete, especially in areas with a freeze–thaw cycle.

Now, what do you think is going to happen to your brand-new stucco if you apply it over a disintegrating surface? Not the way to go. Besides being unstable, that old stucco might have mold or rotting wood behind it. Plus, adding another layer to your home—without removing the old layers—can have a negative impact on the structure. Remember that each new layer adds extra load on your walls—weight that your house wasn't designed to carry. And how many homeowners renovated before you came along? Over time, gravity takes over and starts to pull down all those extra layers, compromising the structure and safety of your home. Do yourself a favor and make

it right: have a pro remove the old stucco first.

If you live in a region that gets snow, you don't want it resting against a stucco wall. When this happens, you'll probably notice the stucco flaking along the bottom of the house, where moisture from the ground and precipitation sit. That's why if we're doing stucco, I like to have a masonry bottom and a stucco finish at the top of the house—usually on the second floor. In cold or wet climates, keeping stucco away from the ground helps prolong its life. The weep screed at the bottom of the stucco (a perforated flashing to allow water to drain) must be a minimum of 4 inches above the ground, 6 inches if synthetic stucco is used (such as an exterior insulation finish system—EIFS).

How to Make Stucco Last Longer

This is for anyone who doesn't live in a warm, dry climate and wants to preserve their stucco for the long haul. The key is to have your pro take steps to control the air and moisture *behind* the stucco finish. One other thing: make sure your contractor is following the manufacturer's instructions for all materials, or the manufacturer's warranty can be compromised. If there's a problem, you'll be out of luck and stuck with the repair bill. So get involved and ask questions. Asking questions rarely leads to problems. It's when you don't ask that things get messy.

Step 1: Choose a tough, durable substrate. Stucco has many layers. The first layer is the substrate—the material the stucco is applied to. I think oriented strand board (OSB) is most common, but plywood sheathing is also effective.

Step 2: Install the all-important air and moisture barrier. It's the barrier's job to prevent moisture from penetrating through to the substrate material so as to prevent wood rot and damage to the stucco surface. Depending on local code or manufacturer's instructions, or both, there might be specific moisture barrier and assembly requirements. Always check what the requirements are and verify them with your contractor.

If your contractor uses waterproof building paper, the vertical seams should be overlapped by a minimum of 6 inches; horizontal seams by a minimum of 4 inches—depending on the product used. Each has a different specification. These seams all need to be taped so no air or moisture can leak in. My crew uses a self-adherent air- and moisture-barrier product that wraps the house like a gift-wrapped box. Because it is self-adherent, it provides one solid layer of protection.

Step 3: Install an insulation system (or mesh), then stucco. Typically, stucco goes up over a steel mesh that's properly installed on top of the moisture barrier. You'll need two layers if you're working over masonry or concrete (one base coat, one finish coat) or three layers if it's going over wood framing (scratch coat, base coat, finish coat). But a couple of new systems have changed the process.

We now have exterior insulation finish systems (EIFS), which are basically rigid foam panels that go over the moisture barrier, like the PUCCS system by DuRock. I like them for two reasons. One, they give your exterior walls extra insulation to increase their R-value (which makes them more resistant to heat loss). Two, these systems help drain any moisture that gets caught behind the stucco layers, which means your stucco will look better longer and your home won't be a target for mold or rot.

Should a brick house be waterproofed or sealed?

Your question tells me you know something important about brick: it's not waterproof. Some people find this surprising, but it's true. Bricks are made of clay, and clay is porous, so it absorbs water. Brick can be saturated after just two hours of direct rainfall. Over time, moisture causes the brick to deteriorate. It takes a while, but brick deterioration happens in both modern brick-veneer homes and traditional brick homes where the brick wall is structural.

So yes, you want to keep water out. But you don't want to seal or waterproof the brick because it needs to breathe. Any moisture that can't get out from behind the wall in a modern brick house will migrate into the home and rot the framing. You don't want that to happen.

The best approach with an old house that has brick all the way into the ground is to work with the natural drainage: keep the ground sloped away from the house so water will run away from the brick after a rainfall. And watch for signs that the weeping tile is broken or blocked: serious water backing up through the basement walls. That will have to be fixed by excavating and replacing the weeping tile around the foundation.

With a modern brick home (brick veneer placed in front of wood framing), take a look from the outside: you'll see small vertical gaps in the mortar. The gaps up high between the first and second floor are designed to allow air in; the ones down low, between the basement and the first floor, are designed to let water out.

One way to protect the interior of your home, whether it is solid brick or veneer, is to keep an eye on the mortar. Crumbling mortar and loose bricks let in water. Find a pro who can do repointing, which means adding or replacing mortar where the older stuff has fallen out. It requires a fair bit of skill and practice, so it's not a good do-it-yourself job.

The worst thing to do is try to waterproof the basement from the inside by putting studs, insulation and vapor barrier against the brick. Sure, for a while you won't feel that dampness, but in time the water will continue to come through the walls and soak the insulation. The only thing holding back the moisture will be that thin sheet of plastic vapor barrier. Better to take care of moisture before it comes into the house.

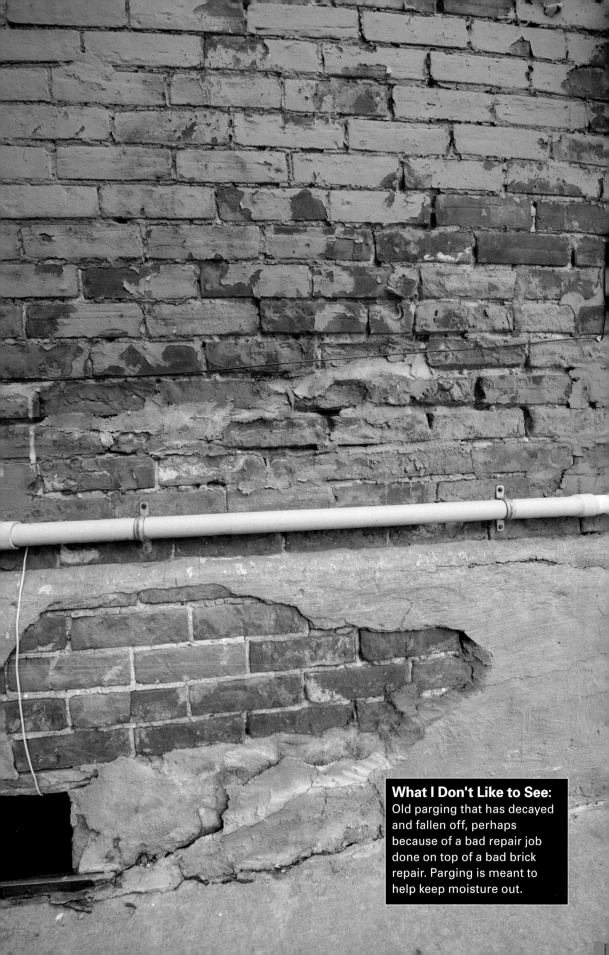

What I Don't Like to See:
Old parging that has decayed and fallen off, perhaps because of a bad repair job done on top of a bad brick repair. Parging is meant to help keep moisture out.

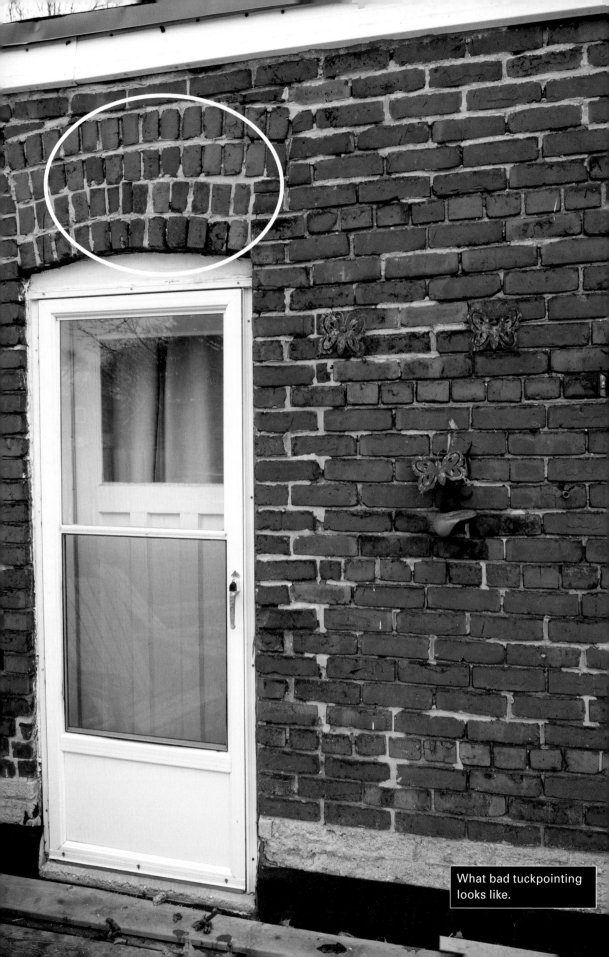

What bad tuckpointing looks like.

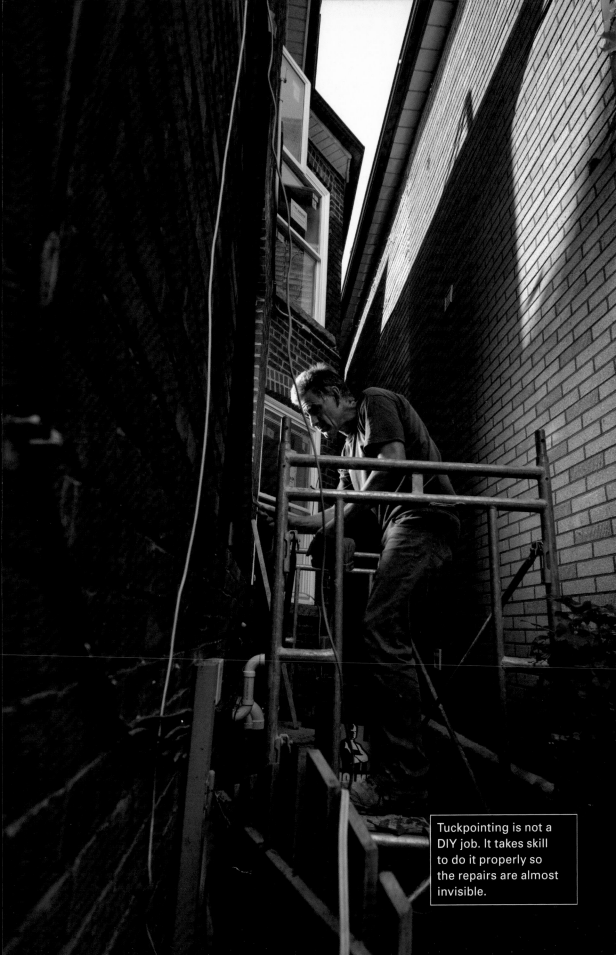

Tuckpointing is not a DIY job. It takes skill to do it properly so the repairs are almost invisible.

I currently have aluminum siding over original cedar shakes on a 1929 home. I'm considering vinyl siding. Do I have to remove the existing wood siding before I install aluminum, or can I put the house wrap, flashing, and new siding over the cedar?

Let me get this straight: you are asking about putting a *third* layer of siding over pre-existing cedar shake and aluminum siding? I'll tell you what the general rule is: two layers are OK. Now I'll tell you what I think: three layers is a really bad idea, and I don't even recommend two. I never like cover-ups: they can hide a problem you'll never know about unless you remove the existing layers—whether it's flooring, roof shingles, or siding—so you can see what's beneath.

I'd tear back the original layer. Once you've opened everything up, you can check the sheathing and fix anything that needs it. You can also put on house wrap; I bet there isn't any on there now. I know people think it's "too much work" and "too expensive," and that's why they don't bother. But if you go right down, you have the opportunity to moisture-proof your home and even add insulation. House wrap improves energy efficiency by preventing air leaks. It's worth it: you'll save money on heating and cooling, and protect your home's structure from water intrusion.

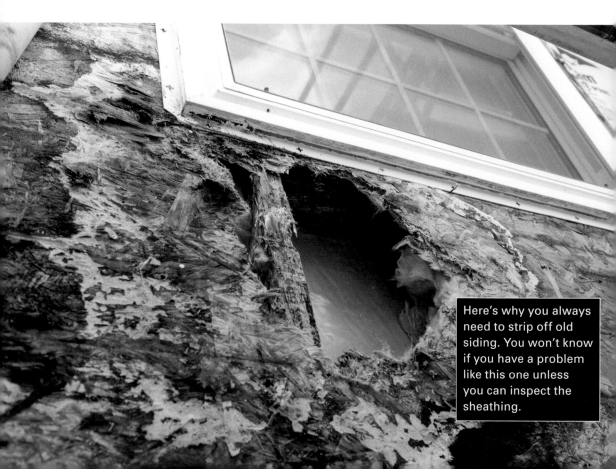

Here's why you always need to strip off old siding. You won't know if you have a problem like this one unless you can inspect the sheathing.

We're having our home reroofed. Should the old lumber sheathing or plywood be pulled off?

The biggest hazard to look out for on a roof is too many layers. Minimum building code allows for two layers, but I think all reroofing jobs should begin by removing old shingles and laying new ones on the plywood deck. That plywood needs to be made visible to judge whether it's still in good condition. So the answer in your case is, not necessarily. It depends on the condition of the sheathing. Tear back the old shingles, expose the wood, check it over and replace worn or rotted sections.

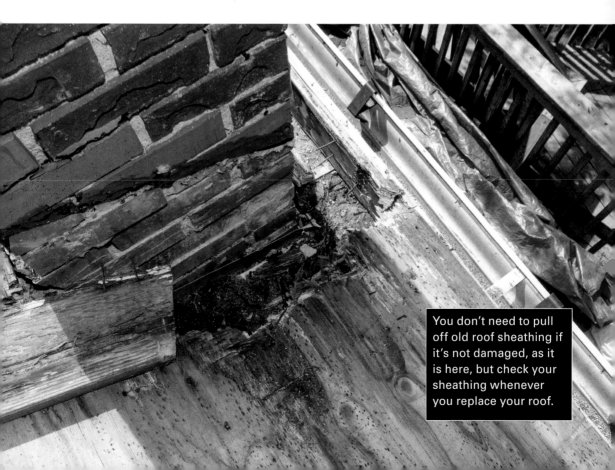

You don't need to pull off old roof sheathing if it's not damaged, as it is here, but check your sheathing whenever you replace your roof.

I like the look of cedar shingles, but I'm considering cement-based siding. What do you think of cement siding?

So far I like what I'm seeing from fiber cement siding, which is one of the newer siding products out there. It looks like wood, but it's actually a mixture of cement, sand, and cellulose fibers. It's durable in extreme weather, fire-resistant, mold-resistant, won't rot or crack, and is good at keeping water from getting inside your home. Plus, it holds paint better than most wood siding: some manufacturers claim it will hold paint or stain for seven to fifteen years depending on your climate and sun exposure. Just make sure you paint or stain it within about three months of installation, or it might start to show signs of breaking down from exposure to UV rays. And you should know that it's trickier to install than other siding. You definitely need a pro. Check out page 36 to see how it stacks up against other types of siding.

What is house wrap and what does it do?

Most of us think of our homes' exterior finish—the brick or the siding—as its weather protection, much like our winter coats. But there's one thing that's even more crucial to protect

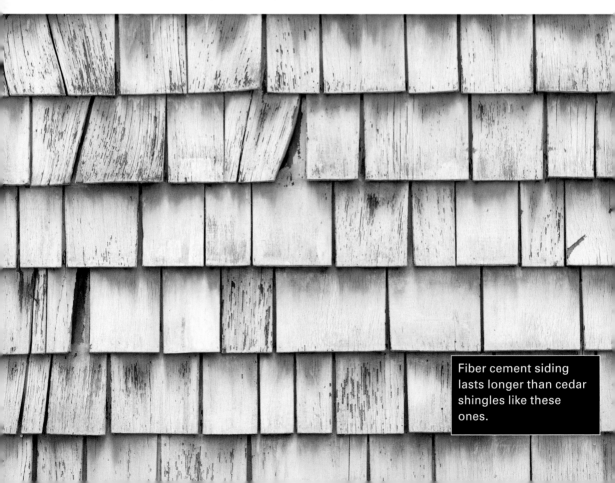

Fiber cement siding lasts longer than cedar shingles like these ones.

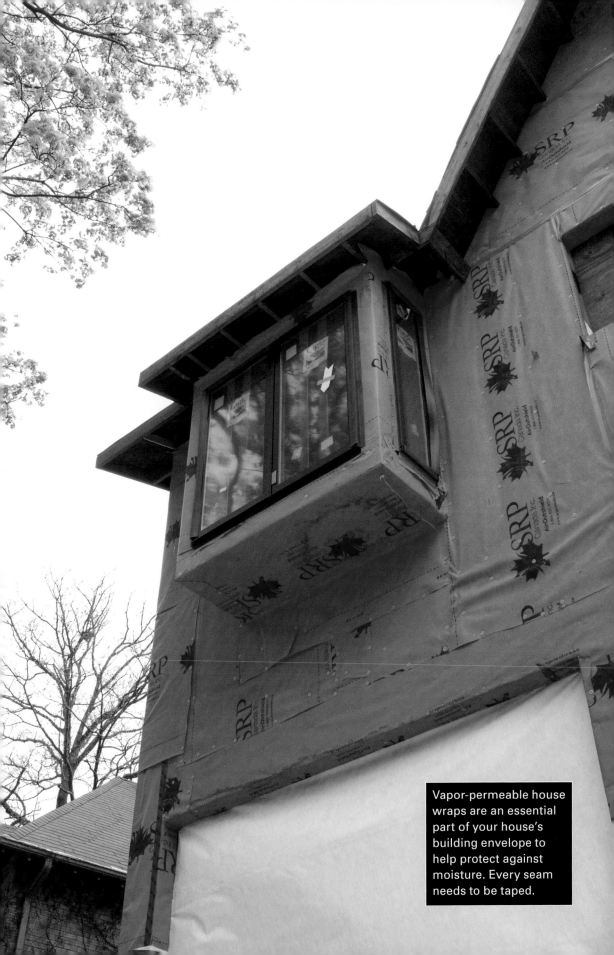

Vapor-permeable house wraps are an essential part of your house's building envelope to help protect against moisture. Every seam needs to be taped.

your home from damage caused by moisture: house wrap. You've probably seen it on new homes as they're being built—Tyvek and Typar are two well-known brands, but I'm a big fan of Blueskin since it's self-adherent.

House wrap is a breathable membrane installed directly over your home's plywood or oriented strand board (OSB) sheathing, underneath the exterior finish. We wrap a house like a birthday present—Tuck-taped at every seam—before we put up any cladding. This way, if water gets in behind the cladding, it runs down the wrap and weeps out the bottom without penetrating your home. Without it, moisture collects on the inner side of the wood, vinyl, or brick sheathing, as well as on the outside surface of the plywood or OSB. Eventually, this can lead to mold and rot—expensive repairs. The wrap sheds moisture from the outside while allowing air to flow through its microscopic holes.

House wrap protects your home in several ways. The membrane stops direct moisture, like rainwater, from penetrating the plywood or OSB sheathing on the outside of your home, yet allows water vapor from within to migrate outside. Don't forget, we create a lot of moisture inside the house: breathing, showers, laundry, and cooking all produce water vapor. Moisture that gets into your wall cavity must be allowed to escape back out through the house wrap. Otherwise, it will rot the wood inside the walls and lead to mold.

The wrap also stops outside air from penetrating the home. It's not airtight—it's a breathable membrane, and it has no insulation value. But it improves energy efficiency by preventing air leaks.

House wrap comes in a 9-foot-wide roll, which minimizes seams and the chances of air leaks. With a stapler and a roll of special tape, two people can wrap a small house in less than a day. But it isn't a job for just anyone. It takes experienced contractors to do the job properly and efficiently. That means a minimum 6- to 12-inch overlap at all joints. Every, and I mean every, hole and overlap is sealed tight with tape. If the taping isn't done right, you're wasting your money. The system won't be effective—you'll end up with air movement and the possibility of water damage.

It's important to get it right when wrapping the membrane around window and door openings. Taking the wrap into the inside edge of the frame, which will be covered by trim,

guarantees a watertight envelope—as long as your contractor does a good job of spraying foam insulation around all your windows and doors. If you end up with tears or holes—accidents happen on a busy construction site—inspect the wrap and make sure you're satisfied that every opening is taped before your contractor covers it with the exterior finish.

Why does brick spall and what can I do about it?

Spalling is what happens when the face of brick or other kinds of masonry disintegrates from ice and water damage. When bricks get wet and freeze, the expansion causes that hard outer surface to break off. This exposes the softer inner part of the brick, which is more porous and will hold water. The bricks will quickly crumble and must be replaced. Spalled bricks can't be repaired. You'll need to call in an experienced, licensed masonry contractor.

Exterior brick walls need to be carefully built to keep water out, especially if they're part of a retaining wall. That's why you don't see foundations built out of brick anymore. If the soil touches the brick, it'll keep the brick wet and soft, which is a recipe for disaster. It's also a great way to grow mold and moss.

Why should I be aware of my property survey lines?

If you're like most people, you never think about a property survey. You got one when you bought the house and now it's stashed away . . . somewhere. But most of us don't know where it is or whether it's accurate. That's a problem if you're planning home improvements to your landscape. You may not need a permit to build a fence or a small shed, but you risk having to rip it down unless you build within the legal setbacks allowed by your municipality. You might also sour the relationship with your neighbors—or spark a lawsuit. Bottom line is, you need to know where your property lines are.

A good survey accurately shows all property lines, easements, and setbacks so you know where you are allowed to build legally. You might have a copy of the original property survey of your house when it was built, but I wouldn't be surprised if that one's out of date if any improvements have been made—maybe a pool or gazebo, a deck, or even an addition. A current survey will note everything on your lot, as well as easements for power lines, sewer lines, gas lines, storm water catch basins, and phone and cable lines. An easement is the right of a third party to use a part of your

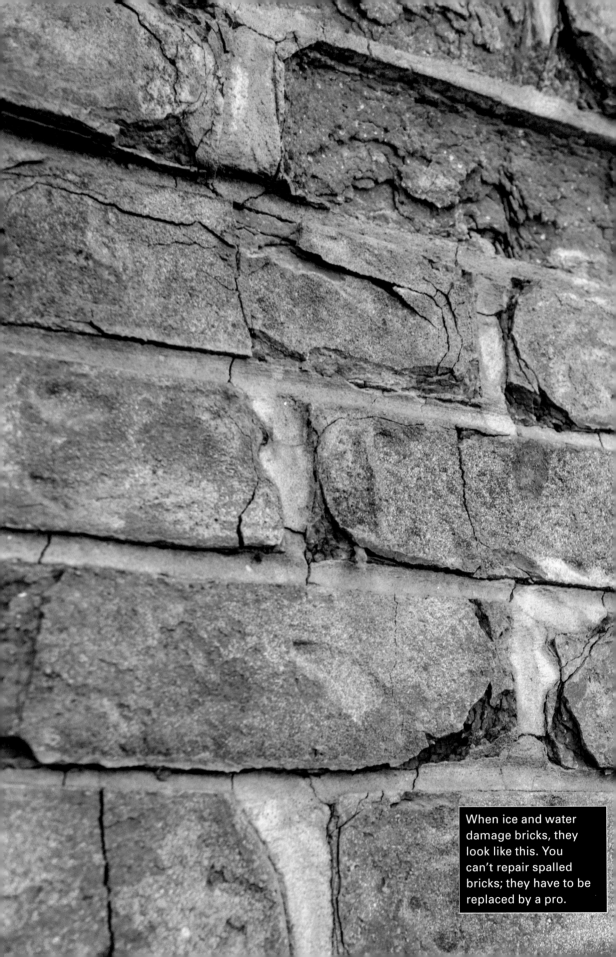

When ice and water damage bricks, they look like this. You can't repair spalled bricks; they have to be replaced by a pro.

The Easy Way to Manage Easements

I got an email from a homeowner who was having issues with the land around his home eroding. He tried to fix the problem by building a retaining wall along the inside of his fence. Now there's water pooling on his neighbor's side. The neighbor called the city. The homeowner has been ordered—at his expense—to remove the wall and restore the land back to its original grade. What a waste.

Most residential properties have drainage easements, which are complex systems the city uses to avoid flooding. Keeping drainage paths clear of debris such as leaves and trash is crucial for them to function properly. Even temporary obstacles can restrict the flow of water within the easement. And guess whose responsibility it is to keep them clear? The homeowner's. Without even knowing it, this homeowner messed with a drainage easement that caused damage to a neighbor's property.

To find out if your property has a drainage easement, check the certificate of title to the property, which you'll find at your municipal land title/registry office. All easements, rights-of-way, and culverts on a property are typically registered on that certificate.

Another option is to check the property's Real Property Report (RPR). In Ontario it's called a Surveyor's Real Property Report (SRPR). In the United States this is commonly called an Improvement Location Certificate (ILC). Its availability depends on where you live. But if it is available to you, get it. This document shows where all the easements, rights-of-way and culverts are located on a property.

Remember, it's your responsibility to know the restrictions on your property and how the land can or cannot be used. I've learned again and again that it's better to be safe than sorry. You'll save money and time, and you'll do it right the first time.

property for a specific purpose. It's on your deed. For example, you might have a utility easement on your deed that allows maintenance workers to access a transformer on your lot, or gas or power lines buried across your property.

If you are building a fence, it shouldn't be on the property line; it should sit entirely on your property,

even if it's just by a few inches. Think about it—how is the fence held up? Are you using concrete footings—do they go over onto the neighbor's property? That's not legal—you can't encroach. If you're looking at replacing an existing fence, don't assume it's in the right place: a survey may show that it was built further inside the property line than it should be. Property lines aren't always straight.

Average lot sizes in new subdivisions have been getting smaller, and the houses are getting larger. Since more of the lot is built on and there's less open space, there's a lot less room for mistakes when it comes to fences and structures in backyards. Every property has a building setback—that's the area measured in from all sides of your lot—that you are not allowed to build on. The setback varies on all sides of your lot—it might be 10 feet on the sides and 40 feet in the back; it could also be zero feet. Setbacks vary between municipalities, from neighborhood to neighborhood, and even between adjacent lots, depending on the zoning bylaws. Lots adjacent to parks, golf courses, greenbelts, and corner lots often have large setbacks. You need to know the setbacks and rules before you build.

If you build something too close to the property line, you are violating a bylaw and can be fined and made to remove it. Also, in some municipalities, you are only allowed to cover a certain percentage of your lot with "buildings." Sometimes that includes permanent structures such as decks, sheds, pergolas, etc. to minimize the poor aesthetics of an overdeveloped lot; other times it only applies to surfaces impervious to water, to limit surface storm water from draining off the property. If you go over that percentage—without being granted permission—you can be ordered to take the structure down.

The setback gives a residential area a consistent standard for building placement, making sure the houses aren't too close together, or too tall so they block light from other neighbors, or too close to the street. Sometimes certain parts of a house are allowed to project into the setback, such as bay windows, decks, or eaves.

Homeowners who are building new or putting on additions can apply for a variance that allows them to change the setback or the lot coverage in their situation. Approval is granted—or not—by the local government.

You generally can't build on an easement—nothing, not even a fence or part of a fence. If you do, you'll have to take it down and compensate for any damage you might have caused. If you plant a garden that interferes with future access, you need to be prepared to have your prize roses torn up if work needs to be done.

Make sure you have a recent accurate survey and understand the setbacks that apply in your area before you decide to build anything. The last thing you want is to have to take it down and do the job again, or risk fines or lawsuits.

What is mudjacking? Can it re-support a porch that has shifted, or do I need to drive piers?

Mudjacking involves drilling a hole in a concrete slab that has a void beneath it and filling it in with concrete. This prevents the concrete slab from getting extensive cracks or collapsing. If the concrete slab is cracked, uneven, or heaving, a series of holes are drilled into the part of the slab that is lower than the rest and then, using pressure, concrete is pumped into it. This raises the slab up so that it's even.

If there's a cellar or cold room underneath your porch, you can't mudjack—you'll be drilling into the cold room. You can only mudjack concrete slabs that are on grade. Mudjacking is only good to raise concrete slabs. If the repair has to do with re-supporting a structure, then you're looking at underpinning, which can include piers.

I'm having a new cedar deck built and I want it to last. What can I do to maintain it and prolong its life?

Cedar has lots going for it: beautiful color and grain, natural resistance to rot and insects, and about the same lifespan as pressure-treated wood—up to twenty years—without chemical preservatives. Cedar has natural oils in the wood that help preserve it.

On the downside, the quality of the cedar we're seeing now is starting to decline. Years ago, builders were lucky: they were working with lumber from hundred-year-old trees. (I guess that means the trees weren't so lucky.) The lumber we're seeing now is from second-generation forests, which are grown faster and harvested sooner.

How long cedar lasts depends on what your climate is like; how much your deck is exposed to sun, wind, and water; and how you finish it. To preserve the color of the wood, you can stain it. Once you stain it, though,

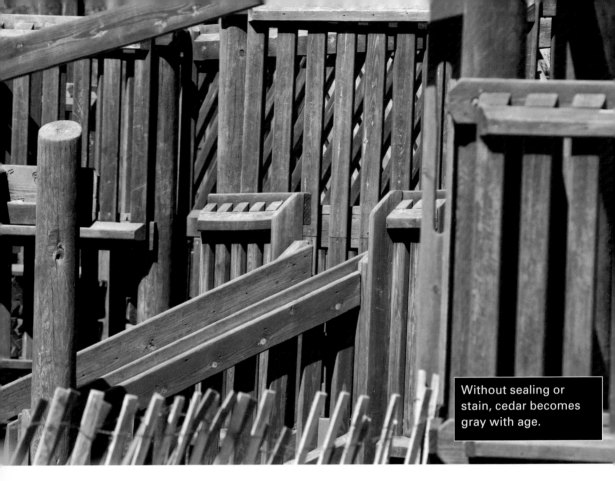

Without sealing or stain, cedar becomes gray with age.

you have to keep that up over time.

Wash your deck every year with mild detergent and water. Skip the pressure washer; cedar is soft and the high pressure can damage the wood. If you're going the route of staining, apply an eco-friendly deck stain or sealer every two to four years to maintain the deck's color. The first time is easy because the wood is new. As it ages, you'll need to sand the wood, remove loose material and then apply the stain or sealer. It sounds like a lot of work because it is.

That's why some people prefer to let nature do her thing and allow the cedar to weather naturally to gray. Either way, cedar can last many years with few areas needing repair or replacement.

I can't decide what to use to build my deck. I want something that's long-lasting, looks great, and doesn't require very much maintenance. What would you recommend?

It's a sign of summer when homeowners start thinking about new decks. It's no wonder: they're a great addition to your living space. The way I see it, choosing the right material comes

down to this: do you have more time or more money? Woods are generally cheaper to build with in the short term, but keeping them looking new requires an annual investment of time. Composite wood costs a lot up front—up to five times more than the cost of pressure-treated materials and installation—but it's very low-maintenance over the long haul. Check out these materials before you make your choice.

Pressure-treated wood

It's not tough to figure out why pressure-treated (PT) wood is so popular for decks and fences: it's usually the least costly wood choice. The boards are impregnated with chemicals that help the wood resist rot and insects, which makes it ideal for exterior projects.

There's been a lot of concern about PT wood in the past, because arsenic was once used to treat it. PT wood is perfectly safe if you work with it properly—it's an exterior product, so never use it indoors—and don't burn it. Increased copper content in today's PT wood has eliminated the use of arsenic, which means your contractor has to use the correct fasteners when building your deck. Once the copper in PT wood gets wet, all of the screws and joist hangers will corrode if they aren't specifically labeled for use with PT wood. Aluminum and copper don't mix, and regular galvanized nails and screws won't hold up for long. First you'll notice staining on your deck around the screws and hangers; then you'll notice structural failure when the screws corrode away.

Since it's not water-resistant, PT wood needs maintenance. Clean it annually to remove dirt or moss, then apply a water repellent every year to guard against moisture damage, splintering, or staining. You can also paint or stain it. But don't apply any finish for at least one year. You have to allow the wood to acclimatize to the environment before staining.

Cedar

I love the look of cedar or redwood, but it is more expensive than PT wood. One way of saving money if you like the look of cedar is to build the structure and supports out of PT wood and use cedar for the planks and rails.

Cedar is naturally resistant to insects and rot, so it requires less upkeep than PT wood. Properly built so the wood never contacts the ground, a cedar deck needs no wood preservative to last as long as PT wood. You can either let the boards weather to a gray color or you can stain them so they preserve the original look of the

One way to save money is to use pressure-treated wood for the structure of your deck and cedar for the decking and railing.

wood. But once you stain it, you'll have to maintain it regularly with sanding and restaining.

Either way, you'll need to wash your cedar deck every year with mild soap and water. Don't use a pressure washer on cedar: the wood is too soft and can be damaged this way.

Composite wood

Composite wood is made of some combination of polyethylene or polypropylene mixed with glass, wood fiber, wood flour, or other wood products, or a wide menu of recycled products. When these products first came out, I wasn't too keen on them. But they've improved and I'm starting to like them better. The boards can be textured with embossed wood-grain patterns to look a lot like real wood. Composite wood comes in a variety of colors; can be UV resistant, fade-resistant, stain-resistant, and insect-resistant; and is less likely to twist, split, or warp. Composite wood is more expensive than natural wood—as much as five times the cost of PT wood. But over the long-term you'll save a lot on maintenance: instead of sweating over refinishing your deck, you'll spend your summers relaxing on it.

Composite wood can be somewhat softer than natural wood and isn't available in long lengths, so your contractor will have to place the joists closer together.

Resin decking or cellular PVC

This alternative decking has no wood in it at all: it's made of 100% plastic. Resin decking is poured, and cellular PVC is pressed. It's nonporous, so it definitely won't mold, splinter, or crack, and it comes in a variety of colors. Like composite decking, it won't suffer in extreme weather and it needs no maintenance besides an annual scrubdown. Plus it has the added benefits of being extremely resistant to stains and scratches. If you're looking for worry-free living, this is it. And of course, that comes with the heftiest price tag.

A couple of drawbacks you should know: cellular PVC has been known to discolor when it contacts rubber, so avoid rubber mats on your deck; also, PVC doesn't look like real wood. Expansion and contraction in regions with large daily temperature swings can also cause problems.

Getting started

After you decide on materials, make sure your contractor has lots of experience building decks. Some people think they can be casual about hiring because a deck is outside the home—don't believe

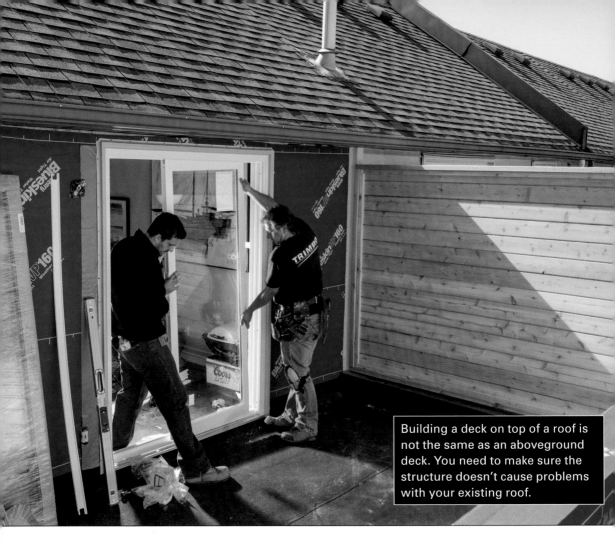

Building a deck on top of a roof is not the same as an aboveground deck. You need to make sure the structure doesn't cause problems with your existing roof.

it. Check references, get lots of quotes, and forget about what a deck "should cost" per square foot. There is no average; every situation is different. It depends on materials, access, details, and size, and on the experience and skill of the contractor.

However, before you start looking for a contractor, you need to make a call to your local building authority. You might not need a permit for your deck, but there's a very good possibility you will—especially if it's attached to your house or over a certain height. And you don't need me to tell you that you don't want to put your money into a new deck and then have to take it down. If you don't get a permit, and you're found out, that's what can happen. Don't take a chance.

Prepare the Deck

If you want a uniform finish that lasts, you need a surface that's been properly prepped to take a coating.

Seal new wood within a couple days

Comparing Decking

Material	Durability	Maintenance	Sustainability	Cost
Pressure-treated (PT) wood	Lasts up to 20 years with proper maintenance	Moderate: requires ongoing sanding, sealing, and painting or staining—can be left exposed	Treated with a chemical preservative that helps prolong the life of the wood	Low to moderate
Cedar	Lasts up to 20 years	Low to high; weathers to silver gray if left untreated; ongoing sanding, sealing, or staining at least every 2 to 3 years to preserve look of original wood	Readily available domestic wood (especially in western regions); minimal chemical treatment	Moderate to high
Composite woods	Most come with a 25-year warranty; boards will fade	Low: scrub once a year with a good deck cleaner	Manufacturing the boards is energy intensive; otherwise, a good use of waste as many contain recycled material; long-lasting	High
Resin decking or cellular PVC	Most come with a 25-year warranty	Low: wash once a year with a garden hose	Excellent longevity, but the material is made of 100% virgin plastic; not recyclable and will end up in landfill	High

of installation to prevent UV damage or water streaking or staining, which degrades the wood and its appearance.

For older wood, use a mild cleaner and a light pressure wash (except for cedar, which is soft enough to be damaged by a pressure washer).

Read the directions on the finish product to know how much attention is needed: a clear alkyd finish won't need as much prep as a heavily pigmented deck stain does.

Let the deck dry out for a day or two after washing, before applying the finish. Look at the table on page 64 to help you decide which finish to use.

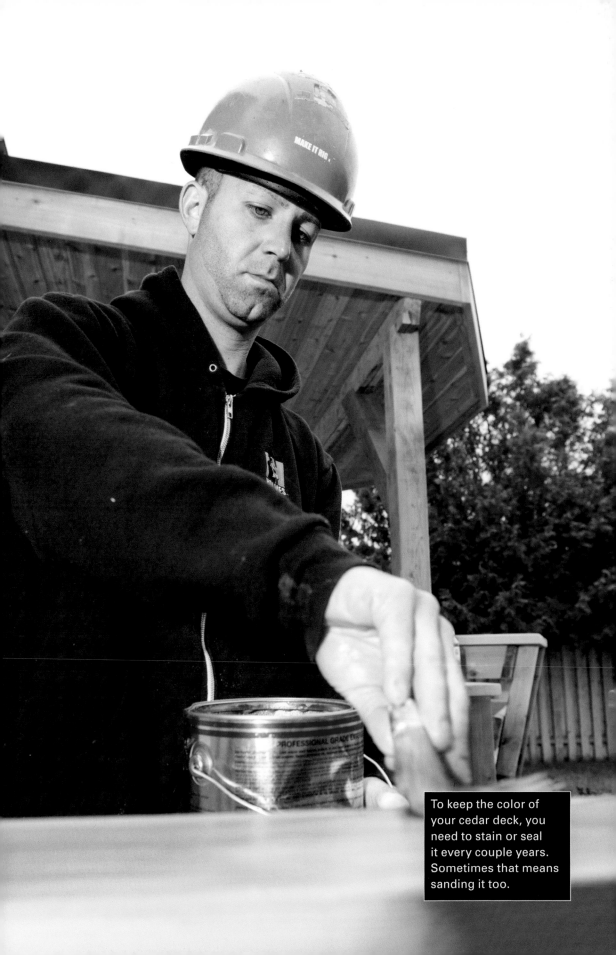

To keep the color of your cedar deck, you need to stain or seal it every couple years. Sometimes that means sanding it too.

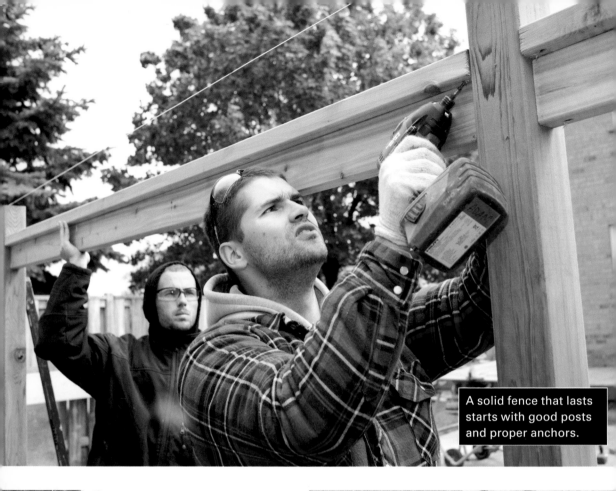

A solid fence that lasts starts with good posts and proper anchors.

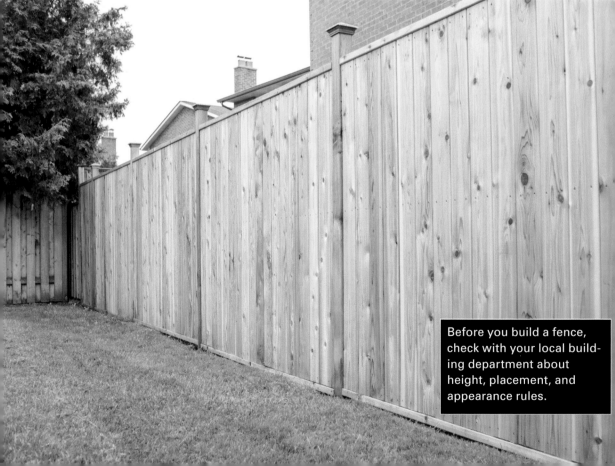

Before you build a fence, check with your local building department about height, placement, and appearance rules.

I am putting in a 5-foot-tall wood fence in the backyard and I've been told I must use 6 × 6 posts. Is this necessary?

That depends on a few things: Where do you live? How much wind exposure will the fence get? How long is the fence? How long do you want it to last? The reason I recommend using 6 × 6 posts is so they resist twisting and warping. Because they are freestanding, they also need to be anchored solidly in the ground with concrete.

The frost can push fence posts out of the ground. That's when you start seeing the concrete footing above the ground—if there is one—and that's no good. That's why I cone or bell concrete footings—then the frost can't push them up.

Building codes don't generally address fence construction. Typically, fences can't exceed 6 feet in height. Common practice for a standard 6-foot fence is to use an 8-foot post embedded 2 feet into the ground. Go above code when drilling the holes for the fence posts. Some municipalities say you have to bury a post a minimum of 3 feet—others say 4. It really depends on where the frost line is. You want to go a minimum of 4 feet below the frost line with poured concrete footings. This makes the posts stronger so they won't move.

Most fence posts are spaced every 8 feet. Fences are usually built using 4 × 4s, but I use 6 × 6s—this gives the fence more lateral rigidity. It makes the fence sturdier in the wind. You have lateral movement with 4 × 4s—you can move the fence back and forth. Not so with 6 × 6s, if the fence is built right.

Why should I not use salt to de-ice my concrete steps and walkway?

The "salt" used on roads, driveways, and paths should not be confused with table salt. The snow melters and de-icers commonly used are more corrosive kinds of salts than table salt is. Sodium chloride is the cheapest kind of road salt. Calcium chloride and magnesium chloride melt ice faster than road salt but are corrosive enough to destroy the roots of grass. Potassium chloride is safer for your lawn, but it can damage concrete.

You can't win with salt, which is why I'm not a fan. When melted snow and ice gets into the soil, it destroys the grass. It causes those brown patches on your lawn along the edge of the driveway and by the road.

Comparing Finishes for Fences and Decks

Finish Type	Transparency	Ease of Application & Maintenance	Durability	Tips
Clear	Most transparent option: completely shows wood's graining and color	Relatively easy to apply, requires least amount of prep before reapplying	Least durable: lasts about 1 to 2 years before it needs recoating; offers little protection from UV damage	Make sure surface is clean and dry—free from debris; maybe some light sanding to remove sharp corners and edges; power-wash surface (if not cedar) and let dry for at least 36 hours
Semi-transparent	Pigments change the color of the wood while showing the grain and offering some defense against UV rays	Fairly easy to apply; less maintenance than semisolid finish; make sure surface is free from debris, clean, and dry; may need some light sanding to remove sharp corners and edges; power-wash surface (if not cedar) and let dry for at least 36 hours before applying finish	Lasts 2 or 3 years on horizontal surfaces, depending on climate, sun exposure, and traffic	Also known as tinted sealers
Semisolid	Most opaque option: stains contain a lot of pigment; shows a hint of the wood grain beneath	Harder to apply evenly and may show brush marks where surface doesn't dry evenly; requires the most prep work (likely complete stripping and cleaning before applying any new finish); requires more maintenance than a clear or semitransparent finish	Lasts up to 4 years if wood is prepped properly before each application; offers the best long-term protection against sun and weather damage; wears out more when exposed to sun	Available in a range of colors; foot traffic is most obvious on semisolid stains
Wood preservative	Available untinted or in variety of tints; gives new wood an aged, silvery patina that looks more even than natural weathering	Most low-maintenance option: requires one application and no maintenance	Won't fade or wear; protects against mold, fungus, and rot	Great for matching new and old wood; nontoxic, environmentally safe; 2 examples are Eco Wood Treatment (EcoWoodTreatment.com) and LifeTime Wood Treatment (ValhalCo.com); also look for boat wood seal

It also makes your pets sick. When I take my dog, Charlie, out for a walk in the winter, sometimes he gets salt on his paws. It burns his feet, then makes him throw up a day after he's licked his paws clean.

Salt is sensitive to temperature changes: the colder it gets, the less it works. It works best when the ground temperature is above 15°F (or −9°C). I'm not sure what winter is like where you live, but Canadians know that temperatures often drop much lower than −9°C in January and February.

Finally, salt erodes the mortar in brick. If you take a look at a brick home from one winter to the next, you'll see the salt eating away at the mortar and leaving bigger and bigger voids.

If you want to keep your pathways from icing over, look for alternatives. I'd rather use sand or gravel because they're not as damaging. Whatever you use as a de-icer, make sure you follow the instructions on the package, and make sure it won't damage new concrete.

Windows, Doors, Walls, and Floors

When it comes to doors and windows, I'm learning that people don't want to spend a lot of money but they want everything to look good. You can find windows and doors that are cheaply made but look good, much like a lot of new housing today. Trust me, you don't want to save money buying something for looks over quality.

Shop around. Take a look at all the different window and door companies and ask them how they literally frame their windows. Is the frame wood, aluminum, or vinyl? There's nothing wrong with vinyl windows. It's all

about the junctions and how they're tied in together, how corners are heat-welded into place. You want a company that brags about how they do it. The mechanics of the doors and the mechanics of the windows are what you're actually paying for, not the looks.

In old homes we used to see a front-porch covering and a canopy over the window. They served two purposes: they kept the driving rain and snow away from the door and window, and they also allowed you to control heat gain from the sun. Let's understand that for a second. The coverings were set at a perfect height so that when the sun was at its highest point on summer days, we did not get the sun streaming in the windows. But in the winter, when the sun is lower in the sky, those warm rays snuck below the canopy and through the windows. It's a shame we don't build houses with canopies and covered porches anymore—they're great low-tech solutions for saving energy costs year-round.

The good news is high-tech windows can pretty much do the same thing. Windows with Low-E glass are specially coated to minimize heat gain in summer and maximize it in winter. If you don't have canopies, you need Low-E windows, especially on south- or southwest-facing windows.

When it comes to floors, it's the same thing: you can put down whatever you want, but make sure you know what you're getting. There's too much junk on the market right now. If you need a budget floor, just buy laminate. It's bang for the buck. But if you choose an exotic or natural wood, make sure you get a hardwood. Too many people are spending $10 or $15 per square foot for a wonderful oak or walnut floor. And then the dog runs across it and scratches it. You want to make sure you put in a high-quality floor that makes sense for the way you live.

Buying right, when it comes to interiors, will save you money down the road. Stop thinking about looks and find out how things are made so you invest in better quality.

Why do my floors bounce when I walk on them?

If your floors bounce, or if things rattle on shelves when you walk past, you're looking at a problem with the joists or the subfloor. The joists are the wooden boards that stretch from one exterior wall to the other. They're topped with plywood to create the floor. The joists may not be strong enough to support the floor, either because they're covering too large a span or because they haven't been blocked with enough

Always Go Above Code for Subfloors

I know I have a reputation for building above code. It's not because I'm trying to overdo it or prove something. Basically, the code is a set of rules that governs how houses are built to provide minimum standards for safety. Minimum code ensures your house won't fall down, that your roof will stay attached, that your floors will hold the weight of furniture and people.

Don't get me wrong, we need a safety baseline to make sure houses will stay standing and not injure anyone. But to my mind, minimum code is about minimum value. And it's definitely not about sustainability. The code doesn't set standards that will necessarily give you long-term comfort or lasting value or quality. If it did, we wouldn't have the problems we do now. I love to build houses that will outlast us all—that won't mold or blow down, burn down, or fall down in an earthquake. I think we can, and we must, build better.

If I offered you a choice between minimum code and spending a few thousand more dollars so your tiles didn't crack or the area around your windows was properly insulated or your basement was totally water-tight, would you spend the extra money? Of course you would. In the long run, you would have a stronger, more efficient, and more valuable home. When it comes to structure, always go for more than code. You won't regret it.

Builders are more often using composite wood products for subfloors and sheathing—such as oriented strand board (OSB)—rather than plywood. It's not as strong as plywood of similar thickness. So why is it used? It's cheaper. Why is it legal? Minimum building code again. I prefer to use plywood. When minimum code allows for thinner, wider-set floor joists and roof rafters, I like that extra strength to tie the structure together.

Because some OSB is made of glue and wood chips, it will fail in a fire in a very short time; this has been proven. No material is "fireproof"—everything will burn at a high enough temperature. But by using fire-rated building materials and products that slow the spread of flame, we can increase the time it takes for a home to ignite and burn. This will also give people more time to escape a house fire and, ultimately, will save lives.

supports between joists. Can you inspect the subfloor from below to see how many nails have missed the floor joists? Every nail that missed allows for more movement in the floor between joists, which creates a bouncy floor.

If you don't notice any nails that missed the joists, the problem may be the building code itself.

Minimum code just isn't enough. Stand in the middle of a room in a new home and start bouncing up and down. You won't fall through, but a floor built to minimum code is going to move and cause problems. If you put ceramic or porcelain tile over that subfloor, all that movement can crack the grout, loosen the adhesive, and eventually, the tiles will come up. Even laminate needs a perfectly rigid subfloor or it will bounce and pop as you walk on it.

Even in a small room like a bathroom, you won't get enough support from a floor built to minimum code: the weight of the fixtures can break your tile and could cause other structural problems in the house.

Go back sixty years or more, and you'll see subfloors built from very heavy planks (plywood, as we know it, wasn't used much until after the Second World War). Under those planks is a very strong structure. We're talking true 2 × 10 joists, set 16 inches apart.

Today's code allows joists as small as 2 × 6 but also limits their span accordingly. Sheathing can be as thin as ⅝-inch oriented strand board (OSB). Floors can deflect up to L/360 (bend as much as the span, divided by 360). This means a 10-foot joist span can deflect about 5/16 inch under a load and still be up to code.

OSB has replaced plywood in many residential construction uses—like roof and exterior wall sheathing as well as subfloors. It's minimum code in many applications. It's less expensive than plywood of similar thickness; it's also not as strong. That's why I prefer to use plywood.

One other thing: to protect a wood subfloor, I like to use Schluter Ditra under tile floors, especially in areas exposed to moisture, like a kitchen or bathroom. It helps waterproof the subfloor and is a decoupling layer that prevents tile and grout from cracking when the floor flexes. You don't need to use cement board there. For a kitchen floor, ⅝-inch tongue-and-groove plywood is best.

Why does the floor sag and slope?

Sloping or sagging floors could indicate a structural problem, or it could just be that your home—like all of us—is aging.

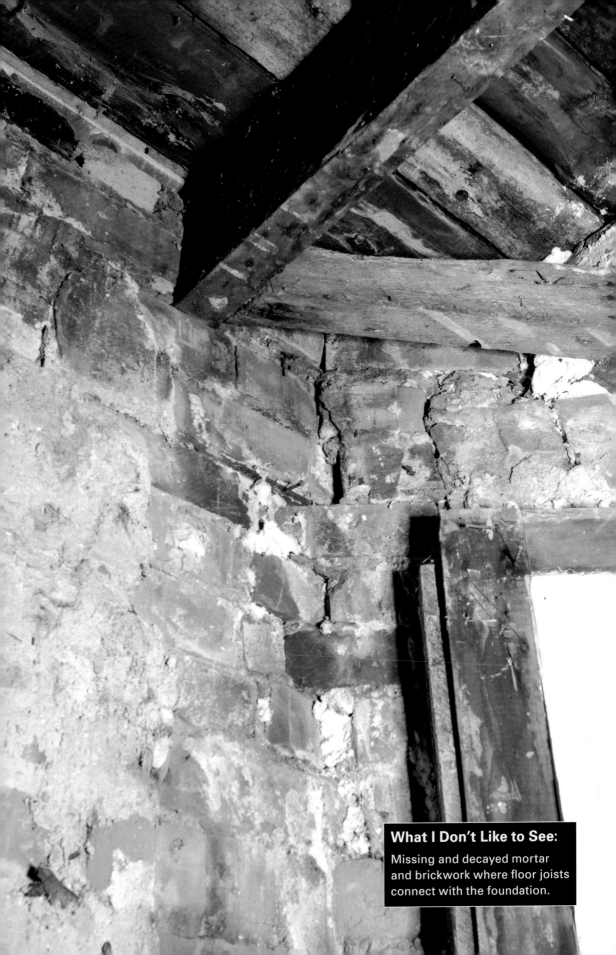

What I Don't Like to See:

Missing and decayed mortar and brickwork where floor joists connect with the foundation.

Two Fixes for Sagging Joists . . .

To get that floor back where it belongs, you'll first need the advice of a licensed contractor or a structural engineer to determine exactly where jack posts should be placed to be most effective in straightening those joists. Holes will have to be dug to allow minimum 2-foot-deep concrete footings to be poured under the posts. Finally, the jack posts should be set up so they're in contact with the joists, then raised until they push the floors above them into a level position.

If you're gutting the house . . .

If you move into an older house that has floors sagging towards the middle, you probably need more support in the basement. Unfortunately it's not as simple as putting up a couple of jack posts under those sagging joists and jacking them up until the joists are straight again. You've got to be prepared for what will happen to the plaster and lath in the walls on your main living levels: they're going to crack, crumble, and sometimes come down in chunks. You may also find that doors will no longer fit right since they've probably been modified over the years to accommodate that shifting, sinking floor. That's why this solution is best used when you're gutting the house anyway.

If you're not . . .

Even if you're not gutting the house, you can still use jack posts in the way I've described—but stop when the jack posts just make contact with the joists. This will give the support you need without destroying any walls above.

Either way . . .

Since you're dealing with a structural issue, you'll need a building permit and an experienced contractor.

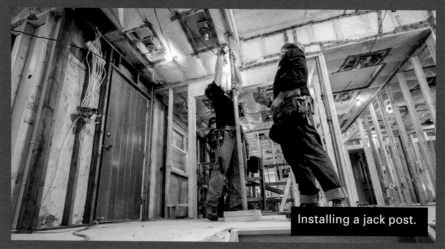

Installing a jack post.

There are lots of clues that signal structural problems: floors out of level, windows and doors sticking or not closing properly, floors that bounce or sag. Not all structural problems are that big a deal. But if *all* the floors in the house slope to the middle, that says something more serious to me.

Start by taking a look at your foundation. If your foundation is settling or sinking, your floors or roofline will sag towards the middle.

Next, inspect the floor joists in the basement. Joists are the boards that rest on the foundation walls and stretch between exterior walls. They have to be very strong to support the floor and all the weight it carries. When joists have to stretch too far without support, they start to sag. That's why we need columns (posts) and beams to create a central support that more joists can attach to. Those columns and beams act sort of like another foundation wall, but in the middle of the basement. Rotting or termites can compromise sill beams and joists.

If you live in an old house with hardwood floors, you'll probably notice at least a slight slope. That's what happens over time as the house settles and the wood dries out. In older homes, sloping is pretty common, simply because of the way things were built eighty or a hundred years ago. The central posts often weren't supported with substantial footings the way that exterior foundation walls were, so those posts have sunk more than the outside walls, and the floors have followed. That's where the sloping floors come from. But most shifting happens in the first few decades after a house is built, so in old houses you usually won't see the floors slope any more than they already have.

Which way do the floors slope? Sloping towards an outside wall is a much more serious problem than a slope to the middle. This indicates that the foundation itself is dropping. If you haven't already noticed a problem from the outside and you see this kind of sloping to one side, you should check the foundation again in those areas, looking in both the basement and the exterior for clues to what's happening.

If the problem isn't due to age or the foundation, you may be seeing the aftershocks of a shoddy renovation. Some homeowners take down "just that little bit of a wall" to open up a room, or they cut through structure to run wiring or plumbing or ducts. They have no idea they may be messing with load-bearing walls. Do you know what happens when you take down a load-bearing wall without properly

resupporting the load? I do. I've seen it and I've fixed it: the floors can start to sag and slope, the windows and doors can stick, and the roof can fall in. It isn't pretty.

Structural problems can be fixed. Rotting or compromised joists can be replaced or sistered (a contractor attaches new lengths of joists alongside existing joists). You can jack up the house to remove and replace a compromised sill beam. A crumbling foundation can be excavated and repaired. These are big, expensive jobs that take skill, experience, time, and—of course—money.

I've noticed that some of the floorboards creak and move when I walk over them. Do you know why this happens? And what is the best fix?

Oh boy, how many times have I heard this one. Floor is all about structure. If you have a squeaky floor, we have a floor that's moving where it shouldn't be.

It could be that the joists are too far apart and weren't blocked, or that the subfloor was oriented strand board (OSB) instead of plywood. I don't build subfloors out of particleboard or OSB (sometimes sold as aspenite). Use plywood because it's the strongest, and glue and screw it to the floor joists underneath or you'll get squeaking no matter what. Floors often start to creak when the nails that hold the subfloor to the joists are able to pull away, and they do so whenever pressure is placed on them—like when someone walks across the floor.

Sometimes hardwood flooring will squeak over time; it expands and contracts depending on the humidity in the house. Hardwood usually shrinks in the winter because there's less moisture in the air; that causes gaps. Plus, hardwood is nailed to the subfloor, and when the hardwood shrinks, it can pull the nails out. In the summer, if there's too much humidity, hardwood will swell and buckle.

A fix is to remove the finished floor and the subfloor and start over using good products. That means a plywood subfloor, not OSB, and glue and screws instead of the usual nails. It's not the cheapest solution, but it solves the problem.

If you have access to the joists from below, it might help to add some blocking. Blocking (also known as strapping or bridging) is bracing placed between joists. This adds rigidity and stiffness between floor joists and prevents them from twisting or warping—that means less squeaking. Depending on your materials and

Humidity can cause a hardwood floor to swell or contract, which causes gaps and popped nails.

installation, there are different ways of blocking. You also have to think about wiring or duct runs in the way.

The old-time practice of blocking means making an X between two floor joists using two small pieces of wood: you take one piece and screw it to the top of one floor joist and the bottom of the next floor joist. Then you do the opposite with the other piece of wood. The two pieces of wood look like an X between two floor joists.

The way I usually do it—and the way I tell my guys to do it—is to get one piece of wood and screw it in squarely between two floor joists. Instead of an X, it's just one solid piece of wood bridging the two floor joists. If the floor joists are 2 × 8, we use 8-inch blocking and screw it in. If they're 2 × 10, we use 10-inch blocking; 2 × 6 means 6-inch

blocking. You get where I'm going: use blocking that is the same width as the joist boards.

My wife keeps talking about opening up our main floor. How can we tell if a wall in our house is load-bearing?

I get this question all the time, and my answer always makes me sound cranky. I don't mean to be insulting, but the truth is: you can't tell; a good contractor can, a structural engineer can, and an architect can. Determining weight load is not the job of an amateur because structure is not DIY.

For a while now, the open-plan look has been the trend. A lot of walls have been taken down to get that look—sometimes the wrong walls. Homeowners make "educated" guesses about structural members, or about what the current bearing load on a wall

is, or that some other wall can take a lot more load than it has. They slap up drywall over old plaster and lath. And for a time you might not even notice, but believe me, the house is affected. The house might even have a second renovation—with more of the same changes to the structure. And what you end up with are cracks in the plaster, buckling drywall, windows and doors that stick, or—even worse—houses that lean, houses with floors that sag and slope.

People sometimes don't think about the crucial role of walls when they think about tearing them down, but they should. Let's say you take down a wall and, because you don't know about loads, you just put up a beam above where the wall used to be. The ends of the beam attach to the interior walls, but if those interior walls aren't supported by the foundation, you have all this weight just resting on the subfloor. This will create such a big repair job that you'll probably have to move out until it's fixed.

If you take down a structural wall, you compromise the safety of your home—simple as that. I came across one bad renovation where another contractor had cut out three 2 × 10s to run new ducting to an addition. I'm surprised the house didn't fall down! Recently I was renovating a bungalow that had been topped with a second floor several years earlier. When I removed the drywall and exposed the beam that held up half the second floor, I found the 14-foot, 10-inch steel beam sitting on no more than 2 inches of crumbling brick. That was scary. You never know what's behind walls until you start opening them and know what to look for.

What do you think happens when complicated designs like this meet with an underground, unqualified contractor?

If you promise you won't touch anything without a qualified pro, I can tell you there are a few things you can look for to tell if a wall is load-bearing. First, find out which way the floor joists go (look at the joists from the basement, or open up a cold-air return vent to take a look). They probably run from side to side across the width of the house. Odds are that the center wall will run at right angles to the floor joists. That center wall will be the structural or load-bearing wall. But it isn't always that easy. In some cases there are structural walls that run the other way, depending on how the floor joists run on the second floor. Structure is never that straightforward, which is why it's an area I never recommend

Structural Wall Red Flags

If your home has had previous owners, you can often tell if they've done remodels involving structural walls by looking for these red flags:

- Unusually large rooms for old houses
- Unusual seams on ceilings and floors
- Floors that slope in some rooms but not others
- Mismatched trim work on doors and baseboards
- Cracks in the plaster above windows or doors

you work on without an experienced pro. Cantilevering is another thing to watch for. It wasn't that common in older homes, but it's used more and more today to spread loads out in different directions. These loads have to be carefully engineered. Exterior walls can have so much glass in them that they don't function as primary load-bearing walls anymore. In open-plan designs, there are flush beams you can't see because they are inside the floor systems—those carry loads where you think there are none. To reduce material costs, builders shrink the size of beams and posts to the minimum and rely on a complicated web to do the structural work. It's just not that simple to figure out where the load-bearing wall is anymore, or how much additional load you can add to any structure.

Always remember: in a renovation, anything is possible. You *can* take out a structural wall—if you bring in professionals. It will mean putting up a steel I-beam or manufactured wood beam (there are lots of choices) to support the house, shouldering the load above (including the roof and potential snow load), and making sure the load is carried properly down to the foundation. To get it right, you need to consult a structural engineer or an architect, and a qualified contractor.

When I start work on a typical century home, I know I'm looking at a building that might have had five owners and five renovations—one every decade or two. If you're owner number six, you need to understand that previous work may have compromised the structure of your home.

Why are my windows weeping and wet in winter?

One of the most common problems I hear about is "leaky windows." Once

the temperature starts to drop, many people start finding windows are fogged up or covered with condensation. Sometimes it's so bad there's water pooling on the windowsill or the floor. So why do we care about a bit of water pooling on our windowsills? Is that such a big deal? Not if it rarely happens; but a little can go a long way.

Condensation can cause finishes to rot or rust. Then the rot spreads to the structure beneath, turning a fairly small problem into an expensive project. Mold is another reason you can't just ignore leaky windows. Mold can grow anywhere it can find heat, an organic food source (such as wood or drywall), and moisture.

I went to one home where I saw mold growing on all the interior windowsills. When I asked the homeowners when this started happening, they told me "not too long after we moved in"—fifteen years earlier. The moisture had rotted through all the window frames, leading to huge air leaks. And it was clear in their energy bills. Their only option was replacing the windows and frames, a job that starts at about $10,000. Not only that, think about the health issues that come with living for years in a moldy environment.

So, why do we get condensation on our windows? Sometimes it's an excess moisture issue. Sometimes it's an inadequate ventilation issue. Sometimes it's an issue of inadequate windows. And sometimes it's a combination.

When the warm air inside your house hits a cold surface—like the glass in a single pane window—you get condensation. Newer windows have air or gas between two or three panes of glass, which provides some insulation and reduces the chance of condensation. Between the two panes of glass there should be an airtight seal. If the seal is cracked, you'll get condensation between the two layers of glass—usually on the inside surface of the outside pane since that's the coldest surface. Those windows probably need to be replaced.

If you have condensation inside double-pane windows and they're in good shape, you have too much moisture in your home. Most of it comes from everyday activities like cooking, showering, doing laundry, or even breathing. Homes are typically built to handle these normal moisture levels, so these activities shouldn't be causing a lot of condensation.

We need free-flowing air moving through the house to keep windows clear, so it could be something wrong with the HVAC (heating, ventilation, and air conditioning). It could be a

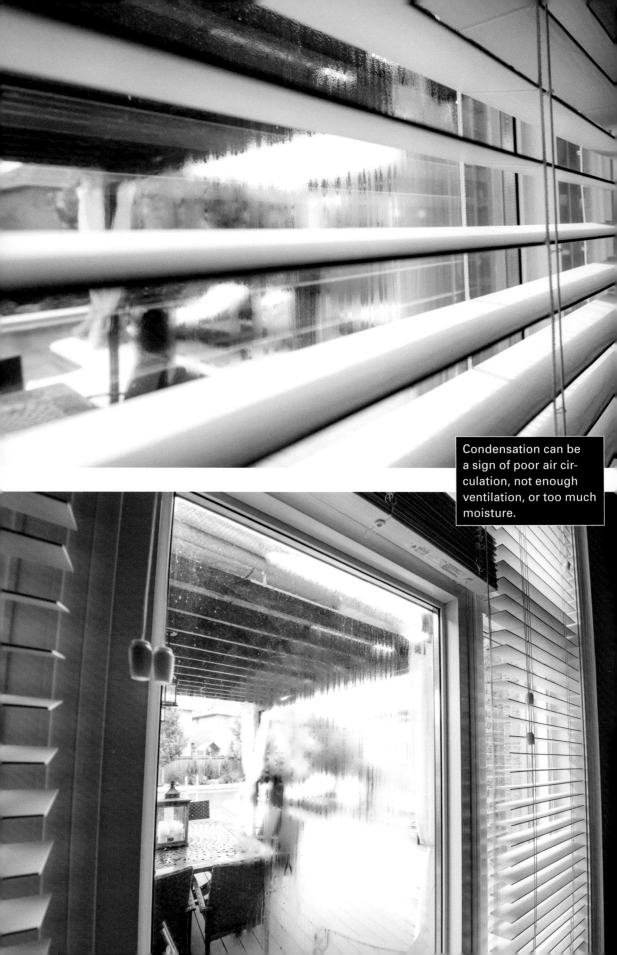

Condensation can be a sign of poor air circulation, not enough ventilation, or too much moisture.

problem with the ductwork in the walls or floor. It could be that the heat registers or cold-air returns are blocked with furniture. It could be that air inside your home is not circulating beyond your curtains to dry out the glass. The problem could be as simple as the humidistat on your furnace being set too high. We need to rule out why the moisture is on the window. It may not be just one reason, or it could be one of many.

The thing is, newer homes may be built too airtight. This makes it hard for moisture to vent out. A heat recovery ventilator (HRV) can help. HRVs exchange stale, humid air for fresh outdoor air, and distribute it throughout the house through the ductwork. They're expensive to buy, but they're energy efficient to run.

Another reason for the condensation could be air leaking: somehow there is air moving between the warmth inside your home and the cold world outside. That's not what we want—ideally you want an envelope around your home keeping the warm air in and the cold air out.

How do you get air leaks around your windows? I see it all the time: they weren't properly installed and insulated. Cold air gets in and around the window and creates condensation.

It's easy to check by carefully removing the interior trim and looking to see how much insulation there is, or isn't. Then spray in some low-expansion foam—but make sure you read the directions carefully. If you use the wrong foam, or use too much, your windows won't work properly. Adding insulation is a lot cheaper than replacing your windows, so try that first.

If it's a moisture issue, a furnace dehumidifier could help. Make sure an HVAC professional adjusts the settings to the proper levels for your home. If you've checked your furnace and dehumidifier, and tried controlling the moisture levels but still experience problems, then you're looking at your home's ventilation. Contact an HVAC expert and look into your ductwork. It could be as simple a fix as changing the filter in your furnace. Believe it or not, if your furnace filter is filled with crap because it hasn't been changed in months, you're going to have very poor air movement.

Or the solution can be as easy as clearing the area around the vents. I was at one job site where as soon as I walked into the home, I noticed condensation. You could already see the paint starting to bubble on the windowsills. What was the problem? Most of the vents throughout the

Five Signs That Your Windows Need Replacing

If your windows are to blame for condensation—not a ventilation or moisture issue—there are some sure signs they need to be replaced:

1. Frost and condensation are a constant issue.

2. It's noticeably colder in the area of the window.

3. You can see mold or decay around the windowsill or frame.

4. The windows are jamming.

5. Condensation or frosting is happening between windowpanes. That means the airtight seal is broken. If that's the case, then your only solution is replacing the entire window.

house had been blocked. Do not block your vents. These are your home's lungs. If you block them, you're essentially choking your home.

What causes condensation in a new home?

If you have a home that was built within the last two years, it is possible that the wood framing is full of moisture. Have you ever seen a new development being built where they cover the piles of framing with tarps to keep the rain and snow off? I didn't think so! That exposed wood will soak up moisture and will continue to let out that excess moisture until it is dry—go figure. That happens within the walls.

It might be that your home is very well built and, as a result, is too airtight. With the weak exhaust fans that are installed in many homes' bathrooms (minimum code, again), you will be lucky if even the slightest amount of air gets expelled. Poor air movement or ventilation in your home will cause condensation. So, open a window just a crack downstairs and install stronger, better-quality exhaust fans. These fans exhaust moist air from inside your home and replace it with dry, fresh air from outside. This will help create air movement. You may also want to look into a heat recovery ventilator (HRV).

It is possible that you have a problem with the HVAC (heating, venting, and air conditioning). For that you should contact a qualified heating contractor.

If you control moisture and make sure your windows are properly installed and insulated, you can prevent condensation in your house.

We're ready to replace our old windows and we're trying to sort out what we want. What do we need to consider? And can you explain why you recommend triple-pane windows?

The two issues you want to avoid with windows are heat transfer and moisture. No matter how good a window is, it's made of a terrible insulator: glass. That means all windows leak heat to some degree. In winter, warm air inside escapes through the glass; in summer, the heat outside creeps in through the glass. Windows will never be as thermally efficient as, say, an insulated wall, but they've come a long way to keep heat where it belongs.

Windows today keep out the elements with a few features I think are well worth the money.

Better quality windows are double- or triple-glazed, which means they have two or three panes of glass. Double-glazed windows are fine if you live in a mild region, or for south-facing windows in a moderate climate. If you live in a cooler climate, you might want to invest in triple-glazed windows for north-facing windows, and choose smaller sizes to minimize heat loss and gain.

Good windows also have an inert argon or krypton gas injected between the layers of glass. This helps provide insulation and almost halves the U-value of a window. U-value measures heat transmission through a window. The lower the number, the better the insulating properties. Windows filled with krypton gas provide the best energy efficiency; argon is almost as good and is more affordable.

Finally, look for windows with Low-E glass (*e* stands for *emissivity*). This means the glass has been treated with a microscopic metallic oxide spray that cuts down the UV light passing through the glass. This coating lets in light but reflects heat back out in summer and helps retain it in winter. It also keeps the sun from fading your curtains and couches. For less than $10 per window, it's a no-brainer.

You can get windows in many architectural styles to suit your home.

Single- and double-hung windows

A double-hung window has two sections, and both of them move up and down. A single-hung window looks the same, but the top section is fixed, so only the bottom section can be moved up and down. A lot of people love double-hung windows because they're the most traditional-looking

Don't Screw Up Window Installation

A lot of people think that windows need to be tight to the structure. That's a big no-no. Everything expands and contracts—whether it is steel, wood, or concrete. Everything in your home, inside and out, will expand and contract. Space around your windows and doors allows for expansion and contraction. Not to mention that we want to add in some spray-foam to make sure it's airtight.

I like to leave $\frac{3}{8}$ inch all the way around the window and/or door to give room for as much spray-foam as we can do. A batt insulation is still going to allow the air movement, which you don't want. Low-expansion spray-foam is easy to use: you can do it yourself or make sure your window or door installer does it for you.

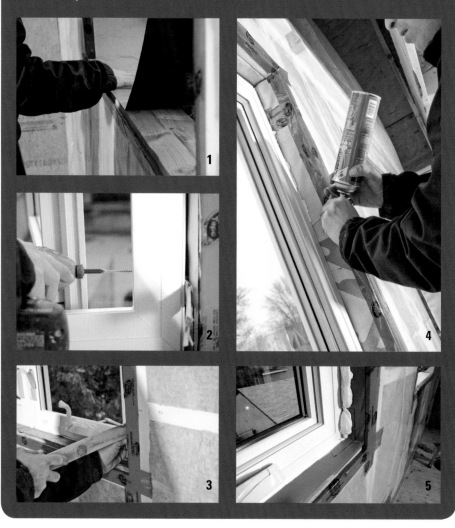

(especially with dividers in them), and because both sections of newer double-hungs will open inward, so they're very easy to clean.

Casement windows

These are tall windows hinged on the side—or top and bottom—so they will pivot open, usually with a mechanism at the base of the window. An awning window is similar, but it is horizontal and hinged at the top; the sash (framework around a pane) is also opened with a mechanism at the base of the window.

Horizontal sliders

With sliding windows, either one or both sashes will be moveable, but since they don't have any mechanical parts, they're much cheaper than any other type of window. They're often paired with a fixed window above. Fixed windows don't open at all; they're just panes of glass. The most common type of fixed window is a picture window.

As for materials, you'll find something to match every budget. At the top end are wood windows. They look beautiful but require ongoing maintenance. A wood window will expand and contract if it is in direct sunlight for any part of the day. As a result, the windows will shuck the paint because expansion stretches the paint to the breaking point. If the window is always in the shade, it won't expand and contract as much, and the paint will remain stable. But you'll want your house to match on both sides, won't you? Sure, so you'll need to paint all around.

Another option is wood-clad windows with vinyl exteriors. They provide more weather resistance and need less maintenance. On a lower-quality vinyl-clad window, you can have problems with water getting under the vinyl and rotting the wood.

Personally, I prefer high-quality vinyl windows to metal or wood. Vinyl is easier to clean, lasts longer, and doesn't promote heat loss the way metal does; and it needs less maintenance than wood.

Proper, professional installation on any window will make all the difference in keeping heat where it belongs and keeping moisture on the outside. Try the tissue trick on your own windows to see how well they've been insulated: hold up a tissue around the window edge and see if the tissue moves because of drafts. Of course, this works best on a day with wind.

Buy good windows and install them correctly, and you'll be spending your money wisely.

Energy-Efficient Windows

Professionally installed windows will make your home less drafty and more comfortable, and they will also shrink your energy bills. Depending on your climate and how old the windows are to begin with, upgrading to energy-efficient windows can reduce a home's energy bills by up to 15% according to Energy Star. Energy Star also rates windows for efficiency based on the local climate. Go to their website (EnergyStar.gov) to find out your climate zone. If you live in a cool place, you can beef up the insulation value of your windows by choosing windows rated for a climate zone colder than the one you live in. The most eco-friendly choices are made close to home from sustainable materials and are as energy efficient as possible. Here's what to look for:

What to Consider	Mike's Picks
Frame material	Wood is most sustainable but high maintenance Fiberglass requires less maintenance than wood Vinyl is most affordable, though manufacturing vinyl releases toxic fumes
Number of panes	Double-glazed (two panes) for south-facing Triple-glazed (three panes) smaller windows for north-facing Quad-glazed (four panes) are also available
Gas fill	Argon is great and the least expensive Krypton is the best insulator
Window style	Single- or double-hung is good Casement has the tightest seal, to minimize drafts

We removed a wall to let in more light on our main floor. It looks great, only I've noticed that some of our doors are sticking. Any idea what's going on?

There are lots of reasons for sloping floors and sticky doors. It could be a matter of age, or there might be foundation issues or problems with sinking or subsidence. The sill beam or floor joists might be rotted out or have been eaten by termites.

But one of the most common reasons is people cutting through

structure to run plumbing, wiring, or duct work. Or maybe someone removes a supporting structure underneath—probably to create an open concept design—without consulting an architect or a structural engineer.

Sometimes, professionals cut joists to run piping or wiring—but it's got to be done properly, without damaging and weakening them. In your case, I suspect someone might have removed critical support. But without seeing the house and understanding how it was designed, I can't be sure. You need to bring in professionals who can assess the house's structure.

There is a quick fix for sticky doors, as long as the problem is not structural. If the door is made of wood, the easy fix is to plane down the edges that are sticking. You might have to adjust the doorknob and latch system.

But if the problem is the structure around the door, then adjusting the door isn't going to solve anything. You're treating a symptom but not solving the problem.

Structural problems can be fixed. With houses, pretty much anything can be done—it's just a matter of skill, experience, time, and of course,

money. But there is no quick fix for structure—you have to take it seriously. For peace of mind, call in a pro to check it out.

Our bedroom is always cold in the winter because it's above our garage. What kind of insulation would you recommend?

There are two problems with attached garages that have living space above or adjacent. First, the risk of carbon monoxide entering your home. Second, the transfer of heat through poorly insulated walls and ceilings. They are related, but different.

It's important to seal the walls and floors that connect the garage directly to the house. That's code. My first pick would be to use closed-cell spray-foam insulation because it gives a thermal break and a barrier between the CO and the rest of the home. Second choice would be to have Roxul batt insulation and vapor barrier professionally installed, topped with drywall that's taped and mudded, of course—you need to seal it. While it's true that insulating the whole garage would help minimize air movement in and out of your garage, let's not forget you have a great big hole in the garage every time you open the

door! An exterior wall of the garage isn't going to be a risk for CO entering the living space.

Also inspect the cold-air returns and/or heat supply. Have an HVAC specialist in to check the airflow and make sure it's balanced.

In my experience it's always the same thing: there's just not enough insulation in the attic of the garage space, which is the floor of your bedroom. Think about it: the rest of your house sits on top of a full basement, which, since it's below grade, never really gets that cold, even if it's freezing outside. So the floor in your main-floor living area is comfortable. Your garage is above grade. The air in it will be the same as outside (unless it's heated—which it isn't or we wouldn't be having this conversation). So you've got a huge space of below-zero air right under your bedroom floor, with only a few inches of batt insulation between you and the outside air temperature. It's just not enough. You need to get that beefed up to increase the R-value.

Another thing to look at is the seal on your garage door. If you can reduce the amount of cold air getting in, that will help. If you're upgrading your garage door anytime soon, consider upgrading to a thicker, insulated garage

door. If you live in a cold region or you've got a workshop in your garage, it's worth looking at a 2-inch insulated door rated R-17 or more.

All of these improvements should warm up your bedroom and they'll also shave a few bucks off your heating bill.

I love the idea of a skylight to brighten up the second floor of our postwar home. But I've watched your show and I'm afraid of leaks. Are skylights a good idea or are we just asking for water damage?

Skylights are great at bringing natural light into an interior room or a space without a window. I love them because they let you switch off lights during the day and reduce energy use. Skylights provide more than three times as much light as a window of the same size—light from above is stronger than light from the horizon. If your skylight is a good one and it's been installed correctly by a pro, you won't have any problems with leaks.

Make sure the skylight you choose has a good curb—a high edge to keep water out and flowing around rather than down and in. Curb-mounted skylights—whether glass or plastic— are smart because they place the skylight higher than the surface of

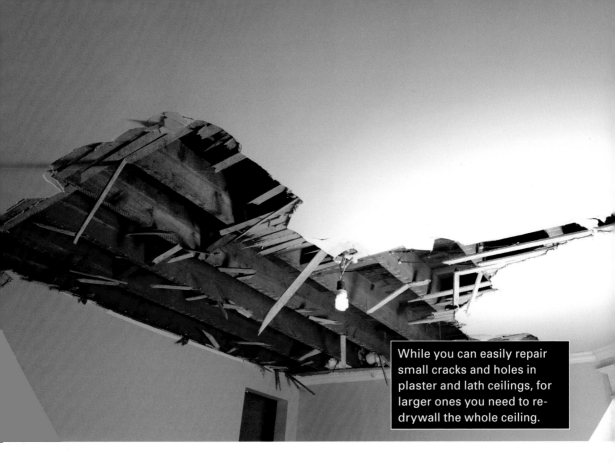

While you can easily repair small cracks and holes in plaster and lath ceilings, for larger ones you need to re-drywall the whole ceiling.

existing plaster. I apply one coat and make sure it doesn't extend beyond the surface of the wall (otherwise it will have to be chiseled down later). For a second coat, I use a sandable Sheetrock 90. For the final coat, I use some sort of drywall compound, which I then sand. If your home is well maintained and the plaster isn't exposed to too much moisture, plaster can last forever.

Why are the screws popping out of my drywall? We just finished the basement and the wall looks terrible now.

I see this one a lot, and I can think of a few things that may be causing the problem. The first is the wood: When was it delivered to the site? Did it sit in the rain for days? As the wood dries out, you might see issues with popped screws.

But mostly, it's a problem with installation. To get a nice-looking finished wall, a few things need to happen. First, your carpenter needs to crown the studs. That means looking down every 2 × 4 to find the natural bow or curve in the wood, and making sure all the studs are installed so they curve the same way. This is crucial: if the crowns face in alternating directions (in then out, out then in), you'll end up with a wavy wall that's just going to

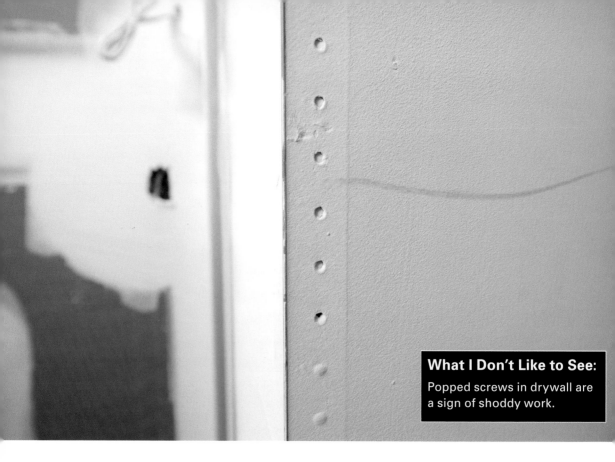

get worse over time. Too many guys out there aren't taking the time to look for the crowns—and they aren't getting rid of twisted or warped boards either, nor trimming off bits that would otherwise jut out and create an uneven surface for the drywall. That kind of shoddy work means you may have screws constantly popping out of the drywall.

A fast installation may also be to blame. Two people working, as a team, can get the right pressure on a sheet of drywall to ensure that it goes on tight. Unfortunately, that's not the way it's usually done. Typically there's just one guy installing the drywall, working very fast. He drills a screw into the drywall, then does the next, and so on. Too often, finishing shows speed, not care.

So, how can you fix the problem? Don't just plaster it again. Take out the screws or nails, make sure the drywall is tight to the stud, then add a couple of new screws (not in the same hole). Then mud over the screws, sand, and paint. That should take care of most minor pops.

Why do you use screws and not nails?

Building codes differ in Canada and the United States, but I use screws over nails whenever possible. When shear strength (the strength perpendicular to the shank of the fastener) is critical, nails are the correct choice. I know I'll get a bunch of people emailing me about the strength of nails versus screws, but I don't care. That's why I say glue it and screw it!

For drywall, nails will pop as a house shifts and settles, as wood shrinks, or in the case of sloppy framing. Nails are also to blame for squeaky or bouncy floors. If you nail the subfloor to the joists, the nails will pull away over time whenever pressure is placed on them—which means whenever anyone walks across the floor. That's why I glue and screw a subfloor to the joists so it's secure. Glue makes the connection and screws hold it in place and won't loosen over time like a nail will.

When you're talking about the envelope of a house, it needs to withstand heavy rain and damaging winds (think of 100-mile-an-hour winds in a hurricane). Believe it or not, that's not hard to do if you choose the right building materials and install them properly.

Lighting, Electrical, and Plumbing

Let's talk about lighting, electrical, and plumbing. We get up in the morning and take it for granted that the light will turn on when we flick the switch, and water will flow when we turn the tap so we can brush our teeth. These are things that we don't really pay attention to. Out of sight, out of mind. We need to pay attention because what we can't see, and what we don't understand, can hurt us. Electrical could cause a shock hazard or a fire; plumbing: a flood. Just because everything looks OK doesn't mean it is.

Everyone rushes in to do a new kitchen or bathroom, but they tend to forget about the plumbing and electrical hidden behind the walls. That's not a good thing. Plumbing gets old. You might be looking at lead pipes, broken pipes, or improper venting that will affect the way your sink or your tub drains. If you just focus on picking new finishings, you're going to miss this stuff. With electrical, you could be looking at hidden junction boxes. It's not OK to conceal a junction box; it's illegal: junctions must be accessible.

Always, always hire a licensed electrical contractor to check out the wiring and do the electrical. Always hire a licensed plumber to do the plumbing. If you do it yourself, at least find out how it has to be done and get the permits. Municipal inspectors aren't there to make your life difficult—their job is to make sure you're getting your money's worth and the work is safely done to code.

When you're working with electrical or plumbing, always take pictures before and after. Document everything you do, and don't work without permits. This is key for resale purposes because it shows you've done everything right. The pictures will not only help you identify what's behind a wall in case you want to hang a TV or a picture later, but it also shows people who might want to buy your home and don't want any surprises. Most homeowners aren't doing this, but this kind of document package is absolutely necessary in my opinion.

Each of the bedrooms in our two-story home has one light fixture, and we're tired of living in the dark. We're considering recessed lighting. What do we need to know?

First, you'll have to check your home's electrical panel to see if you have any open circuits you can use for the extra lighting. Don't connect the new lighting to the wiring for other appliances unless it's allowed under the electrical code in your area. Some appliances have a higher electrical load and should be on a dedicated circuit. And be prepared for a little drywall and paint patching: you'll need to hire a licensed electrician to fish the wires through the home to the electrical panel.

Now, about recessed lighting: I never allow it in the top floor of a house. The heat from those lights will go up into your attic, adding to the heat that's already trapped there. When the heat in the attic meets up with the moisture in your home—we each create about 300 gallons of water vapor per year through

everyday activities like cooking, breathing, and doing laundry—it will create a breeding ground for mold and rot, which can lead to water damage on the ceiling below. Remember that attics are supposed to be cold zones in our homes, with the temperature about the same as outside. Heat in the attic could melt the snow on your roof, which can refreeze when the lights go off, creating an ice dam and possible damage to shingles.

If you absolutely must have recessed lights up there, consider building them into a bulkhead in the ceiling. That will keep the fixtures below the cold zone and it will help you avoid any problems with condensation.

It's also critical that you use the right kind of lights. Some are safe to use in spaces where the lights will come into contact with insulation, and others are not. Code says that only recessed lights designated for insulation contact (IC) can be installed directly next to insulation. They have a rectangular metal box around them that leaves space around the fixture, so the heat produced by a lightbulb can escape. Otherwise, the fixture could overheat and a fire could start. Remember that "insulated" could mean a space you've insulated for heat or for sound. Either way, you need an IC-rated fixture.

Not all recessed lighting is the same. Make sure you use the right light in the right place.

Use the Right Lights Near Insulation

According to the building code, if you're putting a light fixture in an area with insulation, you need a light that's designated for insulation contact (IC), or you need to provide a minimum 3-inch clearance between the fixture and any insulation. IC-rated fixtures are designed with an air space between two housings. The added space means the light won't overheat next to the insulation, which could spark a fire.

Remember, if the area has insulation—that includes an attic, or even the space between the main and second floors, which may be insulated for sound—you need an IC fixture.

If you're using recessed lights in a cold zone, you need to make sure the boxes have a vapor barrier liner. This liner—when used properly with vapor barrier and sealed with house wrap tape—will prevent air movement between the warm zone of your bedrooms and the cold zone above.

This vapor barrier liner is especially important if you are using spray-foam insulation. Batt or blown-in insulation can safely come right up to the sides of the IC-rated box, but spray-foam is different. The contractor can't embed the fixture in foam—even if it is an IC-rated unit. Spray-foam expands before it hardens, so it will creep into any holes in the fixture box. You must have clearance between the foam and the fixture box, which is why you need to make sure your contractor uses the liner.

Make sure your contractor talks to your building inspector about the specific requirements in your area for using recessed lights in cold zones. And don't believe your contractor if he says he can do it all. Make sure you get a qualified, licensed electrician on the case.

Do you think aluminum wiring is unsafe in a home? We were told by our insurance company that it is. Should we be worried?

I get this one all the time, and it's a question that causes confusion. Aluminum wiring was popular in the '60s and '70s because it looks like a cheaper alternative to copper. On its own—that means in a house where all the wiring, receptacles, and switches are rated for aluminum—aluminum is totally safe.

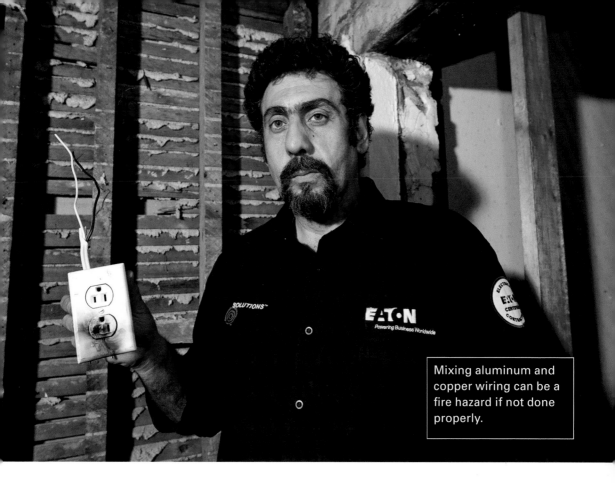

Mixing aluminum and copper wiring can be a fire hazard if not done properly.

The problems come from connecting aluminum wiring to copper wiring—which inevitably happens. I see this often, and people aren't even aware of it because wires are buried in walls. Along comes a contractor to do a repair or an addition and he unknowingly mixes the two. Or you go to the hardware store and buy a simple fifty-seven-cent switch and receptacle and try to install it yourself. Anyone who thinks they can just upgrade aluminum wiring with copper switches and plugs is playing with fire.

It's the mixing that's a safety issue, because different wires are designed to handle different amounts of power (amperage) flowing through them. The two types of wire heat up differently: one expands roundly, and the other forms an oval. If aluminum and copper wires have been tied together wrong, the connection will loosen over time, and this is what causes arcs and fires. The wire comes loose and the electricity literally jumps—or arcs—to the nearest conducting material, creating lots of heat that can start a fire. People have lost their homes and their lives because of this.

It is possible for an electrician to safely mix aluminum with copper wires. The wiring needs to be properly

terminated with the correct wire nuts and a special paste that is rated for aluminum and copper. The paste is essential: it stops the chemical reaction that occurs when copper and aluminum meet, which would cause a gap and an electrical arc. If you have aluminum wiring, it's important that you have a licensed electrician who understands it come in and take a look.

So even though aluminum can be done safely, it's considered too big a risk by most insurance companies—they won't insure your house as long as it has aluminum wiring. You can always get rid of it. Copper is definitely the easiest to maintain, and it's also the best conductor.

Why did our first house have a fuse box but our new one has a breaker panel?

The heart of your home's electrical system is the main service panel. In older homes, that main panel is a fuse box. In newer homes, it's a panel of circuit breakers. They do the same job, but circuit breakers are safer—a breaker will trip the wire and cut power before it has a chance to overload at the panel—and they're not as susceptible to user error, such as replacing a fuse with one that has the wrong rating.

The wiring in your house is just a collection of circuits that are routed through the main service panel. For every circuit, there's a fuse or a circuit breaker. Each circuit has an amperage (usually 15 amps), and that circuit shouldn't be overloaded. When you ask for too much electric current through any one circuit (say, by plugging in too many appliances), the fuse will burn out or the circuit breaker will cut the connection. That reaction keeps the wire from overheating and causing a fire.

The problem with fuses was that people had too many things plugged in and not enough circuits, so they kept blowing fuses. So instead of replacing a blown 15-amp fuse with another 15-amp fuse that kept blowing, they screwed in a 30-amp fuse. That won't blow as often, but it also won't stop the line from heating up at junctions, which could start a fire.

If you're living in an old house with a fuse box, educate yourself about the amperages in each circuit so you can use the right fuse for the job. Or if you are planning electrical upgrades, bring in a licensed electrician to look at whether it should be replaced.

Why do my kitchen lights flicker when my fridge turns on?

You shouldn't see the lights dimming like this. You've got a wiring problem,

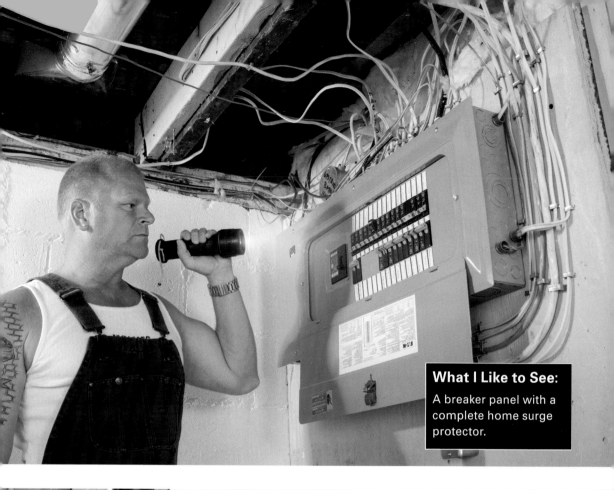

What I Like to See:
A breaker panel with a complete home surge protector.

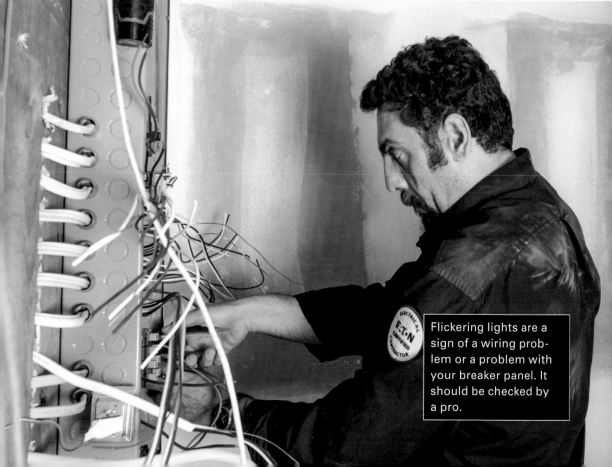

Flickering lights are a sign of a wiring problem or a problem with your breaker panel. It should be checked by a pro.

which is also a safety issue. If you live in an older home, this might be happening because the fridge and lights are sharing one overloaded circuit: the wiring that's providing power to the receptacle for your fridge is also serving the lighting, and possibly other receptacles in the kitchen. The wire is too small to provide enough current to all these outlets, which is causing your kitchen lights to flicker.

I'm not the only one who thinks this is a bad idea: it's actually against the building code in some areas. A fridge has a higher electrical load and should be on a dedicated circuit. That means it shouldn't be sharing wires with any other appliances, outlets, or lights.

It's a safety issue: the inadequate wire could spark a fire. Fuses and breakers are designed to prevent wires from overheating; they cut off the electricity if too much current is passing through the wire. Unfortunately, if fuses or breakers are not the right size or rating to correspond to the wire size, they won't work when you need them to.

You need a qualified electrician to do two things: First, check the circuit breaker sizes to make sure they're not overloaded. Overloading is fairly common, but it's not expensive to fix. While checking the panel, the electrician can split the load. That means installing a second wire from the breaker panel to supply current to some of the kitchen outlets that had been served by one overloaded wire. That way your lights and your fridge will both get the power they need and you'll take care of a possible fire hazard.

Why should I not install a lightbulb in my closet?

First, don't use an open lightbulb anywhere in your closet. Code requires all lightbulbs in closets to be enclosed, so you need a light fixture. This is for your own protection. If the lightbulb breaks—maybe it gets cracked by something in the closet—the exposed elements can cause fire or electrocution.

Second, I'm not a fan of incandescent lightbulbs. Have you ever reached for a burned-out incandescent lightbulb after it had been on for a while? I bet you learned pretty quick that they generate a lot of heat. Now, picture the scene in a typical closet where a lot of stuff has been packed into a small space. What happens if that hot lightbulb comes into contact with clothing or a shoebox? It could start a fire.

If it's a very small closet, I don't recommend an interior light at all. The light from the adjoining room should be enough. But if we're talking about

Warning Signs of Electrical Problems

Call an electrician to help you sort out a wiring problem if you notice any of these glitches:

- Breakers that always trip
- Fuses that always blow
- Flickering lights
- A burning smell coming from appliances or in rooms
- Discolored wall outlets
- Outlets that spark or feel hot to the touch

a decent-sized closet, it's much better to use LED or CFL lightbulbs. Both generate very little heat, so you don't have to worry about creating a fire hazard.

Why does the breaker trip when I try to plug the vacuum into my bedroom outlets?

The answer depends on how old your home is. If you live in an older house, the breaker is likely tripping because you're overloading the circuit. The best way to tell if you're overloading a switch is to turn off any nearby lights or appliances that could be drawing power from the same circuit. If the breaker continues to flip, the wire could be short-circuited. That needs to be fixed right away.

In a newer home, the vacuum could be causing the arc-fault breaker to trip. In the past, bedrooms were the top place fires started due to sloppy wiring, so arc-fault circuit interrupters (AFCIs) were required to protect every receptacle in bedrooms. With proven success and wide market availability, they are now the minimum code for nearly every outlet in the house, including lighting. If the breaker senses anything to do with an electrical short or arc, it will trip, stopping the flow of electricity and very likely preventing a fire. (Or it could be that you're plugging in the vacuum while it's turned on, which is a no-no that might cause a spark or trip the breaker. Only plug in appliances when they are switched off.)

Old house or new, you've got a safety issue, which means it's time to bring in a licensed electrician to take a look and make it right.

Will installing a ceiling fan cut down on my energy costs?

As soon as the temperature climbs, we start to hear about how we need to cut down on home air conditioning to conserve power and help the environment. If you're like most people and you can't live without air conditioning in the summer, you can stay comfortable and shrink your electricity bill if you install a good ceiling fan that will let you turn down the A/C a little.

First, let's make one thing clear: Fans don't make the air cooler. But they keep the air moving, which evaporates moisture on your skin as it moves over you and makes you *feel* cooler. It's a little like the wind chill, but in a good way.

The other thing ceiling fans are good at is mixing warm and cool air. Your fan will draw warm air from the room up towards the ceiling. On some days, that fan may provide all the cooling you need, and it uses a fraction of the energy used by an air conditioner.

When the heat is unbearable, you can use a combination of air conditioning and the ceiling fan. With the fan doing its thing to make you feel cooler, you can bump up the thermostat a couple of degrees. For every degree you bump up the temperature, you'll save 3% to 5% on your energy bill. Set the temperature to at least 75°F (24°C) all day, which is more efficient and helps control humidity better than cranking up the A/C only when you're at home.

In the winter, reverse the way the blades turn to push the warm air down into the room. That makes the floor-level air feel warmer, and you'll save on heating. Now do you see why I think ceiling fans are a smart upgrade?

Get the Most Savings from Your Ceiling Fan

Buy an Energy Star–certified fan. These models are more than 50% more energy efficient than conventional models. That's money in your pocket every time you use it.

Turn it off when you leave the room. Remember how fans work? They don't cool air, they cool people. So unless you're in the room, you won't get that wind chill effect and you're wasting energy.

Make sure you install a CFL or LED lightbulb in the light fixture if your fan has one: incandescent lightbulbs add heat to a room, and CFLs and LEDs burn cooler and use about one-quarter of the energy.

Now before you run out and install the first fan you find on sale, do some planning—or your mistakes will cost you more than you'll ever save.

First, make sure you have enough space for a fan to work properly and safely. That means a ceiling at least eight feet high. You need at least seven feet of clearance to prevent the blades from coming into contact with anyone. Some people will be tall enough to reach it with their hands, so be careful when you're taking off your shirt!

You also want a foot or two of clearance between the fan blades and the nearest wall, since the fan can move air about two feet from the blade. Don't forget about sloped ceilings—they need clearance too, and there are fans specifically designed for angled ceilings.

Smoke alarms require a minimum clearance of three feet from the edges of a ceiling fan blade, so be sure to evaluate this placement prior to installation. A fan that is too close to a smoke detector can push smoke away from the detector, delaying the alarm and losing valuable time for occupants to escape.

Next, make sure the fan isn't too loud. Some of the less expensive models out there are noisy when they operate. Try getting a good night's sleep with one of those running; no way. Other fans aren't properly balanced, so they set off a vibrating hum throughout your home. It'll drive you crazy, so make sure you get a good quality fan.

A dangerous mistake you can make is just taking out a light fixture and using its junction box to hang a fan.

Ceiling fans weigh 15 to 35 pounds. A regular junction box might be able to hold that kind of weight if the fan just sat there, but those spinning blades add extra pressure and vibration that can shake the fan loose. Plus, you may need to yank down on a chain to operate the fan; more pressure. Make sure a fan-rated box that can handle the full weight and vibration of a moving fan is provided.

If your fan is installed properly, it's a great way to help you stay cool in the summer, using about as much electricity as a traditional lightbulb.

Why is one of the prongs on an electrical plug wider than the other? What does the ground do on a plug?

If you've ever tried to put a two-prong plug into an outlet and found it won't go in—until you turn the plug around—you've encountered a polarized plug. A polarized plug can only be inserted into an outlet one way. Most simple household outlets have a "hot" side and a neutral side. With a polarized plug, the hot wire in your appliance can only be connected to the hot wire in the outlet, which is the way it is supposed to be.

That third prong you see on some plugs is the ground pin. If you plug in

a damaged cord or a malfunctioning appliance by mistake, the ground pin offers extra protection from blowouts and severe shocks. The ground pin provides a path for electrical current to go into the ground where it disperses more safely.

It goes without saying that you should never alter the wide prong of a polarized plug to make it fit, and never cut off the ground pin on a three-prong plug. If your outlets don't allow you to plug in an appliance, they are probably outdated. Have a qualified electrician replace the outlets to keep your household running and your family safe.

What are GFCI outlets and where do I need them?

GFCI stands for *ground-fault circuit interrupter*, which is an outlet that protects people from severe electric shocks and electrocution. It's an electrical outlet that incorporates a circuit breaker and it's specially designed to cut the power when current between the hot and neutral prongs differs. Electrical code requires all receptacles in bathrooms, garages, unfinished basements or unfinished portions of basements, kitchen countertops, or within six feet of a sink to be GFCI protected. There does not have to be

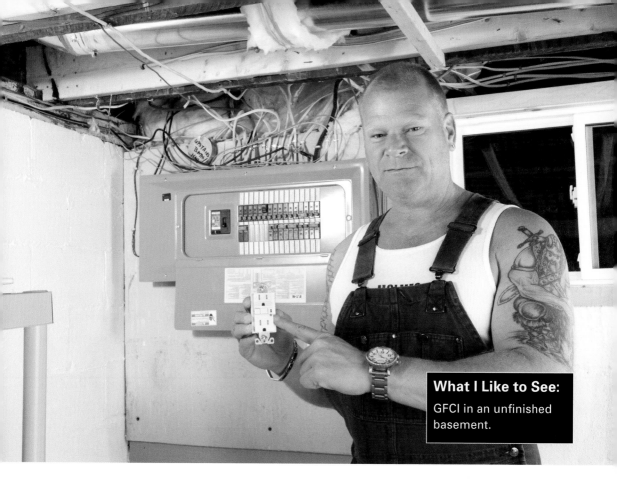

a GFCI device at each outlet, as all outlets wired downstream of a GFCI receptacle device are protected by the upstream device.

I'll explain how they work. A GFCI prevents an unintentional electric path between a source of electrical current and a grounded surface. This is known as a ground fault and it occurs when you have electrical current leaking somewhere. The current is trying to reach the ground; if your body provides a path to the ground, you could get a nasty shock. The GFCI stops this from happening by monitoring the amount of current flowing; if there's a difference—even as small as 4 or 5 milliamps, amounts too small to activate a fuse or circuit breaker—the GFCI cuts the electricity in a fraction of a second.

Suppose a bare wire inside an appliance touches the metal case. The case is now charged with electricity. If you touch the appliance with one hand and your other hand touches a grounded metal object (like a water faucet) you complete the loop and get a shock. If the appliance is plugged into a GFCI outlet, the GFCI senses the change in current and shuts the power off.

You should always install GFCIs in kitchens, bathrooms, crawl spaces, unfinished basements, and outdoors. They're not expensive and they could save your life.

I know it's the right thing to use energy-saving lightbulbs, but the last compact fluorescents we bought took forever to light up. How can we get decent light and save energy?

Good to hear you're trying to save electricity, because North Americans use more energy than anyone in the world. It costs the environment and it eats into your family's budget. We need to do better.

Once upon a time, incandescent lightbulbs were a great upgrade from candlelight and oil lamps. The problem is, they waste a ton of energy. They work by using electricity to heat a filament until it glows. That process gives off a lot of excess heat. Have you ever touched a lightbulb after it's been turned off? Scorching.

Along came a more efficient option in the '80s: compact fluorescent light-bulbs (CFLs). The lightbulbs cost more than incandescents but they last about ten times longer (6,000 to 15,000 hours if they're Energy Star certified) and use about one-quarter of the energy to produce the same amount of light. You get your money back in lower hydro bills. Many people didn't like the early CFLs. Cheap ones took time to warm up to full brightness, some flickered or buzzed, and the light sometimes looked harsh. Plus, while they're good for the environment because they conserve energy, the lightbulbs are toxic: they contain mercury vapor and must be disposed of as hazardous waste. If they go to landfill, they endanger our water supply.

I believe in conservation, so I use LEDs in my house (I like Philips LEDs). Light-emitting diode (LED) technology uses a fraction of the energy of halogen and incandescent lightbulbs, and even less than CFLs. They channel electric current through a semiconductor material—100% of which is turned into light, with no waste heat produced. They contain no mercury and the lightbulbs last forever: 20,000 to 60,000 hours, depending on the manufacturer. If you install a good quality LED when your kid is born, that lightbulb will still be burning after she goes off to college. Another bonus: LEDs don't attract bugs, so they're great outdoors. I've got them around my deck.

You don't use LEDs the same way as incandescent lightbulbs because the light is very focused. An LED is best

Choosing "Warm" Lighting

Let's get one thing straight: you'll never find an energy-efficient lightbulb that looks exactly like an incandescent. But the secret to light that has that yellowish warm glow is to read the Kelvin measure on the label. The color temperature of lightbulbs is measured in Kelvins (K). Generally, you'll get warmer, more golden light if you buy a lightbulb with a lower color temperature rating—between 2,700 and 3,000 K. For cool blue-white light, look for lightbulbs between 5,000 and 6,500 K. If the box doesn't show color temperature, look for a description like "soft white" for warm lighting and "daylight" for whiter light.

for accent or task lighting because the light doesn't spread well in a general wash unless you bounce it off walls or other surfaces or use it as an uplight. They're ideal for under-cabinet lighting in a kitchen, for lighting hallways and staircases, or for security lighting.

Even LEDs aren't perfect. You've probably seen how much they cost—$30 to $40 per lightbulb. You might have a hard time wrapping your mind around the idea of paying that much for a lightbulb. I know I did. But since they use 80% less electricity and last fifty times as long, they'll start paying for themselves in a couple of years.

Many people weren't crazy about the light from the first generation of LEDs. They think it looks too cold and intense, but new technology has allowed for "warmer" light qualities that effectively match the look of an incandescent

lightbulb. They are available in up to 75-watt configurations.

Just be careful about slipping an LED into just any light fixture. Fixtures designed for incandescent lightbulbs can be heat traps, which affects the lifespan of LEDs and CFLs, since they're not designed to take excess heat. If you use energy-efficient lightbulbs in a socket that doesn't allow heat to dissipate, they won't last, and you won't see the long-term savings. Ideally, upgrade to an LED lighting system to get the full lifespan of an LED lightbulb.

The package said our compact fluorescent lightbulbs would last for up to 5 years but ours never last that long. What are we doing wrong?

There are a few reasons yours might be burning out early. Manufacturers make

their claims based on assumptions about how many hours a day they'll be used—typically, three hours. If yours are on longer than that, expect them to burn out in fewer years than it might say on the package. So you might be getting the same number of hours of light as the next guy, but you're using those hours up at a faster rate.

Are you using your lightbulbs correctly? Some are meant for exterior use and others aren't. Some shouldn't be installed in enclosed light fixtures: the heat will shorten their lifespan. And you'll optimize the life of CFLs provided you install them correctly and then leave them on for at least fifteen minutes each time: they don't last as long if they're frequently switched on and off. That means they'll perform better in a kitchen than they would in a closet or hallway. One of the problems with CFLs is people have never been taught how to use them. They're not one size fits all, so you have to read the package and look for lightbulbs suited to various jobs.

What is the life expectancy of plumbing? How long should my toilet last before I need to replace it?

The good news is toilets can last for decades. The bad news is toilets can last for decades. Don't get me wrong: I want your home to last forever, but I've got a problem with everlasting toilets because they're the number one water-waster in your home. If your toilet is more than fifteen years old, it's guzzling anywhere from 3 to 5 gallons (12 to 18 liters) of water every time you flush. If your toilet runs, or you often need to double-flush, you're letting even more money and resources pour down the drain. That's a lot of wasted water when you consider the newest high-efficiency toilets use a maximum of 1.5 gallons per flush (6 liters), and my favorite toilet uses just ¾ gallon (3 liters).

In the past few years, there's been a move to install toilets that reduce the amount of water the average household uses. These models are often called low-flow, ultra-low-volume (ULV), or ultra-high-efficiency toilets (UHET). They basically use smart engineering and powerful flushing mechanisms to reduce the amount of water used per flush. It's simple: believe it or not, the world has a limited supply of fresh water, the average North American uses 92 gallons per day (350 liters), and we can all be doing more to conserve it.

If you have older fixtures, I strongly suggest replacing or retrofitting them. With the right system, properly

WaterSense Toilets

Everyone's probably heard of Energy Star: a program that certifies energy-saving appliances, lighting, and other household devices. Well, if you want to know you're choosing fixtures that save water, look for a WaterSense sticker (epa.gov/WaterSense). Faucets, showerheads, and toilets get to use this label if they meet WaterSense's strict standards for efficiency and conservation.

My first choice would be a high-efficiency 3-liter, one-button-flush toilet. Water-saving dual-flush toilets are also good as long as you use them properly (small button for small jobs, big button for big business).

Does your toilet pass the flush test?

When you hear words like "low-flow" to describe a toilet, I know what you're thinking: yeah, but will it do the job? Well, there's a good way to find out. You can see a toilet's MaP score, which is its Maximum Performance according to independent tests. MaP testing puts toilets through their paces using soybean paste and toilet paper to see how many grams a model can remove in a single flush. The higher the score, the better the performance. In my books, the best toilets use the least amount of water to remove the largest amount of waste. Look up toilet performance scores at Map-Testing.com.

installed, a low-volume toilet will not only put money in your pocket, it will also save more than half of the water you currently use on a daily basis. Dual-flush systems typically give you a small and a large flush option, at a maximum of 1.5 gallons per flush (6 liters), and even less for the small flush (¾ to 1⅓ gallons; 3 to 4.8 liters).

The only drawback I've seen with dual-flush toilets is user error: some people won't know what the two buttons are for. Others are so used to double-flushing, they'll negate the water savings. I prefer ULV toilets with one button because then every flush is simple and guaranteed to save water and money.

When it comes to retrofitting, you can adapt your toilet by installing water-saving devices inside the actual tank or at the back of the toilet. There are devices for water retention or displacement, as well as early-closure and dual-flush gadgets. The most popular is a $10 toilet dam that saves about 1⅓ gallons of water

per flush (5 liters). You can install the dam yourself, and they're considered an effective option. They may leak over time, so you'll want to monitor them to know when they need to be replaced. They also may not work so well on a toilet with a 13-liter flush, since those old models are designed to work with a larger volume of water.

Some people opt to fill plastic bags, big jars, or bottles with water and keep them in the tank to displace water each time the toilet is flushed. While they might offer a quick fix, no water displacement system will save as much water as other low-flow methods.

If you're not ready to replace the entire toilet, you can have an early-closure or dual-flush device attached to the overflow tube inside the toilet tank. They save water by closing the flush valve or the flapper when the tank is only partially emptied. With the dual-flush attachment, the amount of water used depends on how long the handle is held down—lighter for small jobs and longer for, well, you get the idea.

A ULV toilet really is the best approach since it uses considerably less water and produces less wastewater. If your municipality applies a sewer surcharge, investing in a new toilet could mean even bigger savings on your water bill. If you are on a private well and septic system, you will really reduce the load on your tile field as well as cause less wear and tear on the system over the long term.

Why is my sink so slow to drain? It "burps" and then bubbles come out of the drain before all the water goes down.

All the drains in your home have a job: using air and gravity, drains allow waste and water from every sink, appliance, tub, and toilet to flow out of your house and into the sewer. Every time you wash the dishes, you are washing food scraps down the drain. They collect in the trap, which is that curved section of the drainpipe below the sink. The trap is always filled with water to prevent sewer gas from coming up into your home. We need water to rush down the drain and sweep that sludge out to the sewer, but there has to be enough air behind the water to make sure that happens. Otherwise, you've created an opportunity for buildups and blockages in the drainpipe. You don't want that.

Sounds to me like you've got a venting issue—there's not enough airflow behind the water, or the vent stack might be blocked with leaves or snow. Like so many things in a home, plumbing needs to breathe. Think of a

giant bottle full of water. Turn it upside down and the liquid has a hard time getting out. A bit of water sloshes out, but then air has to move in through the mouth of the bottle to replace the water that's left. But if you punch a little hole in the bottom of the bottle, the water will blast out. Good plumbing works like that: it should make water race down the drain.

Every sink, bathtub, or toilet needs a drain line that takes water, waste, and vapor into your home's main vent stack. You'll probably be able to see the stack in your basement: it's the largest vertical pipe you'll see, and it normally connects into the floor of the basement and ties into the outside sewer system. It also climbs straight up through the house and right through the roof. The stack has two functions: it washes waste and water down into the sewer system, and it allows gases to escape safely and water to enter the drainage system through an opening at the top of the stack. That opening is like the hole in the bottom of the water bottle. If the stack were to become blocked or sealed, nothing in your house would drain properly. It provides the air behind or above the water that's absolutely necessary for proper flushing and draining.

Call in a plumber to check that the sink is properly vented—it may be blocked. Or there may be no vent at all. It's possible a cheater was used, which is legal in some applications, but not as good. When it's not easy to properly vent to the outside, a contractor or plumber may suggest using a cheater vent, or air admittance valve (AAV). This kind of valve comes off at pipe nearer to the fixture—for example, a sink in a new powder room—and is buried right in the wall. You can usually hear it sucking in air and gurgling behind the wall when the fixture drains.

They're called cheater vents because they let you cheat a bit on the expense and labor of the plumbing job. AAVs must be installed properly: they need access to free airflow, so if installed in an open wall cavity, insulation must be clear from the device and a louvered opening to free moving air must be provided. The vent needs to rise a minimum of four inches above the height of the drain, be installed level, and has to remain accessible—so you can't drywall over the AAV without a removable, vented cover.

AAVs are mechanical vents designed to allow air into the system to help drains operate while keeping sewer gas from getting into the wall cavity. Unless the valve's gaskets are old and warped, you're unlikely to smell any gas from them.

Personally, I always prefer venting to the outside. I'd only use a cheater as a last resort—like when a homeowner insists on having a sink in a kitchen island and I can't vent it any other way. Code also requires a minimum of one vent in each home to terminate in open air, without an AAV.

Why is my water pressure so bad?

Most of us probably don't think about water pressure until it suddenly drops—like when you're in the shower and someone flushes a toilet. There are lots of reasons—big and small—that could be causing the problem. Here are the solutions.

Clean the aerator

Is the water pressure low just at one tap? Some debris or corrosion may have flaked off from inside the pipes and clogged the faucet aerator. Any handyman can take care of that one by removing and cleaning out the aerator.

Check the flow

Every municipality has a municipal flow rate, which depends on your water source and where you live (this doesn't apply if you get your water from a well). That minimum rate is the flow that's delivered to your home at the main water intake. After that point, all water pressure problems are yours, but between the street and the main intake is the city's responsibility. You may have to call the municipality to do a test.

Upgrade the supply line

If you live in an older house, chances are you've got water lines that are smaller in diameter than today's standard, which will cause weak water pressure. Modern households can't be effectively supplied by a ½-inch pipe, so you'll need a plumber to upgrade the supply line to at least ¾ inch.

Remove corroded piping

Some pipes are made of galvanized steel—not copper—which is one reason for a loss of water pressure in older homes. Galvanized piping corrodes on the inside and deposits buildup that severely reduces water flow. I'd recommend removing galvanized piping and upgrading it to copper or PEX (flexible tubing made from high-density polyethylene). This isn't a DIY job and it won't be cheap: leave this one to a professional plumber.

Fix shoddy plumbing

Bad plumbing jobs are another reason for restricted water flow or pressure drops. Any renovation or addition

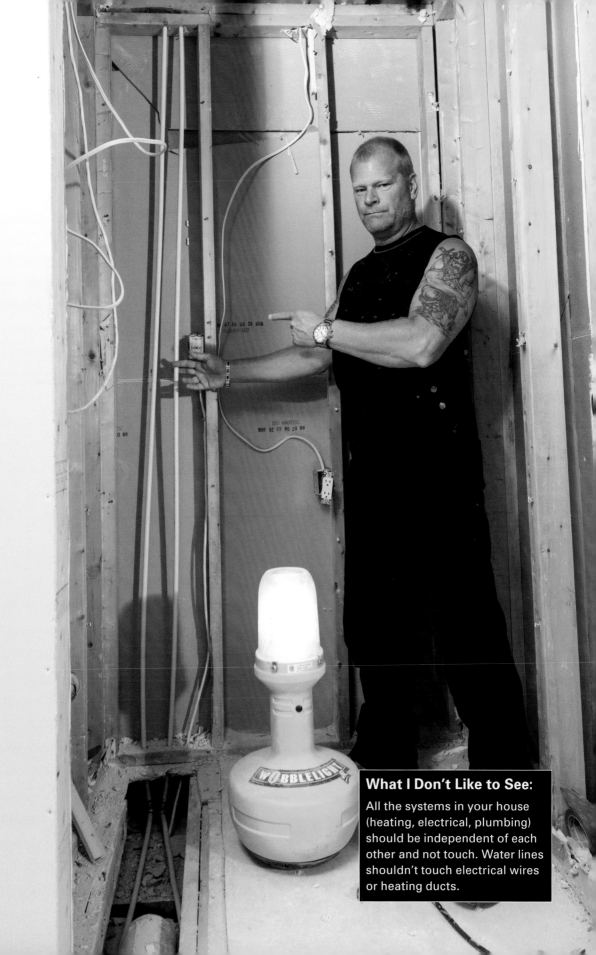

What I Don't Like to See:

All the systems in your house (heating, electrical, plumbing) should be independent of each other and not touch. Water lines shouldn't touch electrical wires or heating ducts.

that altered plumbing lines may be to blame. I've seen how amateurs or bad plumbers have made a mess of lines by using inadequately sized piping or by adding too many elbows, bad joints, or supply lines off other lines. I call it spaghetti plumbing. Eventually, it needs to be scrapped and fixed.

Blame the water

Depending on where you live, the problem might be coming from the water that supplies your house. Some water is highly acidic or contains dissolved minerals that can affect copper piping. With galvanized piping, often the problem is "hard" water, which contains higher levels of calcium and magnesium than "soft" water does. Hard water from your municipality is perfectly safe to drink, but it can cause problems in pipes, appliances, and fixtures.

You can sometimes tell when minerals are accumulating because they'll leave a tough-to-clean stain or layer of scum on sinks and tubs. Not only does the stain look awful, it could also be a red flag for more expensive problems. Hard water can leave a hard scale surface that "clogs the arteries" of pipes and blocks water flow. You can easily clean the minerals out of your showerhead or faucet aerator, but this buildup can be a real problem for appliances that are hooked up to water. Scaling and mineral buildup can damage everything from taps, toilets, and water tanks to dishwashers and sinks. The damage means these units will break down sooner than expected.

If hard water is the problem, you may need to install a water softener, which uses sodium to help neutralize the minerals. A system will cost you up front and in ongoing charges for salt, but it works out cheaper than replacing dishwashers and washing machines before their expected lifetimes.

A bad PRV

A PRV is a pressure-reducing valve. It is a common installation, required where municipal water pressure exceeds 80 psi (pounds per square inch).

What is involved in rewiring a house? Does it leave lots of holes?

Upgrading the electrical to copper wiring is a big job, but it will give you more reliable electrical service and peace of mind that the wiring is safe and functional. It's also a great opportunity to design wiring for what you'll want in the future.

An electrician can wire a new house fairly quickly for about $5,000, but rewiring an old house starts at

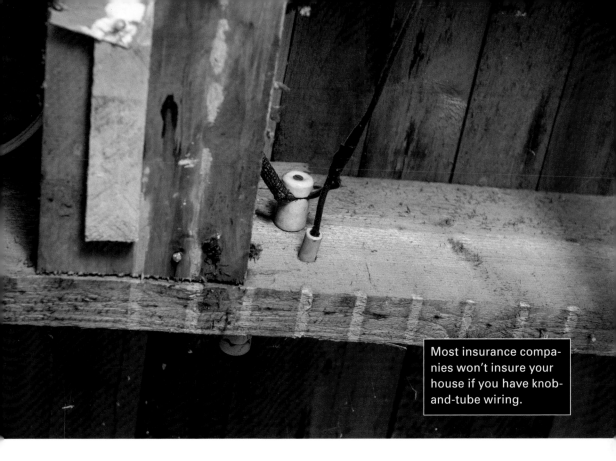

Most insurance companies won't insure your house if you have knob-and-tube wiring.

about $15,000. That's because a new house has no walls getting in the way; in an old house, the electrician has to gain access to the old wiring. He does that by cutting holes in walls and the ceiling about every five feet and then fishing wire through. That means patching holes, sanding, and painting. So yes, it gets messy. That's why I recommend starting from scratch with electrical if you're already gutting a house. Since your walls will already be opened up, your costs come down because it will take the electrician less time.

How many holes you get in the process depends on many things. How big is your house and how old? Is it plaster and lath or drywall? Is it aluminum wiring, copper, knob-and-tube, or a combination? What kind of insulation is behind the walls, if any? Is it one story or two? Is the basement finished? Do you want to upgrade from 60-amp to 100- or 200-amp service?

If the electrician has any trouble locating junctions or fishing for wires, that adds up to more mess and more money.

If you want the wiring done right, try to think ten steps ahead and design for what you may want in the future. How do you plan to set up your rooms? You may not have lamps on

your buffet now, but you might want them down the road, so think about adding a couple of outlets behind the buffet. Don't expect your electrician to come up with these ideas—you need to think about them. If you don't think about these things, most electricians will just stick to their standard routine and run outlets every 10 or 12 feet. I guarantee you'll be happier if you put those outlets where you want them.

In the bedrooms, for example, I'd try to keep receptacles away from the bed but close to the nightstand. And you might want a three-way switch by your bed for all those times you get undressed, tuck yourself in, and then realize you left the overhead light on. With a three-way switch by the bed, you can shut off that light without getting out of bed.

This is also your chance to think long-term. Even if you're not putting in the big sound system yet, you can rough in speaker wires for when you're ready. If a hot tub is a long-term goal, why not get the first step done now. You can also plan for phone lines and fiber-optic cables where you might need them. As I said, it's smart to think about these things before, not after, when changes will cost you mega-money.

Take my word for it: don't take on this job yourself. I don't do my own electrical work and neither should you. Some of the worst reno nightmares I've seen involved bad wiring, which can overload circuits and cause unsafe connections—your house could burn down. Always call a licensed professional and get a permit when you need electrical work done.

Junction boxes stand out like a sore thumb in a room. If the wiring is done properly, why is it so bad to put a junction box behind drywall?

Electrical junctions are essential. These casings, usually made of metal, contain the wiring intersections that allow the wires in your home to connect to the power supply provided by your utility company. They're also designed to protect connections between electrical wires and cables.

Hiding a junction box behind drywall might solve your decorating dilemma, but it will create a bigger problem—it's illegal in most jurisdictions in North America. Electrical code is very clear: whenever wires join together in a junction box, the junction points must remain accessible for inspection without removing any part of the building. Partly, it's so you

can see how many different circuits have tapped into the box. If a common line goes down because of a loose connection, you get into the box and solve the problem without drilling a bunch of holes in your house. Hidden junction boxes are also a fire hazard: they can be flashpoints for wiring connections to fray or disconnect, resulting in a potential for fire that you'll never know about because you can't see it.

Do yourself a favor: cover your junction box with a piece of art so it looks good and can be accessed when required.

What does a whole house surge protector do?

A whole house surge protector helps reduce the electrical fluctuations that occur on any given circuit. Basically, it connects to your electrical breaker box to protect it and your electrical

Protect Yourself with a Surge Protector

If you think you don't need a complete home surge protection system, that means you're thinking "A power surge will never happen to me." Trust me—I learned about this the hard way—destructive power strikes can happen. In fact, a large electrical surge entered my house and I lost all of my electronics that were plugged in. All of them. The first thing I did after replacing everything was install a Complete Home Surge Protector from Eaton Corporation. I've been using these devices for years on the homes I work on and I endorse them. Don't learn the hard way like I did: it's always better to prevent than replace.

devices and equipment—computers, TVs, phones, cable, etc.—from getting damaged by surges or electrical strikes. Unless you use one, these energy fluctuations will shorten the life of all your electronics.

We are used to using surge protectors for computers, but it's just as important for big appliances like your furnace, fridge, and dishwasher. Today's major appliances and heating and cooling systems all have electronics built into them, so they need to be protected the same way we shield a TV or computer. In my books, complete home surge protection is not an option anymore—it's a must.

How can you tell the wiring needs to be replaced without tearing up the walls? All I can see are the outlets, and the panel looks fine to me.

You may not realize it, but your safety at home depends on the electrical system. I'll tell you a story and you'll see what I mean. I once stopped in at a pub I've known for years and it looked completely different. They'd had to renovate after an electrical fire. Luckily, no one was hurt. About 20% of all fires in Canada happen due to electrical fires. And what's the number one cause of these fires? Faulty wiring. It's what caused the fire at the pub. These kinds of fires are completely preventable if you bring in the right pros at the right time.

That means even if your outlets and panel "look fine," that's not enough to know your wiring is safe. So many parts of the electrical system are hidden behind walls, it makes electrical one of the most challenging things to inspect. In an older home, where the electrical hasn't been "upgraded" through the years, an electrician can judge whether the system is still in good repair, still adequate for the demands of your lifestyle, and still safe. In older homes that have been extensively renovated, an expert can tell you how well the electrical was done and whether it's safe. And in a brand-new home, an electrician can tell you if the wiring shows any signs of being poorly installed.

What you *can* tell by looking at the electrical panel is the size of the service your house is getting. Your electrical system is measured in two parts. The first is the size: how much power comes into the house. The second is the distribution: how the power is distributed through the house.

The amount of power available to any house depends on how big the wires are that bring in power from

the street. That incoming power is measured in amps (short for *amperes*), and you'll find anything from 30-amp service to 200-amp service.

I don't know anyone who can live on a 30-amp service—it hasn't been used for decades. The next level, 60-amp service, was common in houses built before the '60s. It was fine then, but it can't handle the energy demands of all the appliances, electronics, and air conditioners that most modern families take for granted. Insurance companies sometimes won't insure service at this level or below.

The typical service size today is 100 amps, which is enough for most people. Some multi-family dwellings or large houses might need 200-amp service. Others like to have this capacity in case they need it down the road. It's not that expensive to change up your service size.

Whatever the size, the service coming in enters the house and goes through a main disconnect switch, which can be part of the electrical panel (in that case it's called a combination panel) or in a separate box just off to the side. Inside this main disconnect switch is either a circuit breaker or fuses. Both serve as filters for all that power coming in, sending out as much power as needed. Do not touch that box or try to remove the cover from an electrical panel. Leave that to an electrician. The electricity coming into that panel or box is enough to kill a person.

Looking at the fuses or circuit breakers on the main disconnect panel is the only reliable way to know the size of the service. In the case of a circuit breaker, the number will be stamped right on the breaker handle. You shouldn't have to open up the panel to see it. In the case of fuses, the cover panel will have to be opened by a licensed electrician. Then the cartridge-like fuses will be visible, and the number written on them indicates the capacity of the service. If you see two 100-amp cartridges, the service is 100 amps.

Even if you can tell the service size by looking at the panel, that won't tell you how it's distributed through the wiring. Several types of electrical wiring have come and gone over the years, but they haven't disappeared entirely— which is what's causing problems today. Knob-and-tube wiring was installed until about 1945, and you can still find it in a lot of older homes. There was nothing wrong with knob-and-tube—in fact, there still isn't anything wrong with it. Same with aluminum, which was popular in the '60s and '70s.

Insurance companies probably won't insure a house with known aluminum or knob-and-tube, but they'll insure you until you get the service upgraded to copper. All three types of wiring are safe on their own—it's the mixing that creates problems: old and new wiring are designed for different amounts of power (amperage). If the newer circuit gets overloaded, that can start a fire.

How are you going to know if there's mixed wiring behind your walls? You probably won't. At the very least, contact your local building authority to find out the last time an electrical permit was pulled. Your best bet is getting the advice of a licensed electrician, who can tell you if the wiring is safe and functional.

What should I do to maintain my sump pump?

If your home has a basement, chances are you've got a sump pump. A sump pump has a very important job: it acts as a line of defense against flooding inside your home. The pump removes any water that accumulates in a collection basin (the sump) and sends it away from the house to keep the water from overflowing inside your home.

Many pumps are wired into a home's electrical system with a battery backup. If power fails and the battery doesn't kick in, the pump won't be able to clear water out of your basement. You know what it means if water builds up and has nowhere to go: a flood.

A sump pump needs to be regularly checked to make sure the system can do its job. Check the motor regularly to make sure it's running and isn't filled with any debris or anything that may cause a blockage.

How should I look after my septic system?

One of the big differences between living in the city and the country is waste. In cities, wastewater from houses is gathered through municipal sewers and treated. There are no sewers in rural areas: each property collects its own waste in a septic system.

Septic systems come in all shapes and sizes, but they all pretty much work the same: there's a holding tank a few feet underground with an overflow opening that allows some water to flow out into the surrounding soil. Depending on how many people live in the home, and how much water they go through, the tank has to be dug

up, opened, and pumped out every few years. Local companies arrive on site to do this using a tanker truck and a large vacuum-like hose. Filters need to be cleaned and the motor should also be tested.

If you have recently bought a property, ask the previous owners how old the septic system is, when it was last cleaned, and how often they cleaned it in the past. That might give you an idea of when you'll need to call someone in to have it drained.

Kitchens and Bathrooms

Kitchens and bathrooms are minefields of potential problems. It pays to keep a lookout for any sign of trouble like leaks, moisture, poor ventilation, and mold. If you use the right products in the first place, and act fast when something's wrong, you can add years to the life of these rooms.

I want to change my kitchen flooring from tile to hardwood. Do I have to remove the tile, which runs under the cabinets?

You should definitely take up the tile and tear right down to the subfloor. It's never a good idea to go over one flooring surface with another. Your flooring material should always go under the cabinets, never just to the point

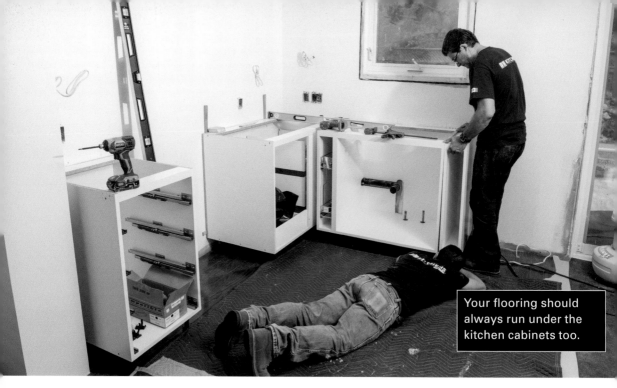

Your flooring should always run under the kitchen cabinets too.

where the floor meets the cabinets. This is important. I'm not just recommending this because it looks better (which it does). Your cabinets and appliances are designed to be at a certain height, which is always measured from the finished floor, not from the subfloor. If you lay new flooring on top of old flooring, the countertops will not be high enough. How will you be able to slide your dishwasher out from the wall the first time it needs to be serviced? (And it will—trust me on this.) You won't, unless your cabinets and appliances are resting on the finished floor. If you ever end up with water leaking down under the cabinets and you haven't put a floor down under them, how will you find out about that leak? I'll tell you: you'll discover it when the leak floods enough to run downstairs. That's because the water won't

dribble out onto the kitchen floor—it will seep under it. Spend a little more now and do your flooring right.

Why can't I lay new tile over the existing vinyl tile in my bathroom?

Listen, I get why homeowners and contractors want to cheat and lay new tile over old flooring. It's less work than tearing up the original flooring and laying the new stuff on a properly prepared substrate. But don't even think about doing it. You'll end up with cracked grout and tile, and your "new" floor won't look like new for long.

I hate cover-ups, which is why I always recommend removing existing flooring before installing something new. How else can you tell the condition of the underlay? You have to take up the old stuff, check out the subfloor, fix what

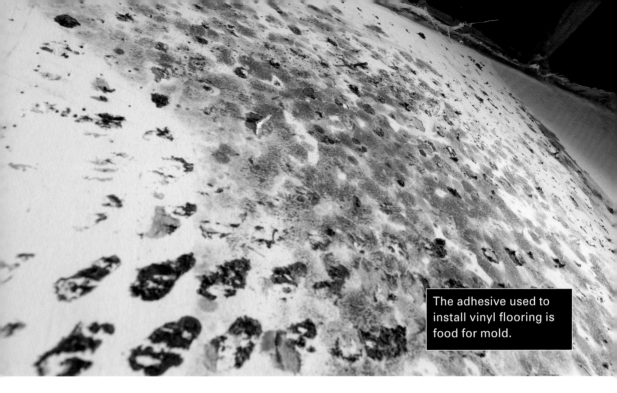

The adhesive used to install vinyl flooring is food for mold.

needs fixing, or replace the subfloor if necessary. When you're taking the time and money to renovate, isn't it worth making an effort to know it's perfect?

With all that moisture and humidity, bathrooms provide the perfect conditions for mold. And what you might not realize is that mold also feeds off mastic, the organic adhesive that's used to install some vinyl flooring. The only way to tell if you've got a mold problem you didn't even know about is to take up the old tiles. Tiling over the problem might cost less in the short term, but how much will it cost when you need to tear out the new floor because it looks like crap?

Hardwood, cork, tile, bamboo— I'm overwhelmed by the number of flooring choices. What do I need to consider when I'm choosing one for my kitchen?

Kitchens see more wear and tear than any other room in the house. Between people, pets, sliding chairs, spills, and all that water and steam, you need something that can withstand more traffic than your garage. When you're thinking about flooring for your kitchen (or bathroom, for that matter, since it faces many of the same issues), go for function over fashion. If you follow fashion, you're bound to end up with a room that looks good when it's first installed, but won't stand up to constant wear and moisture.

Ceramic or porcelain tiles

No wonder floors in most restaurant kitchens are tiled: tile is durable, easy to clean, won't off-gas chemicals, and

it looks great for years. Just make sure the subfloor is strong and level or you'll end up with cracked grout or loose tiles.

I like porcelain better than ceramic tile: it's less porous and more resistant to moisture; more dense so it can handle heavier loads; and the color of the tile is continuous all the way through, so chips and cracks are almost invisible. (Glazed ceramic tile always looks a different color below the surface.) Porcelain is a little more expensive than ceramic tile but it's worth it.

The durability of tile is a plus in my books, but it's a drawback when it comes to dropped items: most glass objects will shatter on a tile floor. A large expanse of tile flooring can also make for a noisy room, because tile doesn't absorb sound. If you're on your feet a lot, tile can be very tiring. And finally, tile can be cold underfoot, though radiant in-floor heating can cure that—for a price. Still, because of their many good points, I strongly recommend ceramic and porcelain tiles for kitchen floors.

Stone, slate, limestone, or marble tiles

Natural stone is another good choice. It looks great, mellows with age, and lasts forever—nothing looks quite like it. On the downside, stone is expensive,

cold to stand on, and heavy (your subfloor needs to be rock-solid and level). It's also difficult to work with, so I don't suggest do-it-yourselfers take on the installation of stone or marble. And remember that stone needs to be sealed before you grout it (otherwise the grout can ruin the surface of the tile) and sealed again every couple of years to prevent staining.

Cork

This is one of the newer and most eco-friendly flooring options because it's made from the bark of a tree—the tree itself continues to grow. Cork absorbs sound and pressure, so it's quieter and more comfortable to stand on than harder flooring choices. It naturally repels moisture and bugs, which makes it a reasonable choice for kitchens. Cork is about the same price as hardwood, and you'll need to seal it every couple of years.

Hardwood

Solid wood flooring is milled from a single ¾-inch-thick piece of hardwood. Because it's so thick, you can sand and refinish it for generations. Even so, I don't recommend wood floors in the kitchen or bathroom. First, it's a fact of nature that wood expands in the heat and contracts in the cold. If hardwood

is laid in winter when humidity is low, it can expand and buckle in the summer. If it's put down in summer, it can shrink to the point where gaps open up between planks during the winter. Add these issues to the risks of exposing wood to all the water and food in a kitchen, and you're asking for trouble. Water or food between planks can breed mold, which deteriorates the wood itself and the air quality inside your home. Liquid can degrade the wood finish. And every time you drop a can or a piece of cutlery, it's bound to leave a dent or a scratch. Do yourself a favor and stick to wood in other rooms.

Engineered wood

I like the look of hardwood but I prefer engineered wood flooring, which is made from three to five layers of wood stacked and bonded together under heat and pressure. It's less likely to be affected by humidity and temperature changes and can be refinished up to five times over a few decades before it needs to be replaced.

Laminates

You've probably heard these called "click floors" because the pieces click together when they're installed. Laminate planks are made of an inner core of pressed and glued wood material, with a photographic image of wood laminated on the surface. They are highly resistant to impact and scratches, but they won't stand up to a big dog's claws or heavy objects dragged across the floor. They can be noisy to walk on and, like hardwood, they can be damaged by moisture; in fact, you'll void the warranty of some products if you install them in high-moisture areas such as kitchens. Laminate has become popular because it's about one-third the cost of hardwood, but I don't recommend it: I predict these products will show their considerable weaknesses over time.

Bamboo

A popular alternative to hardwood, bamboo is actually a fast-growing renewable grass that becomes hard and rigid, like wood, during the manufacturing process. One of its downsides is it travels all the way from China, where bamboo grows and is processed. Bamboo floors are installed and maintained in the same manner as hardwood and, like wood floors, they are available in both solid and engineered planks (several plies laminated together). Like wood and its laminate imitators, bamboo is prone to moisture damage, so I don't think it's an ideal choice for kitchens.

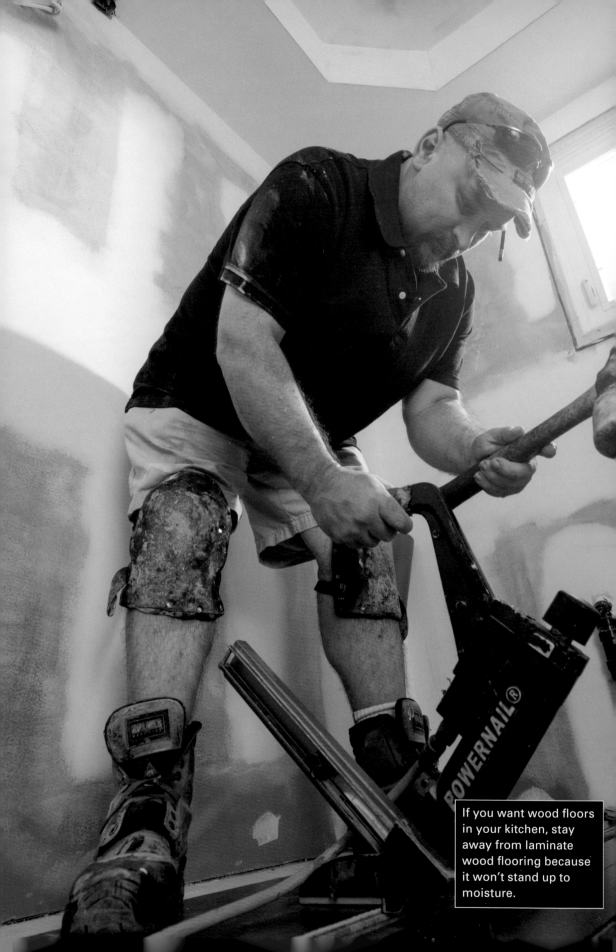

If you want wood floors in your kitchen, stay away from laminate wood flooring because it won't stand up to moisture.

Linoleum

Grandma's favorite flooring is back because it's eco-friendly. It's made of renewable resources including cork powder, linseed oil, rosin, and pigments (for color). It's relatively scuff-resistant, flexible, and it does not burn easily or emit harmful pollutants. Though there's some nice linoleum out there and it's available in a wide range of colors and patterns, some people don't like the look—so consider that for resale value. I don't recommend either linoleum or vinyl. Both are installed using mastic, which is a type of glue that attracts mold. Why not spend a little more money to get something that looks nicer and lasts longer?

Vinyl

Vinyl comes in many styles and colors, but it's best known as the flooring of choice for homeowners trying to save money. It's resilient, which means it's comfortable to walk or stand on, whether applied in sheets or peel-and-stick tiles. You get what you pay for, but even top-of-the-line vinyl flooring will show signs of wear. Vinyl and linoleum should both be installed over mahogany plywood, because it's the smoothest plywood available. But I still don't recommend vinyl in the kitchen: the glue used to install it is going to attract mold, the vinyl itself can shrink, and the only cure for shabby vinyl flooring is total replacement.

Concrete

The industrial loft look has led some homeowners to consider concrete. On the plus side, concrete works really well with radiant in-floor heating and you can make it unique with a variety of color tints or acid etchings. However, it's hard on the feet and prone to staining. Concrete isn't usually an option when you're renovating an existing home: it requires a minimal thickness to make sure the floor won't crack or crumble, which requires extremely strong joists to support the additional weight.

DaroTopp

On several recent projects, I've used an alternative to concrete that's relatively new to North America; it is called DaroTopp. It's a self-leveling synthetic topping (it's made of gravel, sand, water, and a binder) that's delivered by truck and poured in place. It's three times more durable and up to 18% lighter than concrete, and it can be poured right over the subfloor. Like concrete, it's great for covering in-floor heating systems, or you can install flooring over it. I'd recommend it over

concrete if you want the look and if your contractor ensures your house can handle the weight; but it wouldn't be my first choice in a kitchen.

Why would I want to cantilever my kitchen bump-out?

The only reason really would be to avoid excavating down to the footings—which you'd have to do with a full addition, even if it's just a small bump-out. A cantilevered bump-out will give you the extra floor space, but the structure remains above grade. Instead of being supported by its own foundation like the rest of your house, the bump-out is supported by the floor joists, which are tied into the existing floor structure.

My contractor says that regular drywall and greenboard are fine in my bathroom and they're code. Why do you use cement board?

You've probably heard me call drywall the "cover-up" in a home. Sure, it looks clean and finished, but it can hide or create problems unless you choose the right boards for the job. If you put up regular drywall in a moist, humid bathroom, you're asking for trouble with mold.

I'd say mold is a problem in almost every home. It thrives in dark, warm, humid conditions, where the spores feast on organic materials like wood, cotton, and the paper covering on standard drywall. The most common place I find it is behind the tile surrounding a tub or shower, because mold loves moisture. If you've got moisture or humidity, poor circulation, and a suitable surface, you've got a mold feast.

To keep your bathroom from becoming a breeding ground, you've got to understand drywall. Regular drywall is made by compressing wet gypsum, which is a mineral known as calcium sulfate, between two layers of heavy paper. Virtually every home built today in North America has walls covered with ½-inch regular drywall, but you'll never see me using it in damp environments like basements or bathrooms. Gypsum holds moisture when it gets wet. If it stays wet, it crumbles. Plus, the paper covering provides a picnic for mold spores.

Then there's greenboard drywall, which has caused a lot of confusion. For years, bathrooms and kitchens— anywhere you'd find moisture— were built with this drywall with its distinctive green color. Greenboard has a water-resistant green paper covering, so it meets minimum building code requirements as a

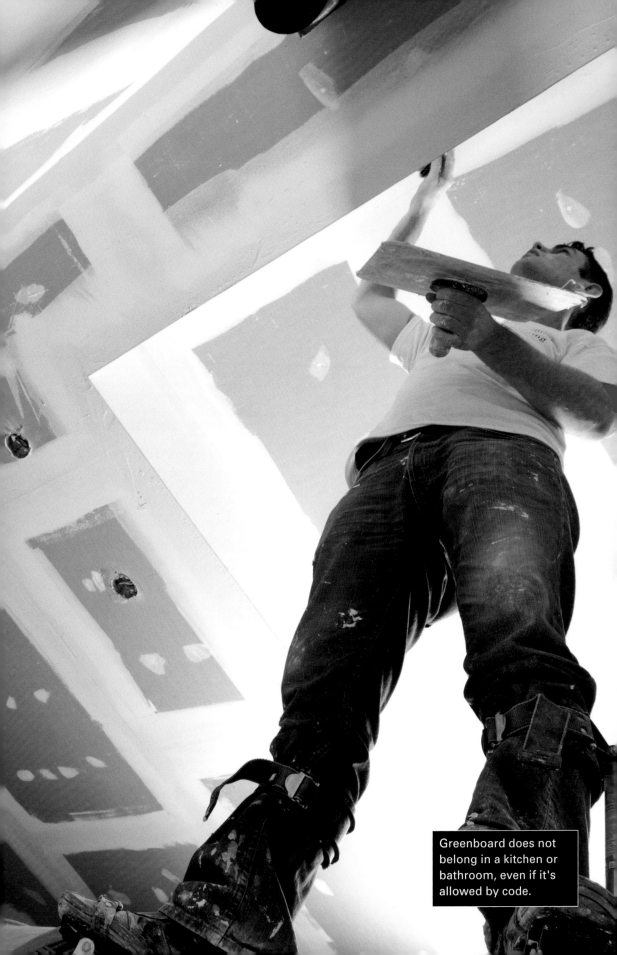

Greenboard does not belong in a kitchen or bathroom, even if it's allowed by code.

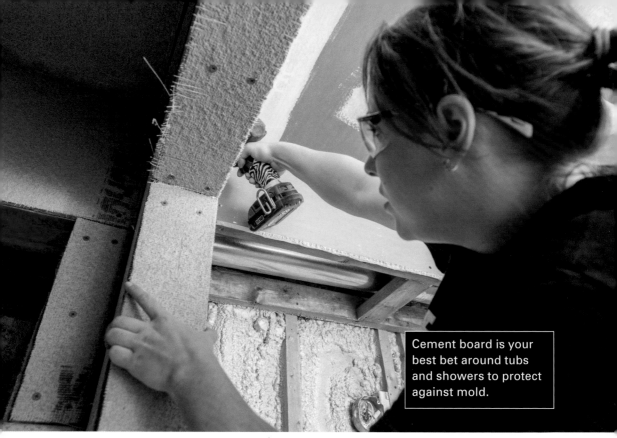

Cement board is your best bet around tubs and showers to protect against mold.

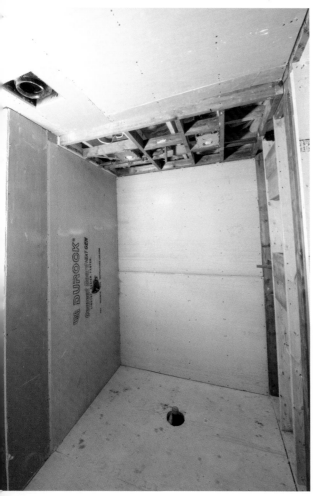

backer for ceramic tiles and other nonabsorbent finish material. It cannot be used in areas with direct exposure to water or continuous high humidity, such as bathtub and shower locations, unless completely protected with a water-resistive barrier. This is another time when you don't want to settle for minimum code. It may be water-resistant, but it's nowhere near waterproof or mold-proof. It's still paper and gypsum, which means trouble. Like any drywall, if it gets wet—think about all the splashing and humidity in a bathroom even outside the shower/tub area—mold will take over. You don't want that.

Comparing Drywall and Cement Board

Drywall	Materials	Water-Resistant?	Waterproof?	Mold-Proof?
Standard drywall	Gypsum, paper	No	No	No
Greenboard	Gypsum, water-resistant paper	Yes	No	No
Fiberglass-faced drywall (a.k.a. paperless drywall)	Gypsum, fiberglass fabric	Yes	No	No
Cement board	Cement, fiberglass fabric	Yes	No, but highly water-resistant	Yes

The only backer board I'd ever install around showers and tubs isn't drywall at all, and it isn't made of gypsum or paper—it's made of cement. Cement board is covered with sheets of fiberglass fabric so it's highly water-resistant. It's harder than drywall and strong enough to support tiles. The cement interior dries more rapidly than gypsum, and since it's paperless, there's no food supply for mold.

For the rest of the bathroom walls—the ones that won't be sprayed by constant water—I recommend paperless drywall. Instead of paper, it's faced with fiberglass, which gives it a rougher surface. If you want a nice smooth finish, you'll need to ask your contractor to apply a skim coat before priming and painting. This stuff needs a real pro to handle installation because it requires more skill to hide nail holes and seams. In bright light, you'll be able to see a shoddy job.

Even with cement backer board, I won't tile a shower without Kerdi, an orange waterproof membrane from Schluter Systems. It goes down before the tiles to help make a shower area watertight. You can read more about it on page 145.

What is the very low faucet I've seen in some of the showers you've built in Canada?

This is the funniest question I get! In Canada, when you have a shower with no tub, it's common to have a "toe-tester" faucet. It's so you can test the water temperature before you step into the shower and either scald yourself or freeze! I keep hearing from US fans that you don't have them down there, but I'm not sure why they're not used.

My bathroom fan is currently vented into the small attic space above the ceiling. There is a separate outside vent from this space to the outside. Is this enough ventilation for a bathroom?

Ventilation is critically important in a bathroom, and your setup is not enough. Minimum code in most regions says every bathroom requires at least an operable window or an exhaust fan to remove humid air. I'd rather see a bathroom with both (of course, it's not possible to have a window if the bathroom has no exterior walls). The next thing you must make sure of is that the exhaust fan vents to the outdoors, period. Otherwise, it will cause serious problems with condensation, moisture, and mold. I've seen the damage that comes from

The "toe-tester" faucet. Only in Canada?

What I Like to See:
A Panasonic fan properly vented outside.

How Long Should You Run a Bathroom Fan?

Most people don't have a clue how long it takes a fan to remove all that moist air you're creating every time you have a shower. They towel off, brush their teeth or shave, and flip off the fan when they leave the bathroom. I've heard experts say the exhaust fan needs to run for at least 20 minutes after you've finished your shower, but I recommend 30 minutes just to be safe. And make sure you crack the door or a window open while the fan runs. If the bathroom is sealed, it restricts airflow and your fan can't push warm air outside. Installing a timer makes it easier. This preventive measure helps control moisture and can add years to the life of your bathroom.

ventilation fans releasing warm, moist air into attics, walls, ceilings, or roof soffits. It causes rot that can destroy your home's structure.

Most people don't realize how important it is to get the best exhaust fan. Yes, it removes steam and odors, but it also has to exhaust contaminants in

the air from the rest of the house. This might include off-gases from building materials and furniture, sloughed-off skin, waste from dust mites, mold, and other contaminants. Minimum code states that a fan that pulls 50 cubic feet of air per minute (cfm) intermittently (with a switch) or runs continuously at 20 cfm, is acceptable. I'll tell you right now, that is just inadequate. It pushes air around without pulling it out. You need to buy a fan that will do the job, like those in the Panasonic series, which run from 50 to 100 cfm.

I keep getting mold buildup in the corners of my shower, no matter how many times a week I clean it. How do I get rid of the mold? Could this mean there is mold behind the tiles and on the wall itself?

The most common place you'll find mold in a bathroom is behind the tile around the tub or shower. You might be looking at moldy walls, or you might just have a problem with surface mold. Either way, your bathroom is telling me you don't have enough ventilation. Is your bathroom exhaust fan working properly? If you put a piece of toilet paper against it while it's running, does the paper stay in place or does it drift away? If the paper falls, it could

be a sign that it's not powerful enough to extract the humid air you're creating every time someone takes a shower.

If you don't have a fan, you need one. It's not a big job to install one, but make sure it's properly vented to the exterior of your home. Venting anywhere else is unsafe and just plain wrong. I've seen the rot that happens when people take shortcuts and discharge the air into a crawl space or the attic or between walls: you'll have a much more serious mold problem in a very short time.

We'd like a spa bathroom but we've heard you don't recommend saunas in a house. Why not?

You heard right—I never like steam showers, steam rooms, hot tubs, or saunas inside a home. Getting a sauna means you're creating a ton of additional water vapor within your home—more than most houses can handle. When you've got that much extra water vapor within the envelope of your home, you're asking for trouble with mold. Don't put your house at risk at all: build your sauna outdoors.

Building a spa properly requires so many special considerations—I rarely see it done right. Many home inspectors won't even look at saunas and steam rooms, and this is one case where I don't blame them: there's no

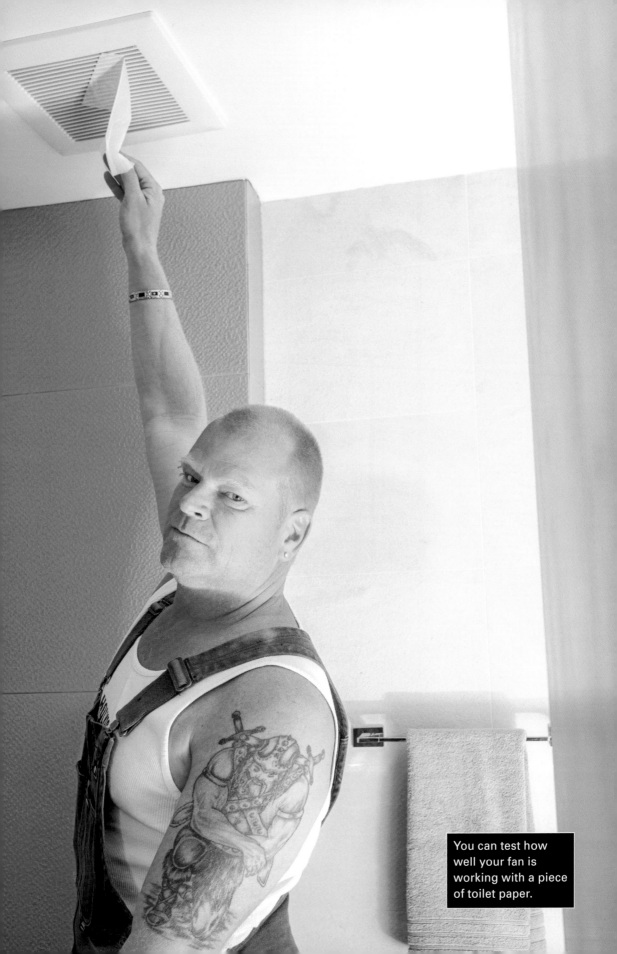

You can test how well your fan is working with a piece of toilet paper.

A sauna belongs outside, not in your bathroom. You can still have "spa" bathroom features like glass shower doors.

way to give them a clean bill of health. I won't be surprised if, in a few years, we see a massive breakdown of these home spas, which will develop extreme problems with moisture and mold.

If you still insist on a spa, make sure you hire a qualified plumber and contractor. The room needs to be completely waterproof, which means using the appropriate membranes for waterproofing, using cement board (not drywall or greenboard) under your tile, and going overboard on ventilation and an extraction fan. And don't add a spa because you expect it to add value to your home before selling: most buyers will want to get rid of it.

What does the orange backer membrane do under tiles and around showers?

Tiling the tub and shower areas properly is probably the number one thing you can do to prevent water damage. You've got to make them watertight. To do that, you need materials that will stand up to a steady blast of moist air without attracting mold, because mold leads to rot. Many people don't realize that many tiles are not waterproof, and neither is grout. That's where the orange membrane comes in. Here's my blueprint for a watertight bathroom:

First, the walls around the tub, shower, and sink must be cement backer board instead of gypsum, which is too soft to support the weight of tile. Cement board is dense and strong because it's made of the same material as the foundation of your home: concrete. It's faced with fiberglass instead of paper, so if it gets damp, it won't crumble or provide a feast for mold (you can read more about why I recommend it on pages 136–139).

Next, I install a Kerdi waterproof system from Schluter Systems, which I think is the best product on the market. Kerdi is an orange waterproofing membrane made from polyethylene covered on both sides by a fleece. Kerdi is nonporous, so it's completely watertight and it separates the tile from the wall and makes it pretty much impossible for moisture to get inside the wall. The system works so well because you can mold and overlap the odd-shaped sections of a shower enclosure—like the threshold and the sloped base— to interlock and fit perfectly. I use a modified thinset mortar to put up the membrane—polymers are added to improve the strength of the bond.

On top of the Kerdi, you need another layer of thinset. It would be nice to get that good, strong adhesion

1

2

3

4

5

What I Like to See: Kerdi on the walls and Ditra on the floor—a complete system to create a waterproof membrane in any wet room.

with modified thinset, but you can't apply it between the Kerdi and the tile because it needs to air dry. Since tile and the waterproof membrane don't breathe (which means no airflow), the thinset would take forever to dry and form that hard bond. So here we use the unmodified thinset, which is more like sandy cement. When it's dry, we apply standard grout, then tiles.

On floors, you need to prep the subfloor and make it watertight before tiling. If the substrate is ⅝-inch oriented strand board, then you need at least another ⅝ inch on top. Again, you want a bathroom floor to be as waterproof as possible, so I'd suggest concrete-based boards instead of plywood (since mold likes wood but not concrete). I like to set them into the subfloor with thinset, then screws.

Before the tiles go down, we put down another membrane. My pick is Ditra, another great product from Schluter Systems. It's an orange polyethylene material with a waffled surface. Again, it helps with waterproofing and, in this case, it actually protects your tiles because it allows a little bit of flex or movement under the finished floor. It basically cushions the tiles and grout so they don't crack. Put down any tile on top and you shouldn't get mold.

Using both of these systems will add about $2,000 to your costs. The extra investment is worth every penny because you know your bathroom will last.

What kind of grout should I use around my bathtub?

Grout is confusing. I often get asked about epoxy grout for tile walls and floors because people think it's a way to make tiles watertight. I always say that you don't need epoxy grout if everything is watertight behind the tiles. Stick to standard grout.

The other thing people do is turn to epoxy grout as a quick fix. That tells me people have a problem with water behind the tiles and they're trying to keep more from going in. In that case, removing old grout and using epoxy is actually going to make the problem worse by trapping the moisture problem behind the tile instead of fixing it. Instead of epoxy, make it right: start from the beginning, rip everything out, and do the bathroom properly with cement board and Kerdi on the walls or Ditra on the floor before tiling with regular grout.

Now, I bet you're also wondering what's the best way to seal your grout. Maybe you noticed that the grout in a fairly new tile floor tile looks dirty

in all the high-traffic areas. You want an easy fix to make it look clean again without all that scrubbing. You might be thinking you should have sealed the grout at the start. I'm not surprised there's so much confusion about sealing. The phone book is filled with guys offering their services to seal or color your grout.

I never recommend sealing grout. It's porous, and it will absorb liquid spills. Light grout will show dirt in a busy bathroom—that's something you can't avoid. In my opinion, grout is one of the materials in your house that's supposed to breathe. If air can flow through it, it allows any moisture that sneaks behind your tile (it will happen, trust me) to evaporate and escape. If you seal the grout and you've got sealed or nonporous tiles, that water has nowhere to go.

Now, sealing tiles is a whole other issue. Depending on what your tiles are made of—most natural stone is porous—you may need to seal them. This has to be done *before* the tiles are grouted. Otherwise, the grout will absorb into the tile and make it look cloudy. If grout penetrates the pores of your tile, you can't fix that.

If you're tired of grubby-looking grout, all you need is elbow grease. Carefully chisel it out—I won't lie, it's a pain—and replace it with a darker-colored grout that won't show the dirt.

Does it matter where on the ceiling a bathroom fan is installed? Can it be on a wall?

After waterproofing a bathroom, the next critical step is installing a top-of-the-line exhaust fan to remove all the water vapor that lingers after every shower. Ideally, you want the fan as high up as you can get it, since warm, moist air is pushed up. That's why mounting it on the ceiling makes the most sense. Just make sure you get one strong enough to extract the air efficiently, and that it vents directly to the exterior.

Why does my toilet shift and lean to one side when I sit on it?

A toilet that rocks can mean trouble. You might have had a long-term leak, which has rotted some of the structure of the floor under the toilet. If your floors are rotting, you never know when you may sit down on the john and end up with a mess!

Don't be tempted to caulk around the toilet in an attempt to keep it in place or stop the leaking. If there's a leak, you need to fix it, not stick a Band-Aid on it. You and I both know the water

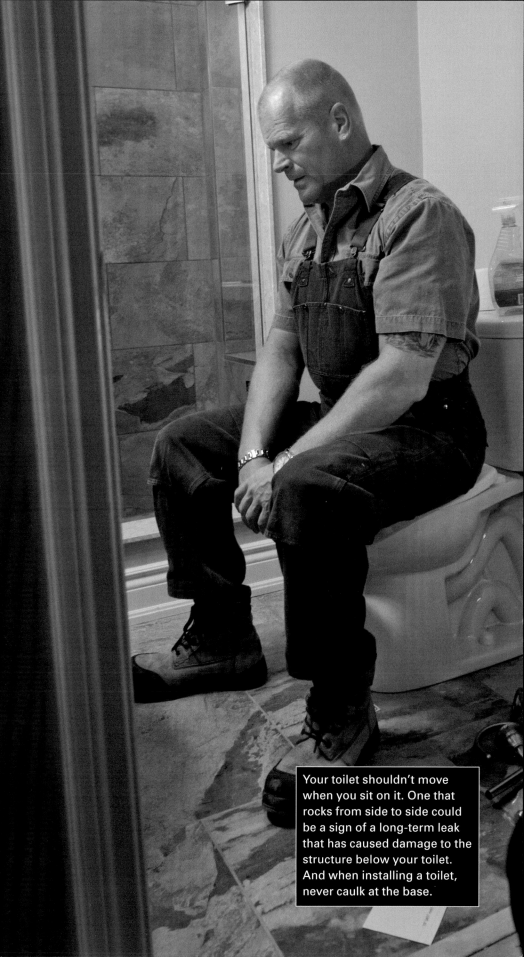

Your toilet shouldn't move when you sit on it. One that rocks from side to side could be a sign of a long-term leak that has caused damage to the structure below your toilet. And when installing a toilet, never caulk at the base.

will continue to leak and damage your floors—only now, it will be hidden. Get a plumber in to take a look at the toilet. Once the toilet is taken care of, you need to have the damaged floors torn up and rebuilt.

And next time you think you've got a leak, don't ignore it—have it fixed. Minor leaks can cause big problems with mold and rot.

My kitchen drain knocks when I pour water down it—even worse with hot or boiling water. What causes this? Is it a problem?

Your drain may be knocking because the drainpipe wasn't properly strapped and secured. Drainpipes are plastic, so they expand when hot water goes through them. Sometimes air gets trapped in the pipes. When the pressure changes in the pipes, it can cause water to suddenly rush in or stop—that's when you hear the banging. It's usually not a problem other than the noise, but it could cause the pipe to crack at a weak point, like at a joint or existing small crack. I'd recommend calling in a licensed plumber to have a look.

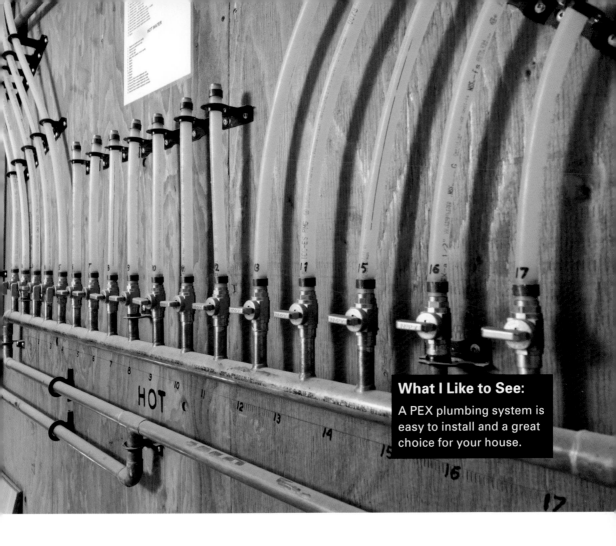

What I Like to See:
A PEX plumbing system is easy to install and a great choice for your house.

Heating, Ventilation, Cooling, and Insulation

Your HVAC system is like the lungs of your home. We're talking about heating, ventilation, and air conditioning. We can't see the system, we don't know if it's clean, we don't know if it's working right until something goes wrong. If you buy a house, should you bring in a specialist to do a test and troubleshoot the HVAC? I say yes.

Over the years, people change a house and don't always address the HVAC. I've heard home inspectors tell homeowners it's time to change their furnace—it's 25 years old—and people just pick up the phone, call a company, and put in a new furnace. But they don't understand: they need to check if there is anything else wrong—for example, with the ductwork. There are companies that can do testing with cameras. They run a scope

camera through all the ductwork and see whether or not the ducts are clean, how much air movement there is, and how much air loss there is from the furnace to each and every register throughout the house.

Understanding the lungs of your home is extremely important. Why? We want air movement. Your home is organic, like your body—it must breathe. Furnace filters can clean the air, but they need the right amount of air movement. What happens if you put in a furnace that is bigger than you need? This is a problem. Less than you need? This is a problem. Make sure you've got the right design for your system, whether or not you've renovated.

The cleaner you keep the lungs of your home, the cleaner your own lungs are going to be. That means cleaning the ductwork once a year. Clean the furnace once a year. Too many people wait till until there's a problem to call in an HVAC specialist. All of a sudden it's a million degrees outside and the air conditioning isn't working. Why don't you call in the spring when they're not busy? How about in the fall to check the furnace before winter? Call them at a busy time, and you're going to pay more money and you're going to wait.

Insulation is a subject on its own. Minimum code for insulation is called a thermal envelope, and it ranges from a minimum R-13 in the wall in warm climates, to an R-20 inside the wall plus an R-5 insulation sheathing over top in the coldest regions. *R* stands for *resistance*, which means the insulation acts as a buffer to keep heat from moving in any direction in the summer or winter. The vapor barrier's job is to stop air movement. We started at 2-mil, went to 4-mil, and now the required thickness for vapor barrier is 6-mil. Now I've got a lot of problems with minimum code for a vapor barrier. If you have a pinhole in the plastic—I mean one pinhole—over a year, that will give you the equivalent of one cup of moisture let into the wall assembly. Moisture is the first step towards mold.

How can we do insulation better? You've seen me use spray-foam insulation many times on the show. It used to be blue, now it's purple. Walltite Eco is the product I endorse for many reasons. It bonds everything together much like spraying a glue on all your walls. Most importantly, on top of that would be its R-value. You get more resistance to heat transfer per cubic inch of this stuff than any other type of insulation, so you can save on heating and cooling. Instead of a bare-minimum thermal envelope, closed-cell spray-foam insulation creates a thermal

break. Think of a cooler. If we lived in a cooler, we could heat it with a candle and cool it with an ice cube, in theory. That's what you're doing with spray-foam insulation—creating a cooler—and that's why it's worth the money.

How much insulation should I have in my attic, and what kind is best?

You're asking the right questions: every unfinished attic requires insulation. Not only will it make your home more comfortable and more energy efficient, it will also save you money on heating and cooling.

The point of insulating the attic is not to keep the attic warm, it's to keep the heat inside the rest of the house from escaping into the attic and out through the roof. The attic must also be completely sealed off from the rest of the living space. Depending on the insulation you use, the insulation itself can provide the seal, or you'll need a vapor barrier (more on that below, where you can read about insulation options). You want to create what's called a thermal break between those two areas of the house—to separate the warm, moist air of the living zone from the cold air of the attic. (I say moist because even if your home feels dry, you are creating vapor through everyday activities such as breathing, showering, and cooking). If warm air from the house comes into

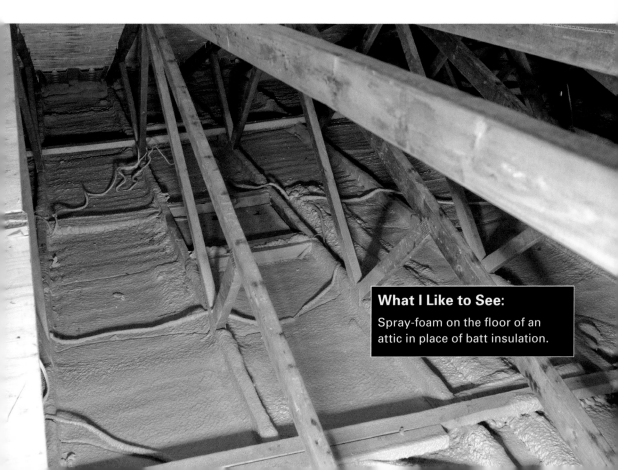

What I Like to See:
Spray-foam on the floor of an attic in place of batt insulation.

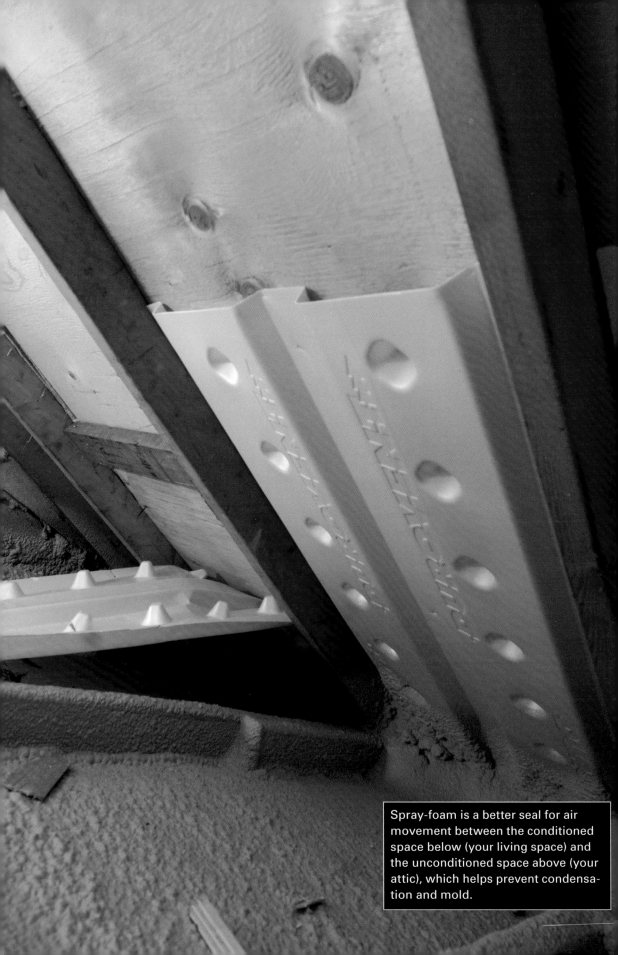

Spray-foam is a better seal for air movement between the conditioned space below (your living space) and the unconditioned space above (your attic), which helps prevent condensation and mold.

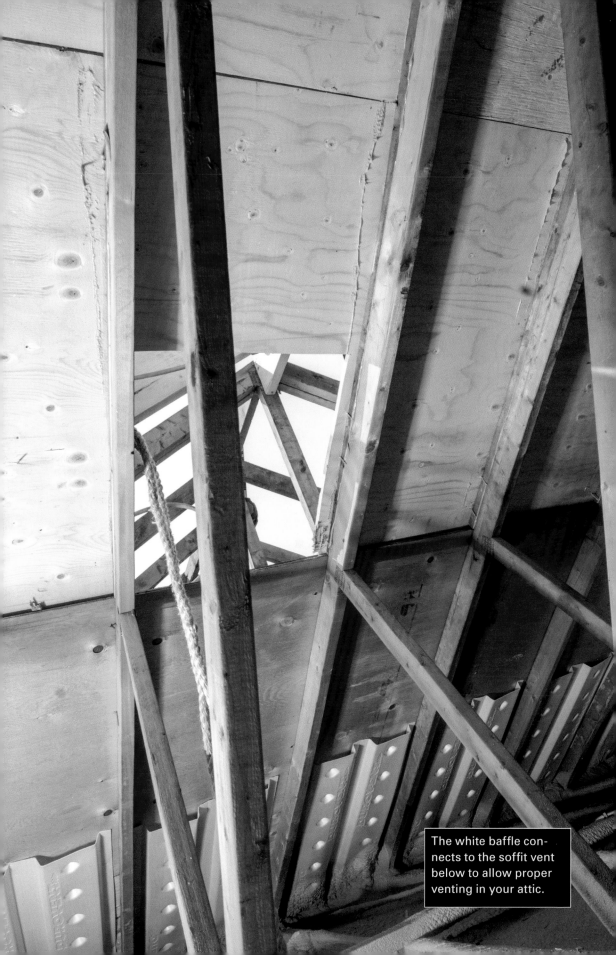

The white baffle connects to the soffit vent below to allow proper venting in your attic.

contact with cold attic air, you'll get condensation. As I've said many times, moisture is the enemy of just about every building material we use. After you've got moisture up there, next you'll get mold and rot. You don't want that.

Now, you could have the best insulation on the market professionally installed, but it won't perform if there's a lot of air leaking into the attic from the living space. That means insulated walls (and attic floors) have to be protected against drafts. Builders shield exterior walls from drafts in new homes by using an exterior house wrap such as Tyvek or Typar (I prefer Typar because it's thicker). That works as long as all the seams are properly taped.

While you want to keep drafts out, you also want to promote airflow in the attic, so you need good ventilation. This helps keep the air in the attic at the same temperature as the outdoors, which keeps your roof healthy and free from the condensation that rots wood

and shingles. You can read more about why you need attic vents, and which ones I recommend, on pages 28–29.

How much is enough?

Depending on the building code in your jurisdiction, an attic in a new home requires a minimum insulation of R-30 across the entire floor (the ceiling of the space below). As you probably guessed, your home's need for insulation depends on your climate: Florida homes require R-30 in the attic while those in Ontario need R-50 and houses in Montana need R-49. Some people say you can't have too much attic insulation, but that's not entirely true. Don't pile it up to the rafters: you need to leave room for airflow, and be sure not to block any attic vents. Without proper ventilation, you'll rot the roof.

Types of insulation

I recommend having an experienced pro install insulation. Do-it-yourselfers tend to pack batts in too

tightly, which reduces R-value. Or you might cover soffit vents with blown-in insulation, which is another no-no. If you want to see the payback, make sure it's done right.

Batt

Batt insulation is the most common insulation in new homes today. It's cheap, and it does a decent job for the price. It comes in blanket-like pieces that are placed between wall studs or floor joists. Most often it's made from recycled glass and sand or mineral wool. I've also used insulation made from recycled denim jeans that have been treated with borax. It's safe to touch (you have to wear protective gear to work with fiberglass or mineral wool), but it's hard to find since there aren't many manufacturers around, and big-box stores need to special-order it. It's also tougher to cut.

The tricky thing with batt insulation is it must be installed very carefully. It shouldn't be compressed, since the trapped air in the fiberglass or mineral wool is part of the insulation value. If the batt gets squeezed into a cavity, it loses R-value. Plus, since batts insulate between studs, and studs don't have the same insulation value, you'll end up with cold spots on the walls where the studs are.

Loose fill

Loose fill comes in fiberglass, mineral wool, and cellulose, all of which need to be applied by a professional. The installer has to blow it in evenly and to the right depth. I've lost track of the number of times I've seen loose-fill insulation that's been blown randomly into an attic, covering all the soffit vents and cutting off the ventilation in the attic. It's not just sloppy—it can lead to ice dams and deterioration of the roof. If you're doing loose fill in a cold-zone attic, make sure your installer uses batts adjacent to the soffit vents (but not covering them) and loose fill everywhere else. That way you'll keep air coming in through the soffit vents instead of clogging them with loose-fill insulation.

Rigid-board foam

Rigid-board foam insulation comes in thick boards made of polystyrene or polyisocyanurate. The blue boards provide more insulation value per inch than the white kind does. I use the blue ones all the time in basements. They're strong and they give that thermal break you need on basement floors and walls to eliminate the condensation that can lead to mold. The other thing I like about rigid insulation is it's not organic and it doesn't hold moisture, so it isn't a food source for mold.

Walltite Eco Spray-Foam Insulation

You may have seen me using blue (now purple) spray-foam insulation. That's Walltite Eco and I endorse it because it's the best spray-foam insulation out there. It improves energy efficiency, which means lower bills for you, it's mold-resistant, and it provides a barrier against air leaks, even in extreme climates. The newest formulation contains recycled plastic—renewable content—and the blowing agent won't deplete the ozone layer.

Walltite Eco is the first 2-pound closed-cell spray-foam insulation to have earned the EcoLogo certification—a widely recognized third-party audit endorsement and an environmental standard. It is also recognized by Greenguard (which gives the Green Seal) as being safe and healthy for children and schools, which means it won't degrade your indoor air quality. It's eco-friendly, it saves you energy, and it's easy on the air—a win-win-win in my books.

Comparing Insulation

Type	R-Value per Inch of Thickness	General Uses	Vapor Barrier Required?	Good to Know
Fiberglass batts and blankets	3.33	Attics, walls	Yes, with all seams taped well	If compressed, R-value is diminished
Mineral wool batts (Roxul)	2.30 to 3.87	Attics, walls	Yes, with all seams taped well	Excellent fire resistance
Rigid-board foam insulation	5	Below-grade walls and floors; foundation walls	No	Also prevents air movement
Polyurethane (closed-cell) spray-foam (Walltite Eco)	6	Almost any application	No	Also prevents air movement

Spray-foam

Spray-foam is the best insulation on the market. I like closed-cell spray-foam because it gives you the highest R-value per inch and it provides a vapor barrier, all in one layer. (Just make sure you check with your municipality: some inspectors still insist on using vapor barrier as well, though they shouldn't.) It covers everything, so there's no possibility of cold spots, voids, or settling. There is no air movement between outside and inside, so there's no possibility of condensation. Since it's not organic, it won't allow for mold growth.

There are two main kinds of spray-foam—polyicynene and polyurethane. Both absolutely have to be applied by a specialized installer. Some types of spray-foam insulation still use CFCs in production (which are harmful to the environment and your health) and they off-gas for a couple of days after application, but if they're allowed to dry fully between applications, they won't affect your indoor air quality. All spray-foam insulation is now being changed over to use eco-friendly propellants.

Some people cheap-out and use ½-pound spray-foam. Don't do it: ½-pound allows air movement. It means you'll save a couple of dollars, but it won't help you in the long run.

For my money, I'd recommend spraying the attic floor with 2-pound closed-cell polyurethane insulation. It's a little tough on the wallet at first, but you'll get it back in lower bills and higher comfort for as long as you live in that house.

I don't have enough insulation in the attic. Do I have to remove the pink fiberglass that's already up there and start fresh, or can I have more insulation blown in on top of the existing?

It's definitely a good idea to beef up insulation in your attic—most don't have enough. You don't have to remove what's there, just have cellulose blown in on top of the batts. Find out what the building code recommends in your region and then go higher. The more the merrier, right?

Well, not quite. As much as you want your attic insulated, you still want it to breathe, so be sure that all soffit vents or foam baffles are kept clear of insulation. Those vents are bringing in fresh air to keep the attic ventilated and cool (which you want, since the attic should be sealed off from the rest of the house). If you block those vents, you could get problems with heat and moisture, which could rot your roof's shingles or structure.

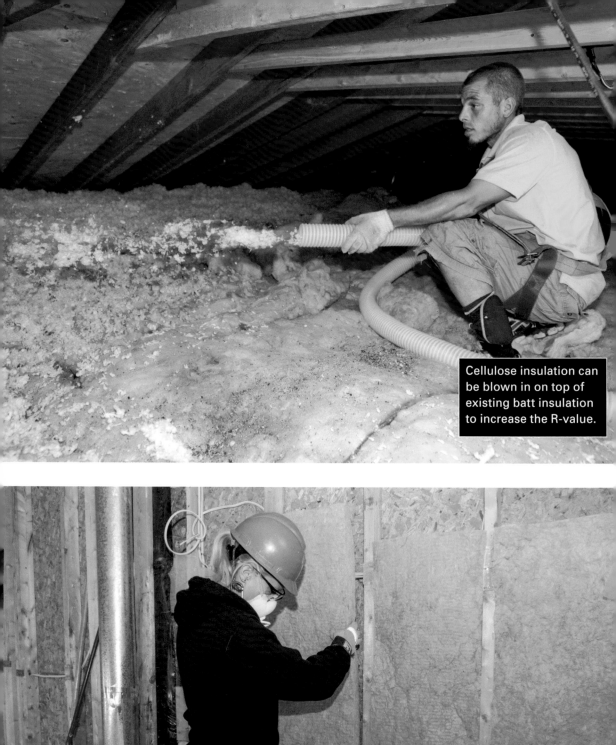

Cellulose insulation can be blown in on top of existing batt insulation to increase the R-value.

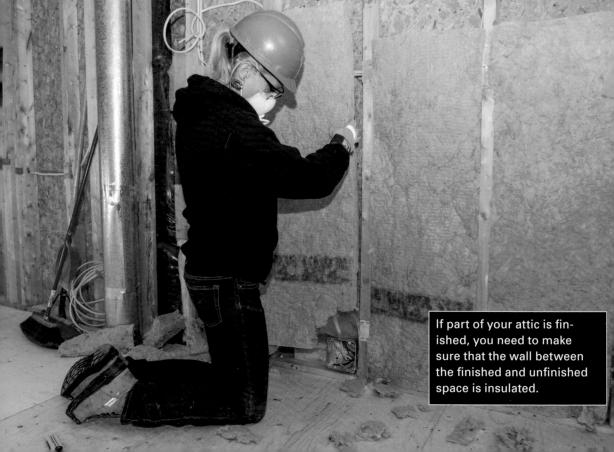

If part of your attic is finished, you need to make sure that the wall between the finished and unfinished space is insulated.

My home has propane heating, and every winter the room with the furnace always smells like propane. Should I be worried?

Yes. If you're smelling propane in your furnace room, it probably isn't exhausting properly. A little bit of a propane smell when the furnace first starts up isn't too alarming. But if the smell is strong and persistent, you need to get the furnace checked. Call an HVAC specialist to check the lines and make sure that it's exhausting the way it should.

Like any natural gas, the propane in your furnace produces trace amounts of carbon monoxide (CO). If CO is accumulating in your house, it can cause health problems or even death. The thing about carbon monoxide is it's odorless, so you won't even smell it. Everyone should have CO detectors in the house, but if you have fuel-fired appliances in your home or an attached garage, they are required.

How do you know if it is better to have separate HVAC systems for the first and second floors?

The typical house doesn't need two separate HVAC systems. Are you really asking how you can even out the heat in your home? Lots of people who live in older homes tell me their main floor feels warm enough in winter and comfortably cool in summer, but the bedrooms upstairs are freezing in January and stuffy in July. Some people have even insulated the attic, installed storm windows, caulked, and weather-stripped—nothing helps. The furnace runs constantly but it's never enough to warm up certain parts of the house.

A few ideas come to mind. How old is your furnace? Have an expert check to make sure the furnace is running at its full strength. Furnaces are like car engines and people: over time they start to lose their strength.

How has your house changed over the years—and how have your furnace and heating ducts kept pace? You could gut your house, install new ducts, and insulate like mad, but you'll still have heating problems if your furnace is too small, too large, or too old for your house. When forced-air gas heating systems become unbalanced, they heat unevenly and inefficiently.

Most people don't realize that a heating system was designed to heat the home *as it was built*. In newer homes, the original layout of ducts and the capacity of a furnace were carefully mapped out to create an evenly heated home using a heat-loss calculation. In older homes, it may have been just a "rule of thumb." As

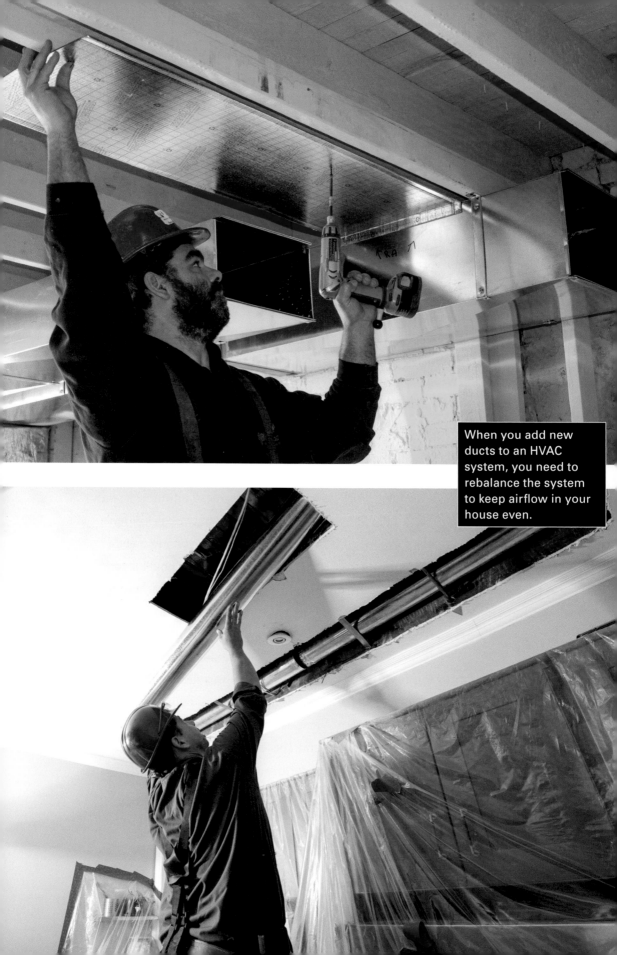

When you add new ducts to an HVAC system, you need to rebalance the system to keep airflow in your house even.

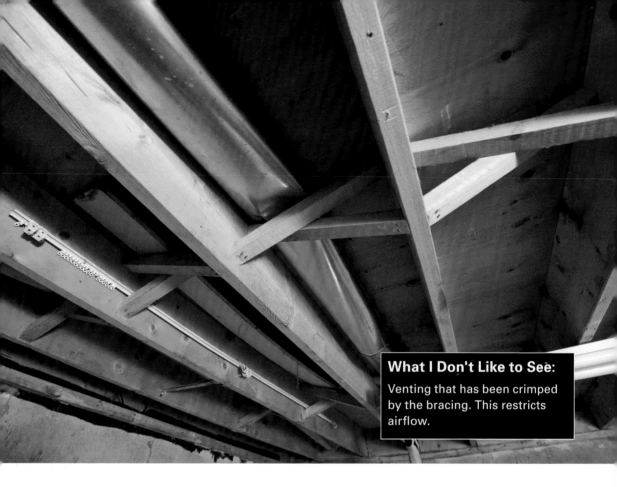

What I Don't Like to See:
Venting that has been crimped by the bracing. This restricts airflow.

we change our homes over time—move a wall here, bump the kitchen out there—we change the way the hot air is distributed, which throws the system out of whack.

If you look at homes built fifty years ago, they contained virtually no insulation. Energy was cheap back then, and huge furnaces pumped out lots of heat into oversized ductwork. As energy got more expensive, people began insulating to keep the heat in and the cold out. The problem is, they didn't necessarily change their furnace or ducts.

Let's look at a simple addition where the contractor did the right thing and insulated the new outside walls. That's the good news. The bad news is he ran a duct off an existing one to heat a new larger space. More bad news: the duct runs through an unheated crawl space and he didn't bother to insulate the duct. Then there's the air distribution, which not many contractors think to recalculate (it's actually the job of an HVAC specialist). So part of the house gets a little cooler while the new insulation keeps another part a bit warmer. Maybe a wall got moved, so the same ductwork that fed a 10 × 10 room is now

The Best Furnace Filters

I teamed up with 3M to make the best furnace filter on the market: Filtrete air filters. These filters catch 99.9% of contaminants in the air—mold, bacteria, pet dander, dust mites, and other allergens—so you and your kids are not cleaning the air with your lungs. They also allow better air movement to help your furnace and ventilation work better.

Can you change your filter too often? The answer is no. Too many people don't even realize that you need to change or check the furnace filter. A rule of thumb is to change the filter at least every three months. If I were you, I'd change it once a month because I'd rather have the filter clean the air than have my family's lungs doing the job.

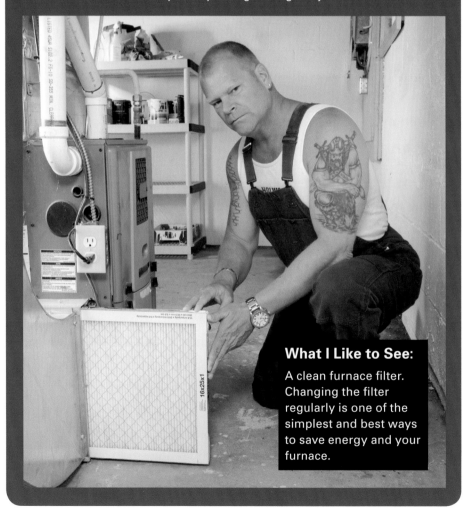

What I Like to See:

A clean furnace filter. Changing the filter regularly is one of the simplest and best ways to save energy and your furnace.

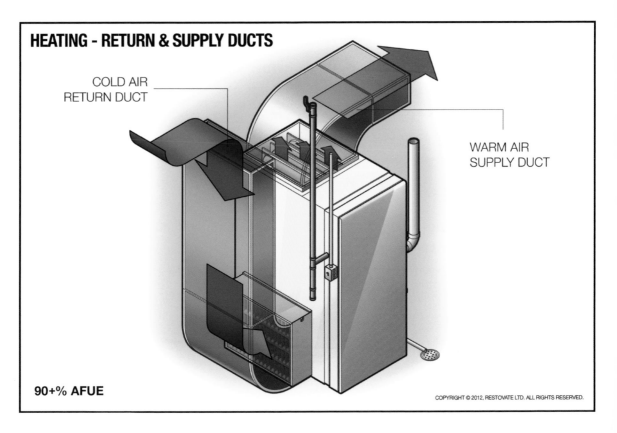

HEATING - RETURN & SUPPLY DUCTS

COLD AIR
RETURN DUCT

WARM AIR
SUPPLY DUCT

90+% AFUE

supplying a room that's 10 × 14. When the owners move in new furniture, they cover an "ugly" cold-air return—choking the furnace. (Don't forget that air movement is essential for heating to work: warm air travels from the furnace through ductwork. Cool air has to be returned to feed the furnace through the cold-air return.)

So, what can you do if you've never thought about how all these changes have affected your heating? Check to see if the cold-air return is blocked, if the ducts are insulated where needed, that the dampers are open and reachable. Make sure all ductwork joints are taped with foil tape—not the stuff sold as duct tape. Keep the furnace fan clean and oiled, change the filter regularly, and replace the belts as necessary.

If your heating still seems patchy, call an HVAC contractor, who can rebalance the system. You'll pay $400 to $1,000 for a heat-loss calculation, which gets you a set of drawings showing how much air is coming out of each duct, and your furnace's size and efficiency. They will also recommend what changes might be made to even out the heat: running new ducts or dampering existing

ducts or moving a register. It's an investment, and it could mean some construction and patching, but you'll end up with a more comfortable home that might even cost you less to heat.

Is spray-foam insulation worth the extra cost? What happens if you insulate with spray-foam and then need to open the wall up to run some wiring?

Spray-foam insulation is absolutely worth it. I recommend 2-pound closed-cell spray-foam insulation. It can be used just about anywhere in your home, it won't mold or leave you with cold spots, it provides the highest R-value per inch of any insulation, plus it gives you a bonus—a barrier that prevents air from leaking. No other product can do all that. You're right that spray-foam costs more up front, but you will get your payback through a more comfortable house and energy savings for the rest of your life. Think of it as a long-term investment.

As for your second question, ideally you'd run the wiring before you spray. But, yes, if you have to open up the wall to do repairs and you cut into spray-foam insulation, that will affect its integrity.

How often should I have the ducts cleaned?

In a house I worked on recently, I removed an old system of ducts. I nearly fell over when I pulled out the cold-air return. It was full of dust and dust mites—it was disgusting. It was like looking at the lungs of a two-packs-a-day smoker.

Think of the furnace as the beating heart of your home. Ducts are the arteries that carry heat to all parts of your home and return cold air back to the furnace to be reheated. If the ductwork is clogged with dust, dirt, and mites, you're blowing that crap throughout your home. The cleaner you keep your home, the cleaner your lungs are going to be.

It's inevitable that the ducts will get dirty over time. Dirt and dust collect. Insulation degrades and the particles settle. Most people don't need to have their ducts professionally cleaned every year, but households with pets or allergies may want it done that often. It's also important to have your ducts cleaned after you've had work done on your house. Renovating and repairs generate a lot of dust, and drywall dust is the worst.

People have asked me if duct cleaning is a rip-off. I don't think so at all. You don't need it done as

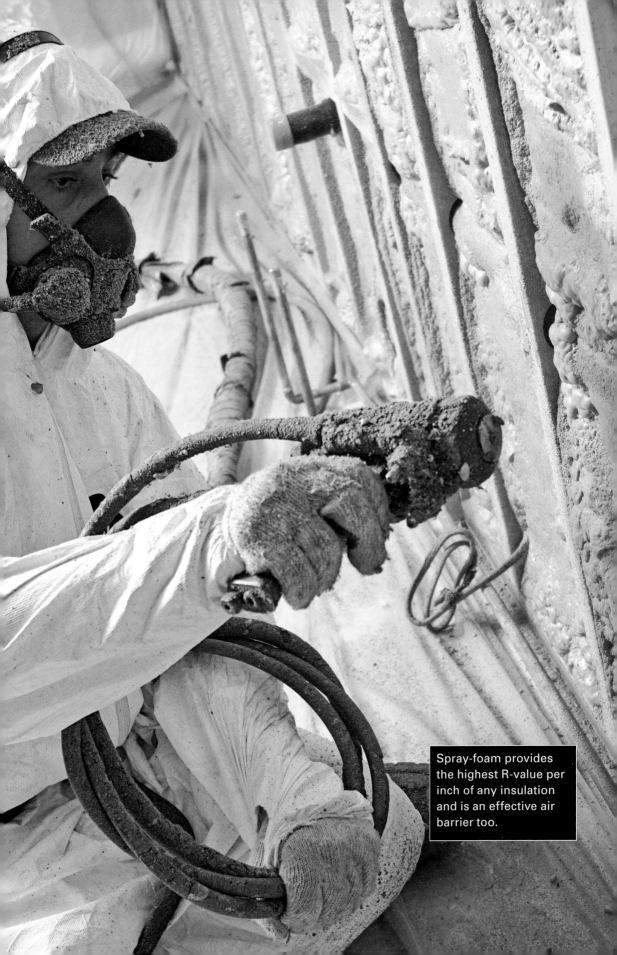

Spray-foam provides the highest R-value per inch of any insulation and is an effective air barrier too.

often as some companies will try to sell it to you (usually by calling in the middle of dinner), but I think it's very important to help with your indoor air quality. Get it done once a year if you have pets or allergies—and have your furnace cleaned that often too.

Make sure you hire a professional company that uses a camera and scope so you can see the ducts before and after. A shoddy cleaning job can damage your heating system and ductwork or pollute your indoor air by stirring up and releasing trapped dust and dirt. Duct cleaners are like any other contractors: there are good ones and bad ones. So protect yourself by checking them out before you hire.

If you've been unlucky and had a fire, you'll also need to clean your ducts. Otherwise, minute particles of smoke and debris will be released into your home, where you can breathe them in. Not good. If the smoke damage is really bad, the usual duct-vacuum-and-brush method may not be enough to get rid of the smoke. You might consider replacing the ductwork entirely if you can.

Why are the air returns in my newer home not ducted with metal—they just seem to run through the wall cavity?

Minimum code allows builders to run cold-air returns in wall cavities, allowing the air to pass between the drywall and studs. They don't have to use metal ducts. The problem is this allows the air to pick up way more dust from construction materials like drywall and insulation as time passes and these materials degrade.

We want our house to be warmer and less drafty. How can we prevent air leaks?

Some people think the answer to a warmer house is to insulate. The truth is that's just part of the deal—even a well-insulated home can lose 30% of its heat from cold drafts. The most common insulation found in homes today is fiberglass batt, which doesn't stop air leaks completely. If it's put up with no vapor barrier—which is likely in an older home—you'll have lots of air movement.

If you've got air leaks—and most homes do—you're wasting money on heating and cooling. Not only that, but your home's structure could be slowly degrading because of those leaks. Air leaks don't just cause cool drafts when you're sitting on

the couch watching TV; they allow condensation to form where warm air meets cool air, which can rot the structure of your home.

You want your home to be as airtight as a cooler: air movement should be minimized, with a thermal break to reduce the risk of condensation. If you seal your home's envelope as much as possible—we're talking about air and vapor barriers—you can save hundreds of dollars a year. I suggest you start at the top and work your way down.

Chimney

If you notice drafts near your chimney, firebox, flue, or furnace vents, you must use a special heat-rated product. Standard spray-foam and caulk are flammable.

Attic

Air can leak into the attic in lots of places. Check around vents and any access point between the living space and the attic, such as the attic hatch, plumbing stacks, and ceiling light fixtures that enter the attic from the rooms below (see more on lighting below). Use spray-foam and caulk to seal any gaps. Just remember that you don't want to seal between the attic and outside—you want to seal between the conditioned living space and the attic. The attic is always supposed to remain the same temperature as outside; so keep vents and soffits clear.

Garage

Anyone whose bedroom sits above an attached garage knows those big doors are a huge source of heat loss and air leaks. You need to get tube-shaped stripping for the bottoms of the doors, which forms a seal when it compresses against the garage floor. You can also get insulated garage doors, which are great if your garage is set up as a workshop.

Windows and doors

We all want windows because we love natural light. The only problem is heat loss: every window leaks heat because glass is a terrible insulator. Remember that the most important thing about windows isn't how much you spend on them; it's making sure they're properly installed—you'd be surprised how rare this is. To test this, put your hand (or a feather or a lit candle) around the casings of all window trim in your home. If you can feel a draft when the window is closed, the window was installed incorrectly.

Let's Talk About Caulk

I like to think of caulking as a windbreaker: it doesn't provide you with insulation like a down parka, but it does prevent cold air from seeping in.

I use caulk to seal gaps that are less than a ½-inch wide in places that don't move much, like window casings or cracks in siding. Make sure you use the right type: some caulk is flexible, paintable, or waterproof, and there are products engineered for interiors, exteriors, and low or high temperatures. The kind you'd use to seal around windows isn't the same stuff you use around your shower door. Read the labels to find out what type you need for your project, whether it's polyvinyl, latex, or silicone.

Caulking should be applied wherever two different materials touch—like your brick house and wood window frame. Sealing air leaks around your house may require several different types of caulking. You can steer towards the right kind by asking yourself two questions: Will it be used inside or outside? Will it be used in a wet area, like a bathroom or kitchen?

Latex caulking dries fast, cleans up with water, and can be painted. But it tends to shrink, harden, and break down when exposed to UV light.

Silicone caulking is more expensive, usually can't be painted, and needs to be cleaned up with mineral spirits, but it's waterproof and it will last for years. The main advantage of silicone is its resistance to UV light, which is very important if you will be using the caulk on the exterior of the house. The sun causes caulking to shrink and crack—there goes your air seal.

Wood, glass, metal, plastic, and masonry all expand and contract at different rates. Silicone caulking is more flexible than latex caulking, which means it will stretch more and adapt better to various materials. Most silicone caulks work both indoors and outdoors.

If you've got wide cracks—over ½ inch—you need to fill them in first so they can support the caulking. I like to fill large cracks with expanding foam since it reduces air leaks. For window installation, I use low-expansion foams that fill gaps without putting too much pressure on the window frame.

Insulating and getting a good air seal around a window is tricky. Many contractors and builders get it wrong by stuffing batt insulation around the jamb, then casing over the window, and then caulking on the outside. But batt insulation doesn't stop air.

Instead, installers should leave a small gap around the window—between ¼ inch and ½ inch. That allows enough room for spray-foam insulation. Unlike batt insulation, spray-foam stops airflow. I use low-expansion foam; high-expansion foam could expand too much and stop the window from working properly. I also extend the vapor barrier on the inside far enough that it can be sealed with Tuck Tape around the window to stop air movement on the inside. Now the window has room to move, but it's also properly insulated and there are no breaks in the protection wrapping the whole house. If you're going to the expense of replacing windows, I'd insist on using this method. If you're keeping the windows, try insulating around them with low-expansion foam—it's a lot cheaper than replacement windows.

For doors, insulate under the casings just like I described for windows. If that's not enough, have someone install good-quality weather stripping, or you can do it yourself.

Lights

Recessed lights could be causing air leaks if they're used in a room below the attic. You need lights that are contained in a box rated for insulation contact (IC). You can also get vapor barrier specifically for recessed lights. Use that around the box, then insulate.

Cracks

You may not realize it, but your home contains lots of small cracks that are leaking air. Think of any penetration into an outer wall for electrical outlets and switch plates, water, drains, cable jacks, phone lines, dryer vents, and plumbing stacks. Use low-expansion foam, caulk, or foam gaskets to keep the air from flowing freely in and out of your home.

How should I insulate the crawl space? It has a dirt floor and vents to the exterior, and the rooms above have very cold floors.

Some homes are built with a partial foundation that's only about 4 or 5 feet deep—just deep enough to go past the frost line but not deep enough to make a full-height basement. Instead, you get a crawl space. Most are cramped,

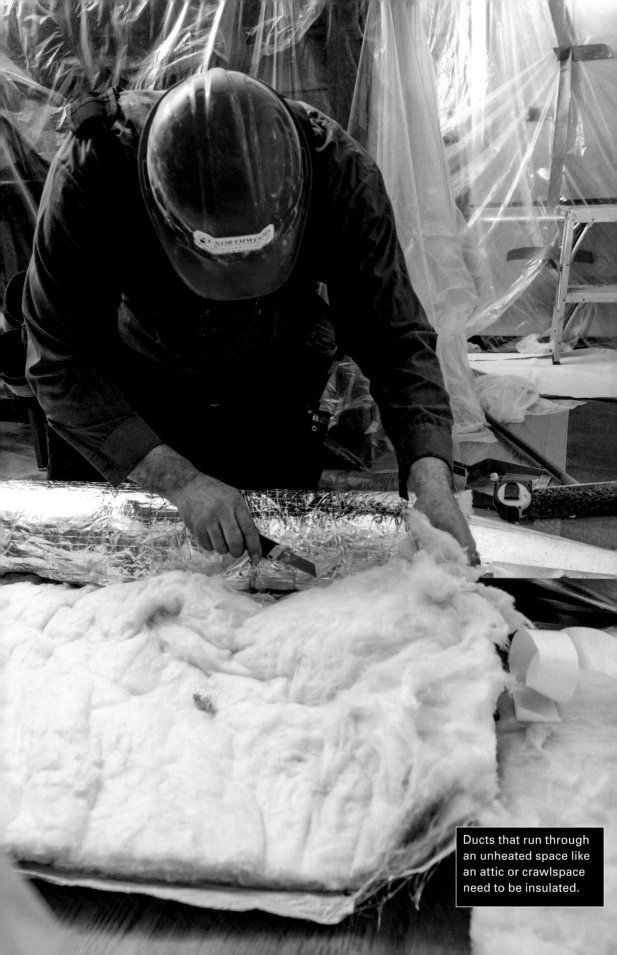

Ducts that run through an unheated space like an attic or crawlspace need to be insulated.

damp, dark, and cold, and you probably don't think about yours unless you have stuff stored down there. But the truth is your crawl space can make a big difference in your home's comfort and heating bills.

A warm crawl space will reduce the likelihood of your house "stacking." When cold air gets sucked in through the gaps in the bottom of your house (and believe me, every house has them), it pushes the warm air up, which reduces the effectiveness of your heating. We say hot air rises, but what really happens is that denser cold air pushes the lighter warm air up to the ceiling, to the second floor, into the attic, and out the roof, if it can. And that warm air is replaced with cold air, which isn't good.

That's why it can be tough to heat a house built over an uninsulated crawl space. Where I live in the Great Lakes area of Canada, I'd tell people to steer clear of such homes, but I know that is not always possible. In that case, you have two choices.

The best way to deal with a cold crawl space is to make it part of the warm side of the house. That means closing off the venting, insulating the foundation walls—preferably on the inside—and supplying some heat. You'll also want to put down a sheet of 20-mil polyethylene or vapor barrier on the crawl space floor. I'd recommend rigid foam insulation over gravel, which keeps the area from losing heat and stops ground moisture from coming up. You'll need a heating duct and a cold-air return to balance out the air exchange to and from that space. Depending on the size of the space, your furnace may not be big enough to supply adequate heat. Be sure to ask your HVAC specialist.

Now, I'll add one more caution. You might have all this work done to make the crawl space a warm zone and be disappointed, even though you'll be helping your heating system. I've never been in a room above a crawl space—no matter how well insulated—where the floor is not cold.

The other option is to make the crawl space into a *proper* cold zone so it doesn't siphon heat from the bottom of your house or invite unnecessary moisture problems. To do this, you need ventilation and insulation. Two vents on either side of the cold zone should be enough to ventilate. And you'll need insulation under the floor of your home to keep it as a warm zone.

Any ducts or plumbing pipes— including traps—running through the space should also be insulated. Otherwise, the cold crawl space will

cool the ducts and the air they carry. Make sure the plumbing traps also stay on the warm side of the insulation.

What does a heat recovery ventilator do? Is there anything I should do to maintain it?

A heat recovery ventilator (HRV) does three jobs: it brings in fresh air to supply the furnace; gets rid of moist, stale indoor air; and recovers heat from the outgoing air to preheat incoming air. HRVs are particularly important to control moisture in newer airtight homes. Airtight homes are more energy efficient because they lose and gain much less heat through air leaks. But the problem is they need a supply of fresh air and a way to move moisture out. Without an HRV, an airtight home has no air coming in and the home is at risk of creating negative pressure (also known as back-drafting; you can read more about this on pages 264–265). Plus, if an HRV fan is starved for air, it won't do the job you've installed it for. Finally, if an airtight home has no place for humidity to vent, you'll end up with mold and poor indoor air quality.

To maintain your HRV, change the filter every six to twelve months. Every couple of years get someone to check out the system, make sure it's balanced properly and that it's still running efficiently. And don't turn it off. Some homeowners will turn off the HRV system because of the noise. But if you turn it off, you won't get the full benefits of the system.

Why is flexible ductwork a problem in dryers and HVAC?

Old-school ribbed or flexible ducts are a bad idea. Flex hose can tear on nails or become compressed, kinked, or bent. It's also dangerous: in dryer exhaust ducts, lint can collect inside the ribbing and cause a fire.

The best exhaust paths are made using solid, smooth ducting. Ideally, you want metal ducting that vents directly to the outside in as short and straight a run as possible. That way, the fan will work efficiently. If the exhaust duct has to make a lot of turns or go a long distance, you may need a fan with a larger capacity. If ducts run through unheated spaces, make sure the ducts are insulated and securely sealed at every seam. Without this, the cold air surrounding the ductwork will cause condensation and leaks.

Clothes dryers have an exhaust duct that lets the warm, moist air and lint from the dryer escape to the outside of the home (never vent it into an attic or crawl space—guaranteed mold and damage). The problem is

HRV versus ERV

Whether you need a heat recovery ventilator (HRV) or an energy recovery ventilator (ERV) depends on where you live. Both systems deliver fresh air to a home's interior. They're used for homes that have minimal air movement between indoors and outdoors, so they need a ventilation system to pull fresh air from outside and exhaust stale air from inside.

These systems typically work by pulling stale air from the kitchen, bathrooms, and laundry room, while delivering fresh air to bedrooms and the living room. In both systems some of the heat from the warmer air is transferred to the cooler air as they pass each other. During winter, the cooler air comes from outside and the warmer air comes from inside the home. It's the opposite in the summer (warm air comes from outside and cold air from inside).

An ERV system does everything that an HRV does, but it also controls moisture. It can transfer some of the moisture in humid air to air that's drier. So in a humid environment, an ERV can transfer the moisture from the air that's coming into the home to the drier air that's going out. But if the outdoor air is drier than the air inside the home, an ERV system can actually increase the amount of moisture in the air coming in. That makes an ERV better than an HRV if you live in a humid environment. But if you live in an area where moisture isn't an issue, an HRV is good.

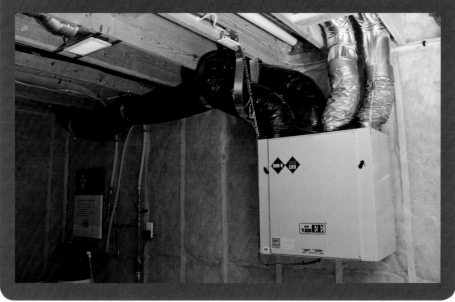

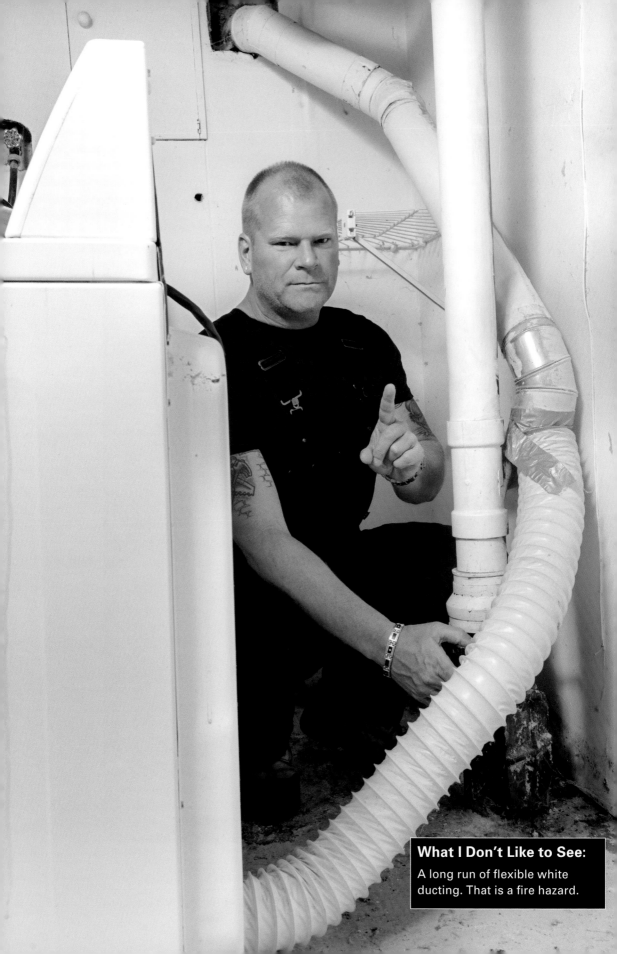

What I Don't Like to See:

A long run of flexible white ducting. That is a fire hazard.

the exhaust duct gets clogged. The level of clogging varies between types of dryers and manufacturers, and depends on how often the duct is cleaned. (You do clean your dryer exhaust duct, right? I recommend it at least once a year.) If you get a blockage, you've got a risky situation. When hot exhaust passes through a duct caked with all those bits of lint, it could end up triggering a house fire.

The other issue is lint gets past the dryer screen and gets caked on the inside of a dryer's exhaust and flex tubes. Fabric softeners, dryer sheets, and anti-static products can make the problem even worse. The lint buildup reduces the performance and efficiency of your dryer—which means you're paying more for it to work less effectively—and you're increasing the risk of a lint fire. Do yourself and your family a big favor and use smooth, rigid metal ducting. Don't connect it with screws because they poke through on the inside and catch lint.

Why should I have a secondary lint trap on the dryer vent?

Lint might not jump to mind when we think of serious household hazards, but it's up there. It doesn't present the same health risks as mold or asbestos but it can light up fast, making it a serious fire hazard. The more lint that accumulates in a dryer vent, the bigger the risk. That's why I like secondary lint traps: they minimize the risk of fire.

If your dryer isn't located next to an exterior wall, you should consider installing a secondary lint trap. The longer the ductwork between your dryer and the exterior, the harder your dryer's exhaust fan has to work to push the moisture out. If the fan isn't powerful enough, the moisture won't make it to the outside and the exhaust will get choked with lint that gets caught in the ductwork (even if it's smooth rigid metal ducting, which I recommend). A lint trap looks like a square box with a window on the front. It should be professionally installed and mounted on the wall or ceiling above your dryer. It's attached to the dryer's exhaust so it can filter the air and catch any airborne lint in the ductwork that wasn't caught by the dryer's lint screen. The less lint accumulation there is in the duct, the better your dryer performs.

Just remember to clean the lint trap at least once a month, plus swipe out the built-in dryer screen after every load. Even if you're cleaning the lint trap once a month, I'd also look through its window to make sure the filter isn't full.

What I Like to See:
Smooth metal dryer ducts with a secondary lint trap to help prevent fires.

Why do you tape the heating ducts? What is foil tape, and why not use duct tape?

One of the most overlooked places our homes lose energy is ductwork. Leaking ducts can cause you to lose up to 20% of your airflow. Remember, that's air you've paid to either heat or cool. You may be turning up the heat or the air conditioning to compensate, which means those losses are really adding up.

Leaky ducts also let air into your household HVAC system. If the air contains dust, microscopic particles, mold spores, and pollen, it will compromise your indoor air quality and your family's health.

If you had plumbing pipes leaking water, you'd be all over that repair. Leaking air doesn't seem to make people feel the same urgency, even though ducts can be leaking for years and draining your bank account.

There are lots of reasons ducts might start leaking in the first place. They can literally come apart at the seams from bad connections and careless workmanship. Insulated flexible ducting can tear on nails or become compressed, kinked, or bent. A contractor who's driving nails through walls or floors can unknowingly puncture ducts.

If your basement ceiling is open, I suggest you inspect the ductwork. You

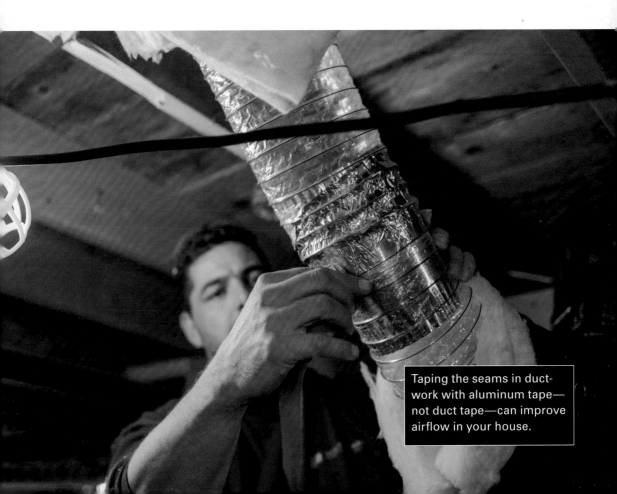

Taping the seams in ductwork with aluminum tape—not duct tape—can improve airflow in your house.

Don't Use Duct Tape on Ducts

I don't know why they call it duct tape because that fabric-based tape with a rubber adhesive should never, ever be used on air ducts. Testing has shown it can become brittle over time, which causes the seal to fail. Cheap duct tape can also burn and produce toxic smoke. What you want is aluminum foil tape, which isn't affected by moisture and provides a strong, long-lasting seal.

could also do this during a renovation, while walls and floors are open in other parts of the house. The major sources of heat loss include holes from nails and screws, and wherever there are joints and seams in the ductwork. If you can manage it, I recommend taping every duct joint or hole using foil tape, which is designed for HVAC systems. Don't use the stuff we all know as "duct tape"—it's good for lots of things, just not ducts; more on that above. You might be tempted to scrap the old ducts and get new ones, but I think it's always best to keep the original ductwork if you can: older forced-air systems use ducts of thicker-gauge metal.

I live in a semi-detached house and I often hear the sound from the neighbors through my walls. What's a cost-effective solution so I don't have to listen to their music?

If you don't share your neighbors' taste in music, or you don't want to hear

every time their toilet flushes, you've got a couple of options.

But before you do anything, remember that the most important job of the wall between you and your neighbor is to protect you from fire and smoke. Before you try to do anything about sound, make sure you're not messing around with fire protection. Fire and smoke can kill you while you sleep. Sound just keeps you from sleeping.

First, there's batt insulation specifically designed to muffle sound. I recommend Roxul Safe'n'Sound batt insulation. Tucked into floor joists or wall studs along with some dead air space, it does a great job of cutting down on sound transfer.

That said, it depends on what you're hearing through the walls. In general, sound comes in two frequencies. It's pretty easy to soundproof for the high frequencies, such as the sound of their budgie chirping; it's harder to block the

low frequencies. If you're living next to a wannabe drummer, you're out of luck: drums are low frequency, so insulation won't completely muffle the sound.

If you want to take soundproofing to the next level, there's a phenomenal drywall called QuietRock. It gives you the equivalent of eight layers of conventional drywall. Make sure your contractor uses hangers to separate and isolate the drywall from the framing.

I noticed the pink insulation in the attic is dirty. What does that mean?

If your fiberglass batt insulation looks dirty, that's a sure sign that you've got air leaking in and out of the house. It's common to find air movement in the attic and wherever exterior walls are penetrated by plumbing pipes or light fixtures. Batt insulation doesn't block air leaks completely; you need a vapor barrier for that, but they weren't installed in the past. When air moves through the insulation, the batts collect dust almost like an air filter.

The fix is to make sure your attic has plenty of insulation and good ventilation (you can find out more about attic vents on pages 28–29). But the most important thing is to try to eliminate air movement between the living space and the attic. Check the vapor barrier for leaks and seal them, or call a pro to install a vapor barrier. Seal around the attic hatch or around penetrations from plumbing or electrical. One thing you don't need to do is remove the dirty insulation—the grime won't affect its performance.

How should I insulate the attic? I have recessed lights in there and I know they are leaking hot air into the space.

I never allow recessed lights in the top floor of a house. The heat from those lights will leak into the attic, which is exactly what you *don't* want to happen.

Remember that an unfinished attic is supposed to be a cold zone that acts as a buffer between the great outdoors and the warm areas of the house. What happens when lightbulbs start warming up the air in the attic? When hot meets cold, you get condensation, which can cause water damage on the ceiling below. That kind of moisture makes a perfect breeding ground for mold. If you live in a cold part of the continent, heat loss can also melt the snow on your roof, which will then refreeze when the lights go off. Before you know it, you'll have an ice dam, which can damage your roof. Now do you see why I don't like recessed lights on upper floors?

First, let's deal with what you need to set up your attic properly. A cold-zone attic needs insulation, yes, but ventilation and vapor barrier are also critical. In fact, the most important thing is to seal off the attic from the rest of the living space below it. That means creating a thermal break on the attic floor: that will keep the warm air of the main house from mingling with the cold air of the attic. That will help you avoid those moisture problems I described.

The insulation I like to see in attics is closed-cell spray-foam on the attic floor, which is the surface right above the ceiling of the second story. That gives you that thermal break that keeps warm air away from cold air, which means you'll prevent heat transfer, heat loss, and condensation.

The next thing you have to look at are those recessed lights. A recessed light that goes into an attic needs to be IC-rated, which tells you it's safe to be in contact with insulation; they come in a canister. Your contractor should seal around each box with a vapor barrier sold specifically for recessed lights. Use that liner around the box, make sure it's sealed properly with Tuck Tape, and that will prevent air movement. Then you insulate around the sealed lights.

The vapor barrier liner is essential if you're using spray-foam insulation. Batt or blown-in insulation can safely touch an IC light box, but spray-foam can't. Even an IC-rated unit can't be embedded in foam. Since foam expands as it cures, and since it sprays out as a liquid, it will seep into any holes in the IC box. That's why your contractor will need to make sure there's clearance between the foam and the fixture, and why it's so important to install that liner around each one.

Why are all the heat vents located under windows?

Some people worry that if a vent is located under a window, all that warm or cool air is going right out the window. Actually, vents are deliberately placed there to help offset extreme temperatures. If that's the coldest spot in the room (or hottest, depending on the time of year), that's the area that needs to be kept conditioned. The warm air from the vent (or cool air, in the summer) is then circulated throughout the room.

If you've got a fairly big space (say 12 × 18 feet or larger) with only one vent under the window and the room feels cold in winter or sweltering in July, you may need another vent. Call in an HVAC specialist to have a look. He'll need to do a heat-loss calculation and look at the size of the supply duct to the room.

Can I put furniture in front of the cold-air return grilles?

I wish more people asked me this because I see it all the time. People move furniture around so they can have a prime view of the TV, and they end up moving a couch or a TV stand over a cold-air return. I guess they put their hand over the grille and don't feel any air blowing out, so they figure it's fine. What they don't realize is they're suffocating the HVAC system.

In a forced-air gas furnace, air is heated over a flame and then distributed by a fan through ductwork to heat the various rooms of the house. For the system to work, you need good air movement: warm air is blown from the furnace through the ductwork. Cool air has to be returned to feed your furnace through the cold-air return and separate ducts, and the furnace exhaust has to be vented safely to the outside.

You can't expect your furnace to heat or cool your home properly if you restrict airflow with a clogged furnace filter or if you block cold-air returns and heat registers. Keep all vents and grilles clear of obstructions—like furniture or carpets—to allow for proper ventilation and even heating or cooling.

Also remember to clean or vacuum the vents and grilles throughout the entire house. It's a minor job that has major benefits for your furnace.

Can I do my own spray-foam insulation? I've seen rental kits online.

Hey, you know I'm a fan of spray-foam insulation (read more on pages

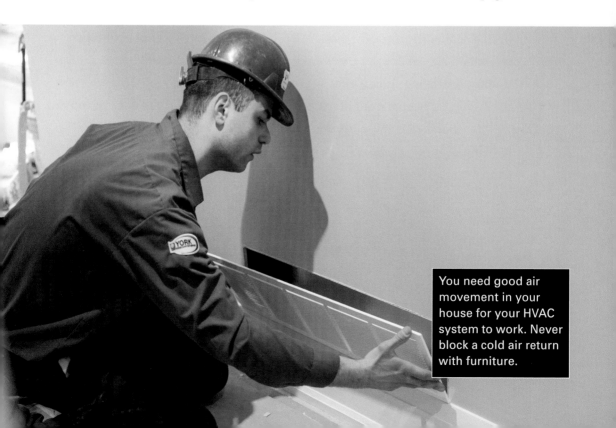

You need good air movement in your house for your HVAC system to work. Never block a cold air return with furniture.

160–161), but installing it is absolutely not a DIY project. The product needs to be applied by trained professionals, and they have to wear respirators and protective clothing—that should tell you it's not a job for a homeowner to take on. When we're doing spray-foam insulation for the show, we don't even allow the construction crew in the area since they're not qualified or protected. If a camera guy goes in to get shots, he must be wearing safety gear.

I know DIY kits will save you money, but a qualified pro will do the job right. If budget is a concern, know that you'll get your investment back over time because your energy bills will definitely shrink.

What is dry rot?

Ever catch a whiff of bad mushrooms? In an older home, especially, that smell might be a sign of dry rot. Dry rot is a timber-destroying fungus that sucks the structural strength out of wood.

The spores that cause dry rot are blowing around in the air. If these spores land on timber and find the right conditions, they germinate and produce fine strands of fungus. What conditions do they need? You guessed it: moisture. The strands form together and grow across the damp wood (or other materials like plaster, mortar, bricks, etc.). If the growth gets big enough, the fungus spreads and looks like a fleshy, orange-colored pancake. You can tell you've got a serious attack of dry rot when wood looks like it's been sprinkled with red dust—those are actually more spores produced by the pancake growth. Once the fungus gets established in there, dry rot leaves the wood dry and easy to crumble. Within months, the structural integrity of your home can be compromised.

You need to act fast if you suspect dry rot. The first step is to eliminate the source of water that created damp conditions in the first place, whether it's condensation, leaky plumbing, poorly installed gutters and downspouts, rainwater coming through gaps in windows and doors, or damaged shingles or flashing. The area needs to be well ventilated and dehumidified.

Next, you'll need to call an experienced mold remediation expert who can get rid of all the affected wood. Structural wood will be replaced with pressure-treated wood, and healthy timbers near the infection will be treated with a special preservative.

When you smell weird odors in your home, don't ignore them and don't cover them up with air freshener. They just might be telling you about a real physical danger behind the walls.

Is Vermiculite Insulation Dangerous?

A great insulator, vermiculite was once considered a naturally occurring miracle mineral. When the shiny flakes of this volcanic mineral are heated to a high temperature, they expand up to thirty times their original size. The expanded vermiculite is lightweight, fire-resistant, and odorless. It was manufactured into a loose insulation blown into attics and walls. In fact, from 1977 to the mid-1980s, the Canadian government offered a grant to people who installed vermiculite insulation in their homes.

From 1919 to 1990, a mine in Libby, Montana, mined more than 70% of the vermiculite used in insulation sold in North America. None of this would be a problem except for one thing: there was a deposit of asbestos at the mine too, so all that vermiculite is known to be or suspected of being contaminated with asbestos. As you've probably heard, asbestos has been linked to serious lung problems and even cancer.

If you have the old blown-in vermiculite, or suspect you do, you should assume it contains asbestos. Now don't panic: Health Canada and the Environmental Protection Agency both say that as long as you don't disturb it, asbestos won't harm you. Asbestos becomes a problem if it's disturbed, which can release fibers into the air and into people's lungs. People who get diseases from asbestos are usually exposed to it repeatedly or for long periods rather than occasionally, and the disease can take years to develop. Keep it sealed behind walls or isolated in the attic and it won't give you any trouble.

If you've got old vermiculite insulation and you're planning a renovation, you should call in a professional asbestos contractor to remove it or make sure it's safely handled during construction. Get more information from Health Canada (HealthyCanadians.gc.ca) or the Environmental Protection Agency (epa.gov).

If you had vermiculite insulation installed after asbestos was banned from use in insulation (in the '80s), it's perfectly safe.

cover the mastic with a layer of flooring that prevents air from getting to the moisture to dry it out. Like so many materials in our homes, concrete needs to breathe.

Don't believe the flooring manufacturers, either. They'll tell you to put down a 6-mil plastic sheet vapor barrier over the concrete so you can install whatever flooring you like, even oak. Another big mistake: moisture comes through the concrete, then gets trapped below the vapor barrier, where mold will grow. This is actually acceptable according to building code, but I don't think you should ever do this.

You can also ignore the people who recommend an epoxy-based product that you apply directly over the concrete to seal it. The epoxy fills in all the cracks and leaves you with a smooth finish, but I would never put a watertight sealer on a basement floor. You might as well go back to putting down plastic, since both will trap moisture. What if you end up with water pushing up against the epoxy from the floor? If enough pressure builds up behind the water, it can cause the sealant to fail. It's the same reason I don't recommend oil paint on concrete. In fact, I never like sealing concrete basement floors in any way.

What kind of flooring do you recommend in a basement?

If you've got a watertight basement, and you've created a thermal break on the floor, you can put down just about anything you want. My top picks are tile or laminate, but carpet is another option.

I'm a big fan of porcelain and ceramic tile in a basement because they're easy to clean, last forever, and you can warm it up by installing an in-floor hydronic or electric heating system.

My last choice would be carpet. I know a lot of people like it for comfort and warmth in a basement and I can't argue with that. My problem with most carpet is it off-gases chemical fumes into the air you breathe inside your house, which can make people sick (see more about off-gassing on pages 260–261). At the very least, get it professionally cleaned right after it's installed, especially if you have little kids who will be playing on it. This will help get rid of the fire retardant that's sprayed on all new carpeting—another chemical you don't want contaminating your air. And go with carpet tiles: you can replace sections easily when they get stained, and the vinyl backing keeps moisture from seeping in.

How to Finish a Basement Floor

Here's what I do to prevent moisture and condensation before I lay down flooring on a concrete basement floor. It's a combination of rigid foam insulation laid on top of the concrete, with plywood on top of that. It adds about 1⅝ inch of thickness on the floor before you put down flooring material, but most new homes have high enough ceilings to allow for that.

Step 1: Foam boards
Your contractor starts by putting down 1-inch rigid foam board. You can use pink board by Corning or blue board by Dow—both are great products. Don't glue them down because glue provides mold spores with a food source.

Step 2: Seal edges and joints
Next, the crew will apply low-expansion spray-foam along all exterior edges where the flooring meets the walls. Then they'll need to Tuck-tape every joint.

Step 3: Plywood
On top of the foam, you'll want ⅝-inch tongue-and-groove plywood. Screw this into the foam and the concrete floor with Tapcon screws, which are designed for concrete. They're expensive but they are the best screws for this job, and nothing else on the market compares.

Step 4: Flooring
Now you can finish with any flooring you want: carpet, tile, just about anything. You'll have a strong enough base to put down ceramic or porcelain, though I recommend using Ditra as well in those cases since it has a cushioning effect to protect the tile and grout from cracking.

WHY IT WORKS
My method solves the condensation problem. The foam is an insulator: it creates a thermal break between the constant temperature of the concrete floor and the ever-changing temperature of the air in the basement. The insulation between the two temperatures prevents condensation, and you know what that means: no mold.

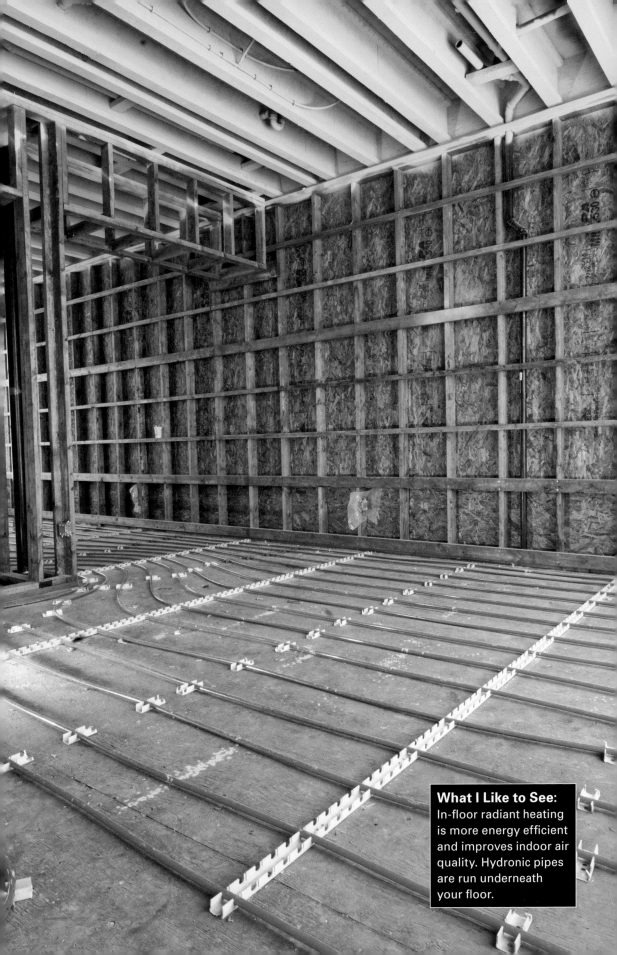

What I Like to See:
In-floor radiant heating is more energy efficient and improves indoor air quality. Hydronic pipes are run underneath your floor.

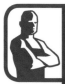

The Best Subfloor Under Carpet

It's important to put in a good subfloor if you're carpeting the basement, or it will smell musty. I like modular subfloor panel systems because they are specifically designed to protect against moisture and mold on concrete floors. Amvic's Amdry insulated subfloor is a good option: it has 2-inch-thick rigid EPS foam that is channeled to help drain moisture.

We have some water in our basement even if it hasn't been raining. How do we know if this is a foundation problem or a problem with the grading?

I like to say that the success or failure of a house has to do with one thing: how it handles water. That means rain, snow, condensation, and even the water table under the house. We can't live without water, but it can be a real pain. Water can cause rot and mold, endangering your health and destroying buildings. That's why I build houses to keep water out.

First, take a good look around your house. Is it built on a hill? In a valley? On flat ground? Ideally, you want your home on fairly high ground, so water will naturally drain down and away from the house. If you live in a low-lying area, you're pretty much guaranteed to have more water issues.

Next, look at the land directly surrounding the foundation. In a best-case scenario, you want to see a slight slope of at least 5 or 6 degrees as you move away from the house. That is enough to keep water moving away from the foundation. You can take a few measurements to assess the degree of slope: for every foot you move away from a foundation wall, the ground should drop by ½ inch. So, over a 6-foot span, you should see a drop of at least 3 inches.

You might be looking at one or two spots causing problems with water. I've seen this happen around walkways or a paved driveway. Over time, pavement starts to heave and it begins to slope towards the house: this is going to throw more water against the foundation.

Do the window wells have proper drainage? You should see the window well filled with gravel, and the end of a length of drainage tile (that also needs to be filled with gravel). If it's done properly, that drainage tile will lead to the weeping tile, keeping water away from the foundation.

One of the best and easiest ways to keep your basement dry is to make sure you have proper grading around your house.

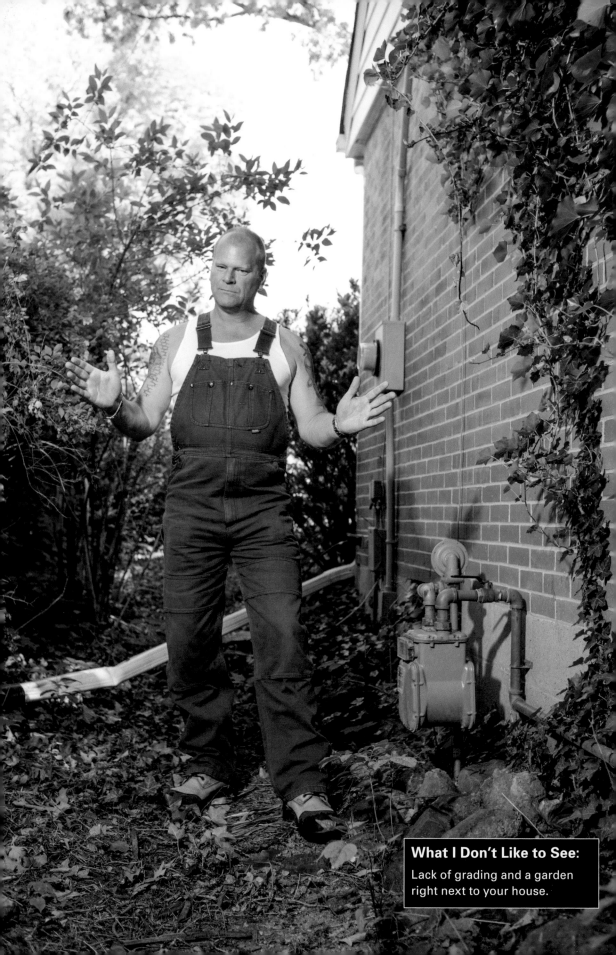

What I Don't Like to See:
Lack of grading and a garden right next to your house.

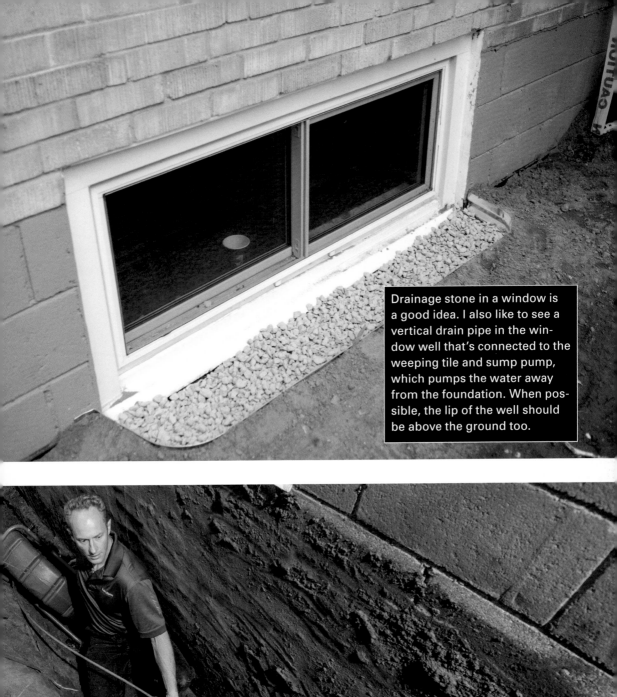

Drainage stone in a window is a good idea. I also like to see a vertical drain pipe in the window well that's connected to the weeping tile and sump pump, which pumps the water away from the foundation. When possible, the lip of the well should be above the ground too.

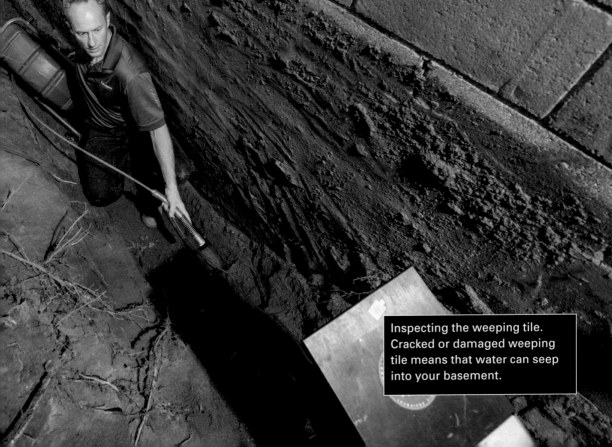

Inspecting the weeping tile. Cracked or damaged weeping tile means that water can seep into your basement.

Your garden may also be to blame. When people are planting flowerbeds next to the house, they often mound up the soil so it drops away from the plants in all directions. What they probably don't realize is that mounding soil like this sends rainwater flowing back against the house. Then you're throwing more water at the foundation every time you water that mound. If you're going to have plants near your foundation, you want the kind that don't require additional irrigation.

If the slope of land around the house is fine, you might have a problem with the weeping tile. When your foundation was built, the builders would have laid weeping tile along the base, covered it with gravel to help water flow away from the house after it trickles down through the soil. "Weeping tile" isn't quite the same as it used to be: as early as the 19th century, builders laid clay pipe around the house; today we use durable corrugated plastic with slits in it. For homes in the city, weeping tile connects to storm drains; in the suburbs or rural areas, it might be collected in a sump well and pumped to ditches.

One problem with weeping tile is the ground above it can become compacted. If the water can't squeeze through the ground to reach the tile, the tile can't drain the water away. If that's what's happening, water can seep into the foundation if it wasn't completely sealed. If you live in an area that freezes, the ice can put pressure against the walls, which is bad news for a cinder block foundation.

If the weeping tile is clogged or there's a broken tile, you may need a major excavation. The smartest method involves replacing the weeping tile or wrapping the foundation with a flexible waterproof barrier, or even both. It's expensive. I suggest you call a reputable foundation specialist to check the condition of the tile and see what you're looking at.

Whatever you do, don't try to waterproof the basement from the inside by putting up studs, insulation and vapor barrier against the brick wall. What will happen is you'll get rid of the dampness for a while. But water will continue to seep through and soak the insulation, and a thin sheet of plastic vapor barrier will be the only thing holding back the moisture. Always take care of moisture from the outside, before it comes into the house (see more on page 202).

What is the dusty white powder on my basement floor?

That chalky white residue is called efflorescence. It's a salt deposit that blossoms (effloresces) out of the floor as moisture evaporates from the masonry. In other words, it's a red flag that you have a moisture problem in the basement.

What's happening is the basement floor is getting wet on the outside. Moisture is seeping in through the foundation—think of concrete as a heavy, hard sponge—and leaving salts on the floor when it evaporates.

I'm not a fan of painting basement walls or ceilings to prevent moisture from getting in, even though I've seen lots of products on the market for that. They just don't seem to work well. The moisture will continue to migrate through and leave those salt deposits unless you seal the foundation on the outside.

I've heard that leaky basements can be caused by hydrostatic pressure. What is this, and how does it affect my basement?

Most people think ruined carpets, couches, and drywall are the worst thing about wet basements. Not a chance. A much bigger threat is constant hydrostatic pressure. That is, the

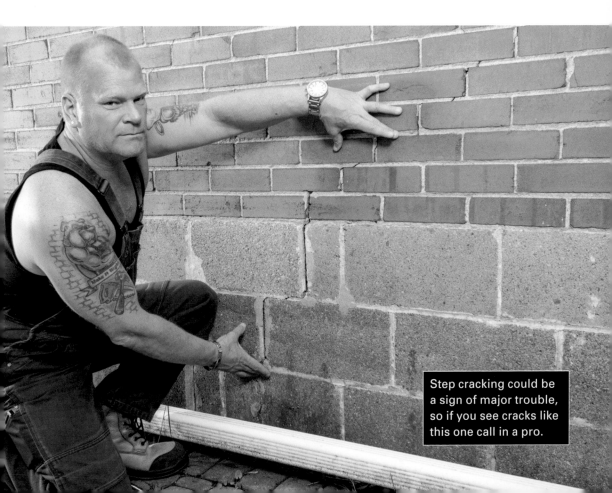

Step cracking could be a sign of major trouble, so if you see cracks like this one call in a pro.

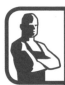

Three Basement Waterproofing Options

Damp-proof coating

Damp-proofing is a black tar or asphalt compound that gets painted or rolled onto concrete foundations. It's the least expensive option, so many people will use it to try to save money. The problem is these coatings will not give you a 100% waterproof foundation: they are designed to stop water vapor transmission through concrete. That happens when water vapor moves through the basement wall and evaporates on the inside of the basement. This method won't stand up to hydrostatic pressure and also won't take care of existing cracks in foundation walls that are allowing water to penetrate.

Waterproof coating

Professionally applied waterproof compounds are another option. They cure into a rubber coating that's 100% waterproof and will prevent water seepage into the porous walls of the concrete foundation.

Dimpled membrane

This membrane is the best solution I know of to keep water from coming in. It's code for new construction in many areas, as it should be, in my opinion. It involves excavating around the foundation and mechanically fastening this waterproof membrane to the exterior of the foundation wall. The area gets backfilled, and the membrane keeps water and water vapor from coming into contact with or penetrating the foundation wall. The dimpling in the material creates an air gap that lets the foundation wall breathe. Any groundwater that gets past the membrane will drain to the footings and be taken away by the weeping tiles. That means no hydrostatic pressure can build up.

pressure of existing groundwater, plus seasonal meltwater from snow, pushing on the foundation of your home. This pressure is powerful enough to cause your basement walls to buckle over time. It's one of the main reasons you'll see cracks in foundations and water seeping in through the concrete (remember, concrete looks solid but it slowly absorbs water).

What's the big deal with a little crack in the foundation? I'll tell you: a horizontal crack can be a warning sign that the strength of the wall is compromised, which can lead to catastrophic structural failure. If the crack is big enough that you can stick a dime in it, call a good structural engineer. Hydrostatic pressure causes these cracks about three feet below grade, and the pressure can actually snap the wall.

In most causes, hydrostatic pressure builds up because of a problem with the weeping tile. The drainage system has either shifted or broken, or it's choked with tree roots. With every rainfall, the water pours through the downspouts. If they deposit water next to the foundation instead of at least 6 feet away (you wouldn't believe how often I see this mistake), and the weeping tile can't do its job draining the water, that puts lateral pressure against those walls. One day you could end up with a crack in the foundation, which will be expensive to repair. The solution here is to waterproof your basement from the outside but make sure you choose a method that stands up to hydrostatic pressure.

Can I use pressure-treated wood to frame my basement renovation?

Pressure-treated wood was designed to be used outdoors only. The wood is injected with preservatives that are engineered to resist rot and insects, which is why you'll see lots of pressure-treated decks, fences, and sheds.

I'd frame a basement with a treated lumber that is coated or impregnated at the factory with a durable, water-based, low-VOC film that resists mold, moisture, and fire. Use this lumber with a paperless drywall and you'll be doing a lot to protect the basement from mold.

We have an unfinished basement. How should we insulate it?

Let me tell you, this is the single biggest mistake I see in basement renovations. You can't insulate the walls the same way as you'd insulate the rest of the house, because of the temperature differences between the parts that are

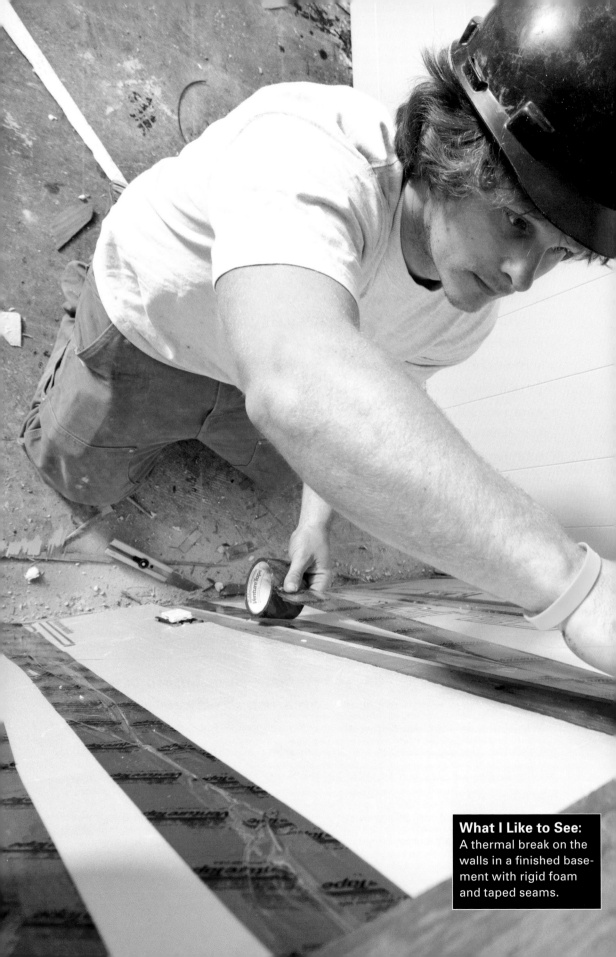

What I Like to See: A thermal break on the walls in a finished basement with rigid foam and taped seams.

above and below ground level. And if you don't get the insulation right, you're going to build the perfect environment for mold and mildew, which can cause health problems for your family.

The main living areas of your home that are above ground can handle air movement behind the drywall. You can use batt insulation, which air can move through, because the air temperature in those walls is the same from top to bottom. The temperature is different from the outside of the wall to the inside, obviously—that's why you need a vapor barrier on the warm side of the wall—but top to bottom, the temperature is pretty constant above ground.

The basement is a different beast. On those walls, the temperature is variable. And because moisture can wick through the basement walls and floor (remember, concrete looks solid but it's actually porous), you don't want to attach wood studs directly to the concrete walls.

The common way of finishing a studded basement wall is to put the studs about an inch out from the wall. But most contractors get the next step wrong—they follow minimum code, which treats the basement like any other part of the house. They stick insulation batts between the studs and put up 6-mil vapor barrier. It looks fine, but as long as those studs are one inch away from the outside wall, there will be air movement. The problem is, we don't have a zone of constant temperature in the basement—there can be several degrees' difference between the floor and the ceiling of your unfinished basement, and that causes problems. In the winter, that means air in the basement will be warmer than the outside air. The warmer interior air will rise up that wall and, where the foundation is above ground, it will hit a cold zone. We all know what happens when warm air meets cool air: condensation. Because condensation is now trapped behind the vapor barrier, mold will fester and rot the wood. So, what can we do?

Some contractors will sell you on putting metal studs right against the wall with no air space. Bad idea. It's an exterior wall, so you're still going to have air movement and condensation. In all that moisture, the metal will rust. I predict that within five years you see every drywall screw because they will rust right out too. Do not waste your money: the only place to consider metal studs in a basement is an interior wall.

To properly insulate and finish a basement, you have to address the issues of outside moisture coming in

and temperature fluctuations inside that cause condensation. What you need is a thermal break. A lot of people think insulation batts can stop airflow, but they only baffle it. The method I use is to glue 2-inch rigid foam board insulation to the walls with proper foam adhesive (use the wrong glue and you'll ruin the insulation). I leave about a ¼-inch gap around the perimeter of each board. Then you'll want to have the gaps filled with low-expansion spray-foam, and the seams Tuck-taped. Again, you're trying to stop air leaks that lead to condensation and mold. Once you do that, then you can stud, insulate, and drywall with paperless gypsum board, just to be safe, since it's mold-resistant. You don't need plastic sheeting as a vapor barrier because you've created that thermal break on the inside with the foam-spray-foam-Tuck-tape combination.

Of course if your budget allows, you could skip the rigid foam and use closed-cell spray-foam insulation on the walls, since the spray-foam acts as insulation and thermal break all in one. It's more expensive, but it's the best insulation you can buy, and you won't be sorry.

Don't forget the floors. You want to start by making sure there is no water coming in, then they also need a thermal break before you put down a finish flooring. Paint, sealant, or epoxy over the concrete is not OK unless you want to keep the concrete from breathing (which you don't). And you can count out anything laid with mastic adhesive (like vinyl and linoleum), since mold loves mastic.

To prepare the floors, you need to create a barrier that will control the air leaks that lead to condensation. Screw in 1-inch rigid foam board insulation with Tapcon screws made for masonry (don't use glue), top with a layer of ⅝-inch tongue-and-groove plywood, and then finish with whatever flooring you like.

What does a sump pump do and why do I need one in my house?

In some regions, minimum code requires new houses to be equipped with a sump pump to keep basements dry. What we're talking about is a small pump located in a small hole, or sump, in the basement floor. Any water that enters the basement ultimately finds its way to the lowest spot—the sump. The pump is equipped with a foot valve that turns it on when the water in the sump reaches a certain height.

It tells me we're doing things wrong if sump pumps are now standard fixtures. I'd rather see the problem

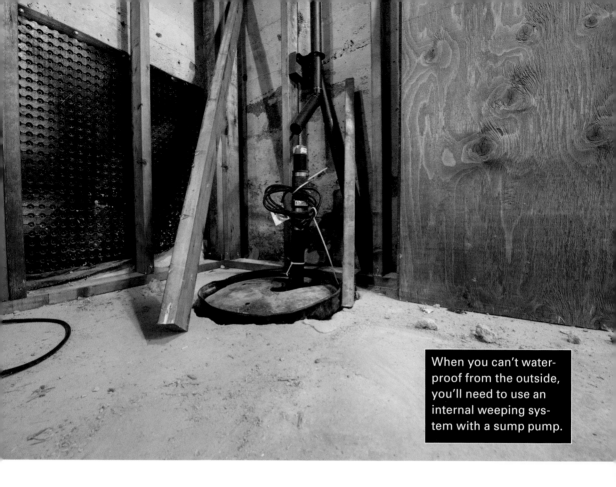

When you can't water-proof from the outside, you'll need to use an internal weeping system with a sump pump.

solved from the outside. If we do things properly, we don't need a sump pump. All you need is a floor drain for the times when you need to wash the basement floor or if some plumbing problem causes water to get into the basement, such as a washing machine overflowing.

Some contractors and foundation specialists will tell you they can install an interior weeping system. It's not my first choice—I'd rather build to keep water out than try to get it out once it's inside—but some homes don't have enough space for an exterior excavation because of neighboring houses, driveways, etc. An interior system works only if it's done right. This is what you can expect: along a perimeter wall, the crew will dig a narrow trench in the basement between 6 and 8 inches deep, and put in a corrugated plastic weeping tile. The tile gets covered with gravel, then cement, and the tile collects water from the base of the walls and empties it into a sump well. A sump pump carries the water out of the sump well and outside the house through a plastic pipe.

In most areas, you must have a sump pump if you have an interior weeping-tile system. (Check with

your municipality.) In fact, nowadays, any time you renovate your basement as a finished space, you'll likely be required to have a sump well and a sump pump to empty it. The code was changed in some areas to prevent leaky basements—and expensive insurance claims—but I've got several problems with it.

The first problem is that minimum code in some areas says that the waste pipe needs to extend outside the exterior wall by only 8 inches. It's pointless, because it means water is pumped out and dropped right next to your foundation, where it flows back into the house through the porous foundation wall, back down to the weeping tile, back into the sump pump, and back out. It creates an endless cycle of pumping.

I think a smarter idea is to require the pipe to run underground at least 12 feet away and empty into a dry well or a dry pit that is three to four times the size of the sump well and filled with stone. The water has to be discharged on your property and you have to keep it away from neighbors, sidewalks, driveways, and streets.

Pump failure is one of the most common reasons we get flooded basements in the spring. You can also get a battery-powered backup sump pump with an alarm, which is useful in case the power goes out during a heavy rainstorm (just make sure you test and replace the battery regularly). If your basement tends to flood during spring showers, consider getting a heavy-duty pump that can handle the flow.

Can I add a bathroom to the basement? What challenges do I need to know about?

Putting in an extra bathroom makes life easier, and in many ways, a basement bathroom is just like any other: it needs to be watertight and mold-free. But basements come with unique challenges, so this is not the time to cut corners. You need a pro with experience and training to make sure everything is done right.

And yes, you'll need to get a permit. I'm not sure why, but there seem to be plenty of contractors who love to work on basement bathrooms without permits. In every municipality I know in Canada, you absolutely need a permit; every time you touch the plumbing you need a plumbing permit, and you may also need a building permit. Be smart and check with your city's permits office. If a contractor says you can skip the

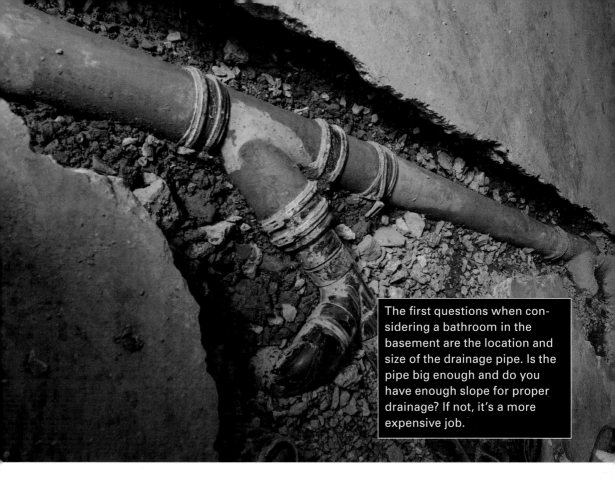

The first questions when considering a bathroom in the basement are the location and size of the drainage pipe. Is the pipe big enough and do you have enough slope for proper drainage? If not, it's a more expensive job.

permit, he's wrong and he shouldn't be working on your house no matter how good (or available or cheap) you think he is. If he doesn't know you need a permit, what else doesn't he know? If he knows and is lying to you, what else is he willing to lie to you about?

Nowadays, most new homes have a rough-in for a bathroom in the basement. Unfortunately, builders don't give much thought to where they throw in the rough-in, so yours might be located in the wrong spot, such as beside the furnace or under ducts. If yours is in a bad spot, your contractor will have to do more work to get everything functioning properly.

If your basement has a rough-in, at least you're starting with a proper vent line. That means air behind water—which you need for showers, sinks, and toilets to drain—and you can tie into that in a more convenient location. If you need to move the bathroom to a better location, be prepared that your contractor may end up running a vent line from the basement up to the roof. It could be a pain to find a zone that you can run through—maybe an

Basement Bathroom Checklist

You can read more about how I recommend finishing bathrooms in Chapter 4, but here's a cheat sheet:

❏ **Properly and legally vented pipes that conform at least to minimum code.** No cheater vents hidden behind walls!

❏ **GFCI outlets, which are grounded.** These protect you against an electrical shock in case the outlet gets wet.

❏ **Powerful exhaust fan** around 110 cfm (cubic feet per minute), vented to the exterior. Leave it on for twenty to thirty minutes after every shower.

❏ **Mold-resistant cement board around the tub or shower**; fiberglass drywall on other bathroom walls.

❏ **Silicone caulk around the tub.**

❏ **Waterproof systems by Schluter Systems**: Kerdi to line the shower and tub area and Ditra under the floor to protect against cracking.

upstairs closet—but it's crucial that your contractor does it. Otherwise, you're going to have problems: your sewage won't drain properly, and nobody wants to deal with that.

Renovating an older home where there's no basement rough-in is a big job. Retrofitting a basement to put in a bathroom will never be as simple as installing one above grade.

Let's start with drainage. Obviously, your toilet needs to drain. If the basement doesn't have a drain for sewage, the contractor will have to build one in the floor and tie it into the main waste pipe. Drains need to be sloped properly so gravity will carry the waste away. For it to be done right, be prepared to have a portion of the concrete floor broken up. It's a lot of work, it's messy, and it's not cheap.

The next thing you need is a vent for your toilet, one that meets code. Again, if your plumbing isn't properly vented, nothing will drain properly— not the toilet, the sink, or the shower. If your house has never had a basement bathroom, it probably won't have a vent stack either. Your contractor will have to tie into an existing vent on an upper level, or put in a new one that vents out of the roof of your house. This is another messy job that requires drywall, roofing repair, and painting.

People wonder why it costs so much to do a small bathroom in the basement: this is one of the reasons.

In an old house, sometimes the main sewer drain sits higher than the level of the basement floor. If the sewer drain in your house runs horizontally partway up the basement wall, there's no way that you'll be able to install a toilet down there and have gravity take care of drainage.

If this is the case, you'll need an upflush toilet, which is also called a sewage ejection system. You'll have a special, lined sump hole cut into the basement floor, where the macerating system for the sewage ejector sits. In a few seconds it grinds waste and paper, then mixes it with the water from the toilet reservoir when you flush. Everything gets pumped up through a pipe that ties into the main waste drain. Like any pump, the one in the sewage ejection system will need to be maintained regularly and replaced when it wears out. Since the material is shredded and pumped up, you can install a low-flow or a standard toilet. I like toilets that use less water because they're more environmentally friendly and save you money.

Don't listen to any contractors who try to cut corners by installing the drains without digging into the floor. They'll say it will cost you more to break up the concrete because of the labor and concrete disposal, and they'll recommend a raised floor in the bathroom. They will want to hook up the toilet, sink, and bathtub or shower drain under the floor to the vertical portion of the existing drain above the floor.

It's a bad idea: you're already dealing with a cramped space, so why would you do anything to compromise the ceiling height? More importantly, a raised floor won't give enough fall for the waste pipes. If some contractor wants to do this to your bathroom, they are trying to get out of doing work that's dirty and dusty and heavy. I'd wonder what else they will want to cut corners on.

I'm interviewing waterproofing contractors to fix our leaky foundation, and their estimates are all over the map. What should I ask to help me make an informed choice?

In my experience, when people are looking at a renovation, they get a little lazy about doing their homework. At home shows I ask people how many contractors they should talk to and the answer is always the same: three. How many references should you check? Same: they tell me three. It's the magic number.

What to Ask Waterproofing Contractors

Will you be waterproofing from the interior or the exterior? Exterior solutions are always the best because they keep water from penetrating the basement in the first place (find out the options on page 202).

Are you going to expose the weeping tile? A pro who is waterproofing from the outside will also check the weeping tile to make sure it's in good working condition. Think about it: you called them because you have water coming into the basement. If they are already digging, a pro will take that opportunity to check for any blockages in the weeping tile and, if there are any, clean them out. If not, the weeping tile would need to be replaced.

How will you check the grade around the house? The proper slope will prevent more water from coming in. Attention to these kinds of things is what separates the pros.

I'll tell you one thing: contractors come in threes—the good, the bad, and the ugly. About 10% are ugly. They have no conscience and they just want to take your money. About 20% are pros: they can't start next week because they're usually booked pretty far in advance. The remaining contractors are bad. They either don't know enough or don't care enough, or maybe both. They're harder to spot.

If eight out of ten contractors don't know or care what they're doing, there's a pretty good chance that the three you've chosen to interview are in this group. That's why it's so important to check out way more than three

people about your basement. Same with three references: even the worst guy can get it right three times, or at least fool three people.

When it's time to look at estimates, most people throw out the top and bottom bid and take the middle. Don't do it. You need to take ownership for being the boss and you need to ask hard questions. Find out what the price includes, and why.

Whatever you do, don't work with anyone who doesn't have a license or insurance. I know it's tempting to save a buck by going with a friend of a friend. But just because you're working with someone you know,

that's no excuse for throwing out the rules that apply to renovations. You could be liable if something goes wrong on the job.

Our neighbor's drain just backed up all over their finished basement, and we're afraid it could happen to us. Is there anything we can do to prevent this?

Anyone who's ever had a drain back up never wants it to happen again—it's one of the most frustrating and expensive problems a homeowner can have. Your home ends up filthy and it's a lot of work to get everything fixed. Fortunately there are a few things you can do to protect yourself and your home.

Gravity takes water and waste out of your house. Every drain in a house—sinks, toilets, tubs, showers, and laundry—goes to a drain that runs under your basement floor. The drain takes waste and water out to the sanitary sewer line in the street and eventually to your city's sewer system. Three things must happen for the system to work: the lines must slope down to let gravity do the work; they must have no blockages; and the vertical drain lines must empty below the house and extend above the roof so gases can escape and air can enter the

system and help with proper flushing and drainage.

If any one of these conditions isn't met, you'll get problems. You may smell sewer gases escaping into the air inside your house or water and waste backing up from drains and toilets. These are almost always avoidable if the plumbing is done right the first time and maintained properly over time.

It's possible that the house waste line that connects to the main sanitary sewer isn't large enough for the demands of your household. It's more likely that a backup is triggered by a blockage in your drain. In older houses, the old clay pipe can break down with age. If your house is surrounded by trees, it may be that the roots have locked themselves around the pipe and broken it, or crept inside and blocked the pipe so water can't flow.

If you have an old clay-tile drain, do you have any idea what kind of condition it's in? There's really only one way to tell: have a camera inspection done by a professional plumber. It's way cheaper than tearing flooring, furniture, and drywall out of your basement after it's been soaked by sewage. Make sure you get a copy of the video with a time and date stamp on it and ask the plumber to note the distance from the house that

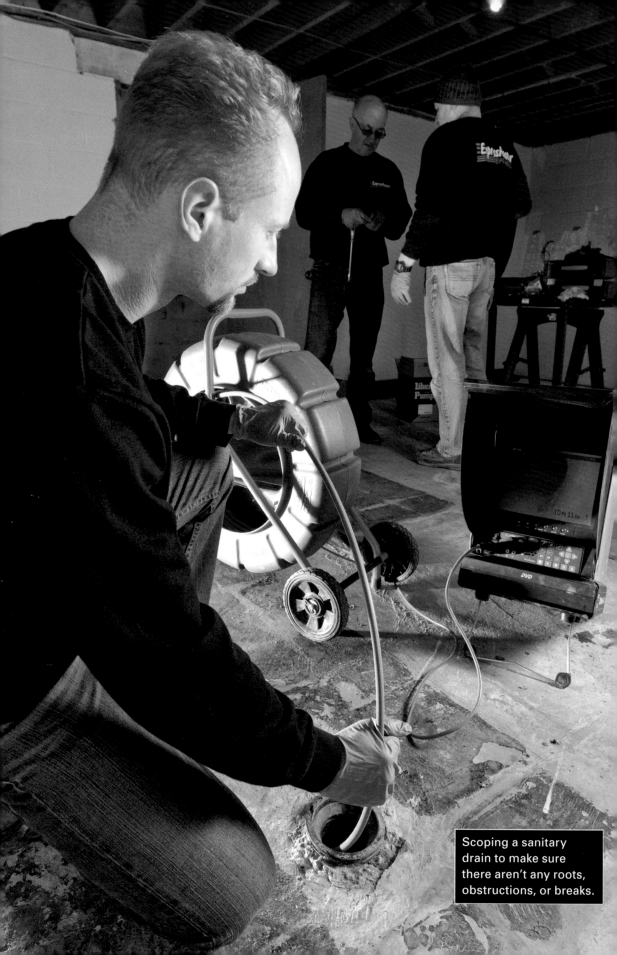

Scoping a sanitary drain to make sure there aren't any roots, obstructions, or breaks.

any potential obstructions are located. If there is a problem with your clay-tile drain, get it fixed before you have a backup—or another backup. Replace the clay tile with PVC, which won't corrode and which resists tree roots. Yes, you'll have to excavate, and you might have to break up the basement floor, but you won't regret this investment.

If the video shows you the drain looks good, check it again in two or three years. If you can see breaks in the tile and a tree root or dirt is getting into the drain, but there is no significant danger of a full blockage, check it again next year. Whatever you do, don't spend money on finishing your basement without making sure the drains are in good shape first.

Years ago, downspouts were sometimes fed directly into weeping tile at the base of a home's foundation wall, which ultimately connects to the main sanitary line. As populations grew, this put too much strain on the city's sewer system, so this is not common practice anymore. You likely won't be required to dismantle an existing setup, but I would recommend you do it anyway.

Those downspouts might be full of debris. If they are, they could overflow and dump tons of water where you least want it: right beside the foundation, where it will have an easy time working its way into your basement through porous concrete walls. This kind of setup can also push the accumulated debris down past the junction of the weeping tile and the sewer drain and cause serious sewer backups into your house.

I'd dig the downspouts out, lead them as far away from the foundation wall as you can, and have them deposit water on a swale, a gravel pit, or into a garden. Just make sure you keep everything on your property: you can't drain onto the sidewalk, the street, or a neighbor's property.

Storm drains and sanitary lines are separate in new municipal systems, but you can still get a sewage flood if there is a blockage downstream either on your property or in the general municipal system. In the case of sewer backups, you may need a camera inspection to figure out exactly where the problem started. If it's on your property, it's your problem to fix; if it's on city property, depending on where you live, call them and they'll come out and deal with it.

Mother Nature can also cause sewer backups. Sometimes, the back pressure from the main line in the street is so powerful—say, from a big storm with heavy rain—that the system can't handle all the water. It gets forced up the main sanitary sewer pipe and

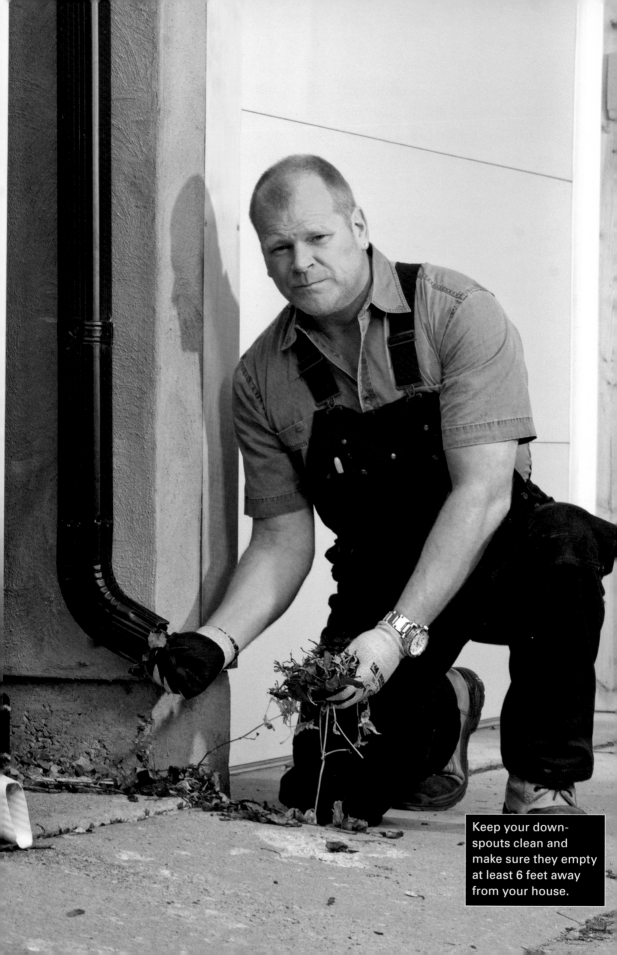

Keep your down-
spouts clean and
make sure they empty
at least 6 feet away
from your house.

into your home. You can avoid this by having a professional install a backflow preventer in the main drain, under the concrete floor.

Backflow preventers are standard for new homes in some municipalities, but they are actually illegal in other municipalities. Some cities are worried that if every house gets a backflow preventer, the pressure from a backup with nowhere to go may destroy its sewer system.

Where they're legal, I'd recommend having a backflow preventer installed because it could shrink your insurance premium. If you do get a sewer backup, your insurance policy may be your only protection. You need to make sure your policy is not limited and that you're covered in case a drain backs up.

How can you determine if it's necessary to underpin a house? What's involved?

The basement in most modern homes is ready to finish once you take care of moisture issues. If you're living in an older home, you may have a basement ceiling that's much lower. I've seen basements with 6 feet of headroom or less. Even then, some of that space is taken up with ductwork. In the old days, basements weren't designed for living; they were for storing jars in cold cellars,

stoking a coal furnace, and maybe washing laundry. If your basement looks anything like that and you want to turn it into living space, you'll probably have to lower the floor. Making a basement deeper can be done using a tricky process called underpinning.

I'm going to warn you, this is a big, expensive, and complicated job. You may need a conveyor belt or a line of workers passing off buckets to haul the dirt out and get the concrete in. So don't be surprised when contractors want to charge a small fortune. I've seen quotes of $30,000 to do a 600-square-foot basement.

Most people describe this process as digging out the basement, but that makes it sound too easy. You're actually undermining the structure of your home—temporarily, anyway. Before your contractor lowers the floor, he has to create a new footing for the foundation under the existing one (the footing is the widest part of the foundation, which your walls sit on). If someone just digs down to below the level of the footing, it would weaken the structure of the wall. If the foundation wall was not perfectly centered on the footing, it could shift and start to give way.

Properly underpinning a house takes time because the work has to be done gradually. You generally work

3 to 4 feet at a time. The contractor will dig down underneath the footing, getting down to undisturbed soil for a short stretch. Then they will dig out a cradle of some sort and pour some concrete into it to extend the footings down to the new floor depth. Only after the concrete has set can they move on to do another 3 feet, then another, then another. Go any faster and you compromise the foundation, which is the most important part of any house.

Even when a crew moves slowly like they should, they can run into problems after the concrete has been poured. New concrete doesn't adhere to old concrete that has already set. Plus, new concrete shrinks as it dries, so you're going to end up with a gap—and the chance of movement between the old and new footings. That's why minimum code says that everywhere you have underpinned, you need to create a continuous support between new and old footings. You do this by using about an inch of nonshrinkable grout tucked under the full width of the original footing to create what's called bridging or a footing or an underpinning, depending on how it's done. Sometimes, the grout doesn't go right to the back and the inspector won't see the problem if the first few inches are completely sealed. Filling that gap is critical or you're compromising the structure of your home. Gaps leave you with a foundation that could break—and you won't even know until it's too late.

There's a good way to fill this gap, and it's a method that was developed by John MacRae. He created a U-shaped trough that cups the old footing from below. Concrete is poured in and vibrated so it settles into place under the footing and up the other side. This holds it securely in place. This method eliminates the problem that nonshrinkable grout sometimes fails to fix, and it's approved by engineers.

One more thing: if your basement has an exterior door—typically with concrete stairs leading down to it—you'll need to underpin that area too. If your contractor tells you he doesn't need to bother with the stairs, he's wrong. You'll need to lower the stairs, walls, and floor of that entry. In fact, the foundation walls of that entrance must be 4 feet lower than the new basement floor, with a new structure all the way up. It can be done—anything is possible with renovating—but it's a huge job. I've heard of walk-in basements that cost twice as much to lower as you'd pay to lower just the inside. If your basement requires this kind of radical work, putting up an

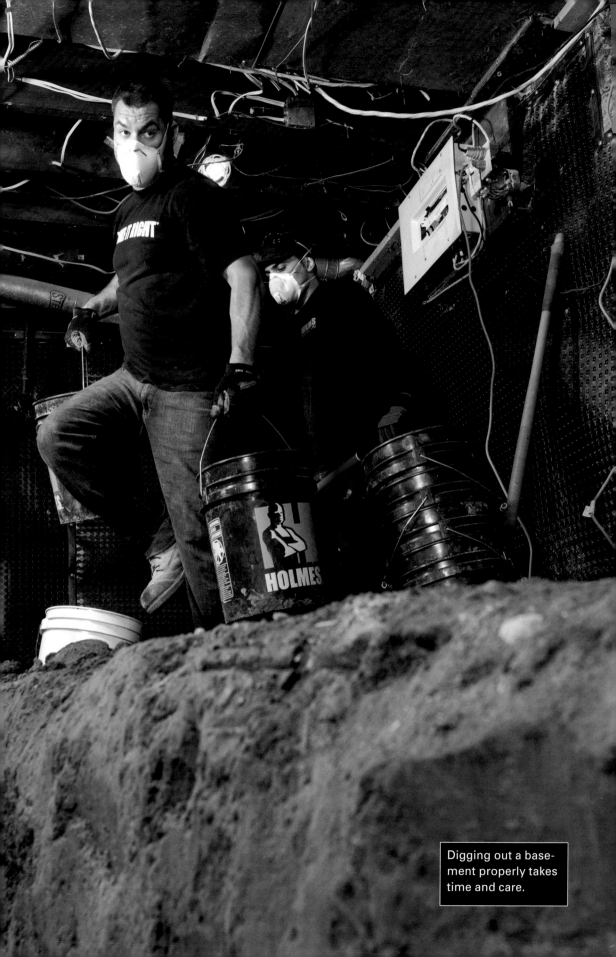

Digging out a basement properly takes time and care.

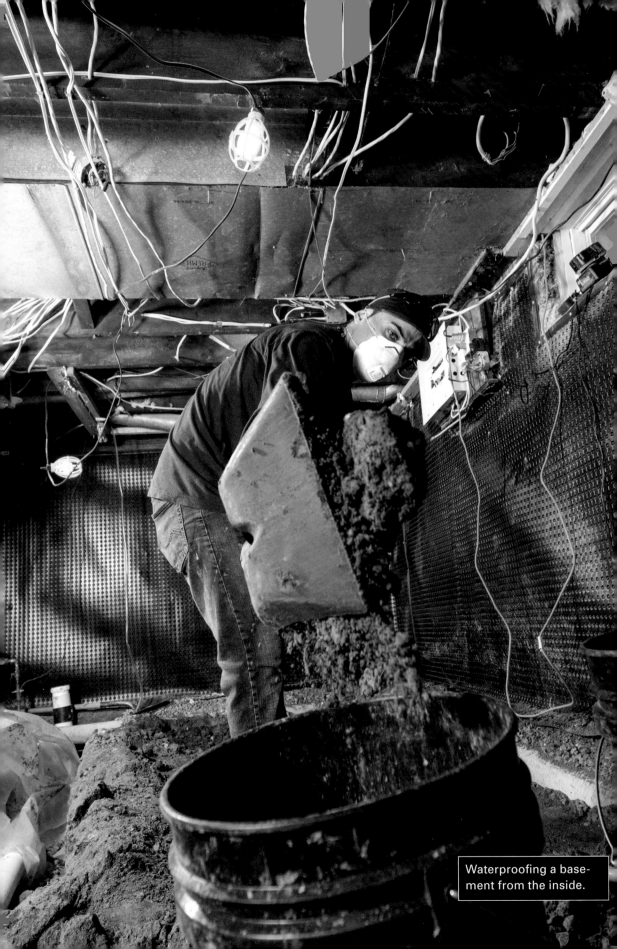

Waterproofing a basement from the inside.

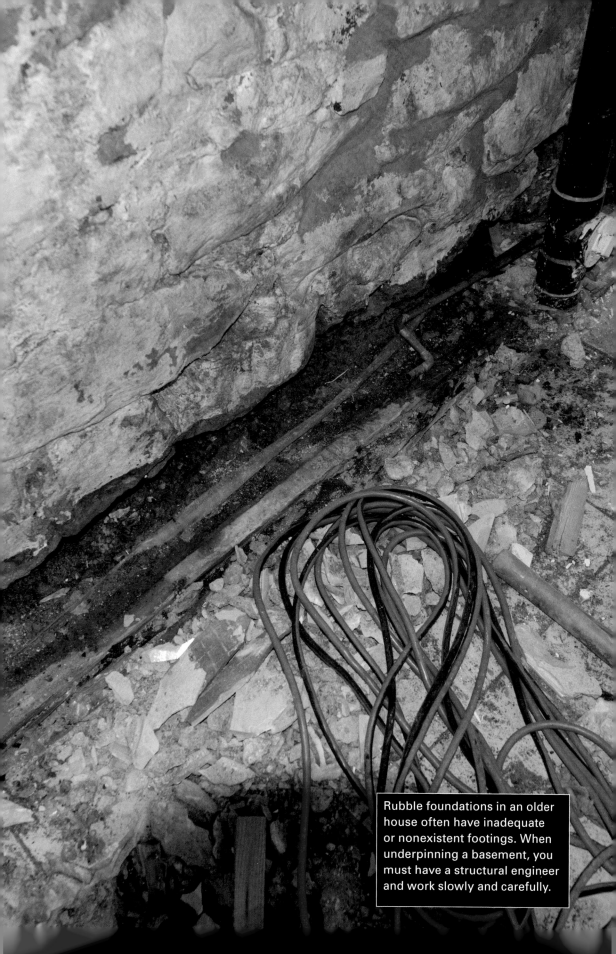

Rubble foundations in an older house often have inadequate or nonexistent footings. When underpinning a basement, you must have a structural engineer and work slowly and carefully.

Hire with Caution!

The foundation is the most important part of your house. If someone messes it up, your house could fall down, so don't take any chances when it comes to hiring a pro to do your underpinning safely. I've seen too many shady companies doing jobs they're not qualified for—probably because they can charge so much. I saw one house where the contractor dug below the flooring for the entire length of the foundation. They likely did not have an engineer providing the design or installation method. The structure cracked, the city stopped the work, and the homeowners had to move out. The family was lucky the whole house didn't cave in. Choose an experienced contractor who's done this kind of work many times before and who's done it well. Don't settle for three references—I'd check at least ten, and visit at least five sites to see the finished job.

addition may be a less expensive way for you to gain space.

You absolutely need a permit for this work, so don't work with anyone who tells you otherwise. You're playing with the structure of your home. The contractor is legally responsible if anything goes wrong while he's on the job, but once he leaves, it's on you. You don't want to be going after them if you run into problems once they've packed up and moved to the next job.

Getting permits and working with a solid contractor will also make your next step easier: talking to your neighbors. If you live in an older house or in the city, you might be a few feet from your neighbor's place. You and your contractor are responsible for making sure the

work you're doing doesn't compromise the safety of *their* foundation. Reassure the people around you that the work will be done safely and legally.

We want to lower our basement and finish it as a den/playroom. What's the difference between bench pinning and underpinning?

Both of these methods will help you create living space from an existing basement with a low ceiling. Both require building permits and experienced contractors who have done this job before. You don't want someone who specializes in kitchens and baths to start tinkering with your foundation. Remember, a botched foundation job can compromise the structural integrity of your

home. That's a nice way of saying your house could fall down.

Underpinning will lower the basement floor and leave you with more usable space, but it's a difficult and expensive job. Working a few feet at a time around the perimeter of your foundation, your contractor will excavate and pour new footings beneath your original footings. Then the wall will be built up in sections. The load has to be carefully and safely transferred and supported—you can't rush an underpinning job. What you're actually doing is deliberately undermining your home's foundation—in a controlled way, if it's done right—so you can support and rebuild it.

Your finished interior basement walls will be flush from top to bottom. Once the new, deeper walls are finished, the basement floor will be dug out and lowered so the room gives you those higher ceilings you're looking for. You can read more about what's involved in underpinning on pages 217–222.

Bench pinning a basement costs less, but you end up making your basement smaller around the perimeter even though you get a higher ceiling. With this method you aren't digging down below the original footing—it stays untouched. Instead, a new foundation is poured

inside the existing one. This means your perimeter walls won't be flush like they would be with underpinning: each wall will have a concrete "bench" at the bottom, which eats into your floor space. For every foot you dig down in depth, you must add a foot in width to the bench. So if you want to gain 2 feet of height, you'll have a 2-foot-wide bench along the base of every perimeter wall. Keep this in mind when you're designing your finished room.

What's the best kind of foundation for building a new home or addition: concrete blocks, concrete pour, or insulated concrete forms?

The foundation is the most important part of your home, and it needs to be done right. All three foundation types have advantages and drawbacks. Here's what you need to know.

Concrete block

These blocks can be a smart choice for foundation walls. They're sturdy, strong, and easy to work with. And at about $7 per 10-inch block, they're also the most affordable.

The biggest downside of concrete block is it's the least resistant to moisture because of all those joints. When the concrete shrinks as it dries,

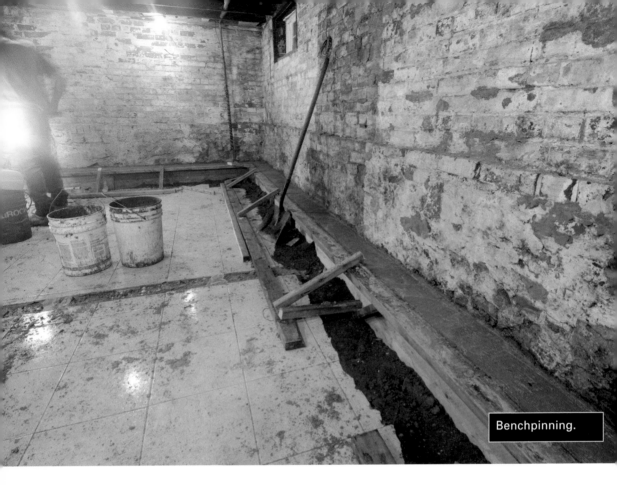

Benchpinning.

it can create gaps between blocks. If you don't have everything properly waterproofed, these voids are an easy entry point for water.

Concrete pour

About two-thirds of residential and commercial basements use poured concrete. The average home will cost about $160 per cubic meter (roughly 35 cubic feet). That is about 20% more than concrete blocks. For that price you get a denser, stronger, more solid foundation.

But concrete isn't perfect. Its strength will be compromised if it's not poured properly or allowed to set properly. You may get cracks, which can grow into bigger problems. You've got to make sure the concrete goes in as a single pour, and it has to be protected from the weather while it cures (sets).

Poured concrete walls get added strength from metal rods called rebar, but concrete is still porous. That means it's like a sponge: it's filled with air pockets. If your basement has any gaps in its moisture barrier, water and air can seep through the concrete and cause mold, which can lead to rot and structural damage.

Insulated concrete forms (ICF)

My ideal foundation is built from an excellent system called insulated concrete forms, or ICF. Actually, they can be used from the foundation right up to the roofline. The forms are made of rigid foam insulation with hollow centers, and the forms fit together like Lego. They are reinforced with steel, then concrete is poured into the center. This gives you a straight, strong wall with its own built-in insulation and vapor barrier with an insulation value of R-40. An ICF foundation costs about $3.50 per square foot.

If you go this route, you'll need to add a layer of moisture protection, such as Rub-R-Wall. This waterproof seamless foundation coating is sprayed on the exposed exterior foundation to make it waterproof. Rub-R-Wall costs more than other methods for sealing your foundation, but I think it's a great investment.

One disadvantage of ICF is it's difficult to detect defects after the concrete is poured. If you end up with voids that aren't filled—which you won't know about because the concrete isn't visible—it can affect the walls' structural integrity. This is also a newer building material, so it will be harder to find contractors who have worked with it and know how to install it properly. Do your homework before you hire a pro.

What do you prefer in basement ceilings: drywall or a drop ceiling?

Aside from moisture issues in a basement, the ceiling is the other big difference between finishing it and finishing any other room. Here are the pros and cons you need to consider.

Drywall ceiling

Look at any home renovation show where they've done a basement and you'll see drywall on the ceiling. That's not because it's a better choice, in my opinion; it's because people like the look of drywall. It's tough to argue with the simple, clean finished look of a smooth painted ceiling. The other big advantage of drywall is it can be attached directly to the joists, which means you maximize headroom. If you don't live in a home with generous ceiling height in the basement, this can be a benefit. If there aren't pipes or ducts attached to the bottom of joists, drywall only costs you ½ inch of headroom (that's the thickness of the material). If you're concerned about noise from the TV or a sound system in your basement, you can install soundproof drywall on the ceiling. It's more

expensive, but it will minimize the transfer of certain frequencies.

However, you need to consider that closing up your ceiling with drywall makes everything up there inaccessible: cables, electrical, ductwork. If you need to open up the ceiling, drywall is messy to repair. You may also have a code issue to sort out: if there are electrical junction boxes, you can't permanently cover them with drywall because it's dangerous and against code.

Suspended or drop ceiling

I'm a fan of drop ceilings because they're practical: they give you easy access to all the systems that drywall would bury. You'll appreciate this every time you have a repair to do or you want to run a phone line or speaker wires either for the basement or for a TV room on the floor above. Same goes for water damage: suspended panels can be easily replaced if a leak starts from above or if you get condensation damage from sweating pipes. Not so with drywall.

If you're into acoustics, you'll want to look into ceiling tiles made of soft, sound-absorbing material to minimize sound deflection and echo. Suspended ceilings also come with built-in resilient properties for soundproofing.

Ceiling tiles also have their disadvantages. For starters, suspended ceilings can cost from 3 to 5 inches of headroom. This may not be a concern in a newer home but it likely will be in an older home.

Choosing a Ceiling System

Smart homeowners will consider more than just looks when they're deciding what kind of ceiling to put in a basement. Ask yourself these practical questions:

Do I need to max out headroom? If so, drywall is better.

Do I have electrical junction boxes between the joists? If you do, you have to install a suspended ceiling or else move the boxes before drywalling.

Are there obstructions hanging below the bottom edge of the joists? A combination of drywall and a drop ceiling might work.

Am I going to need easy access to the ceiling? Then you'll appreciate the convenience of ceiling panels.

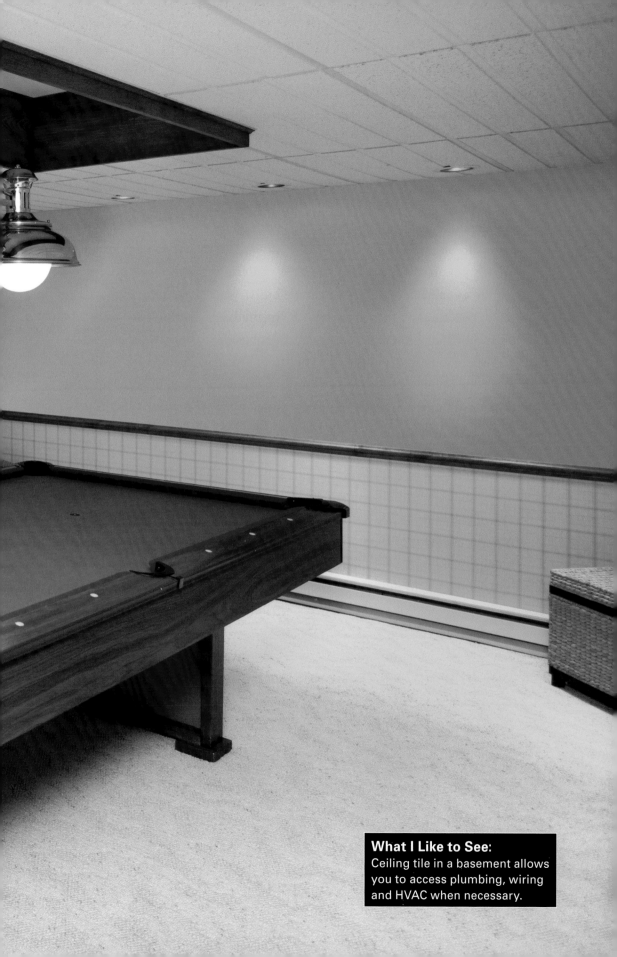

What I Like to See:
Ceiling tile in a basement allows you to access plumbing, wiring and HVAC when necessary.

And then there's the aesthetic issue. Some people think a drop ceiling looks like it stepped right out of the '70s. It's true those old 2-×-4-foot foam panels can look institutional, but the good news is there are more choices available today and many of them look a lot more stylish.

It's possible your ceiling might require a combination of drywall and ceiling tiles, especially if you have HVAC ductwork hanging low in certain places. You might want to drywall under the ducts and put up a suspended ceiling across the flat part. There's no wrong answer: you just need to make the best decision for your situation and whatever obstacles are in place.

Would a dehumidifier help get the musty smell out of the basement?

A musty smell says two things to me: there's moisture in the basement and mold. A dehumidifier might help get rid of some of the odor, but it won't do anything to get rid of the mold. It's still there, and it will return as soon as conditions are right. Mold spores are everywhere, and mold sets in and spreads as soon as it has moisture—which you've already got—and a food source, which is something organic like wood or paper. Finally, like us, mold needs air.

Mold not only smells bad, it gets into the air you and your family breathe. If the moisture problems go untreated, you may be compromising everyone's health by lowering the air quality inside your home. Yes, it can be more polluted than the air outside. Read more about this on page 271.

Because of the way houses are built, your basement may not be insulated properly. Your walls and floor need a thermal break—spray-foam insulation provides insulation and an air break all in one. This stops warm and cool air from colliding in the basement and causing condensation, and the start of mold.

I share my favorite way to waterproof and finish basement floors on page 194, and walls on page 202. You'll have to pay someone to make it right, but I think the air you breathe should be as clean as possible. A dehumidifier alone isn't enough.

I find water pooling in the middle of the basement floor after a heavy rain. Where is it coming from?

If water shows up in your basement after rain falls or snow melts, you're probably looking at a few problems: a leaky foundation, hydrostatic pressure, and improper exterior drainage. Seems like I get emails about wet

basements all the time, and it doesn't seem to matter if the homes are new or old.

Start by taking a look outside. What is the grading like in your yard? Proper grading is essential for managing the water around your home and directing it away from any building's foundation. Your property should slope at a minimum 5-degree grade away from the foundation walls on all sides—a ½-inch drop for every foot. If the ground slopes towards the house or it's flat, you have grading problems.

Downspouts, which connect to the gutters to drain water from the roof, can cause water in the basement if they're broken or set up wrong. You should have a downspout for each length of gutter, and they need to be properly connected. Not only that, but it's crucial that the downspouts extend at least 6 feet away from the foundation and that they deposit water on soil that slopes away from the house. If they direct water onto a splash block or collect in a rain barrel or into weeping tile, the water could pool around the foundation and seep inside. If you see standing water alongside the foundation, or depressions in the soil under downspouts or near window wells, you know you've got a problem with the downspouts.

The other issue might be that the weeping tiles are blocked, broken, or missing. For years, we've built homes with weeping tile laid under the foundation, next to the footings. Any water that seeps down to the footing through the ground, or percolates up from underground, will end up in the weeping tile, where gravity can carry it away.

The path of least resistance for water is to move through the weeping tile rather than through the basement wall. That's true as long as there's no blockage or broken tile. If the water has nowhere to go, it will end up in your basement. Over time, what was once a perfectly good weeping tile system can stop working: clay tile can break down, tree roots can break the tile or clog it, even soil that freezes and thaws can shift tiles so they no longer connect. I'd say most clay weeping tile systems stop working properly after a few decades.

You can have your system inspected and scoped with a camera to see what condition the weeping tile is in. If it's bad, you'll need to remove and replace it. Modern weeping tile is a 4-inch plastic hose perforated with holes that let water in. A net covers the tube to keep out silt and soil. I'll tell you right now, this is a huge job: the perimeter of your home needs to be excavated down

to the footings. While you've got the foundation exposed, you can check it over and repair any cracks, then have the foundation properly waterproofed. You can learn more about waterproofing the basement exterior on page 202. I prefer exterior waterproofing, but if that's not possible you can set up an interior system. Find out more about interior waterproofing on page 206.

Can you put laminate or hardwood right over radiant heating in a basement floor?

I like the newest generation of radiant in-floor heating more than any other kind of heating in the world. You get comfortable, even, efficient heat in a room because the system actually heats up the floors and walls—and your feet—rather than just blowing warm air over them. In a hydronic system, hot water flows through rubber tubes embedded in a concrete floor or under tiles or some kinds of hardwood. Or you can also get an electrical system such as Nuheat, which is like having an electric blanket under your floor.

In-floor heating is more efficient because you—especially your feet—get to use the heat at ground level, where you can enjoy it. Forced-air systems actually do a better job of heating the ceiling than your feet, since warm air is pushed up by cooler air. With radiant heat, your room feels more comfortable and you get fewer cold spots, so you can lower the temperature on the thermostat: you're conserving energy and saving on your bills.

There are a few drawbacks I've seen to a radiant heating system. It takes longer to change the temperature of a room than it would with a forced-air system. And if you convert your whole home to a high-quality in-floor system with durable PEX tubing throughout, there won't be ductwork to run central air conditioning through. Fortunately, there are cooling systems available for hydronic in-floor systems.

You can use a radiant heating system under any type of flooring, including carpet, tile, vinyl, and certain hardwoods and laminate, although ceramic and concrete make the most efficient use of radiant in-floor heating. Some hardwood floors will cup or warp because of in-floor heating. I'd recommend engineered hardwood because it's entirely stable.

If you do go with an electrical in-floor heating system, you'll need to have an electrician wire it directly to your panel—you can't tie it into your existing electrical system. To protect the electrical from getting wet, you have to put a watertight floor over top.

Radiant heating is straightforward to install in new construction. If you're retrofitting, the tubes can be installed from beneath the floor with metal fins in what's known as a "staple-up" installation. Make sure the area is insulated: you don't want the heat generated to escape down into the ground below.

Why does water seep through the basement floor in early spring?

You know the saying about April showers, right? We get a lot of precipitation in the spring. It's good for those May flowers, but that extra moisture outside can affect our homes. I can think of a handful of reasons for a wet basement floor.

Clogged weeping tiles

Have you had the weeping tiles scoped recently to see if they're clogged? Over time, clay weeping tiles can crumble, shift, or get broken by tree roots that work their way inside. Yours may need to be cleaned out, or they might need to be replaced. Call a specialist in drainage repair and waterproofing to have them scoped and flushed. If your drainage tiles need to be replaced, it's not a cheap job, but it's not something you'll want to put off.

Hydrostatic pressure

Groundwater is always in the soil around and under your foundation. In spring, water levels rise. If the water has nowhere to drain, you'll get pressure forcing the moisture through the concrete. (Remember, concrete is porous. It absorbs water.) This pressure can be strong enough to crack the foundation. A sump pump can help get rid of excess water by pumping it out of a sump well in the basement floor and sending it as far away from the foundation as possible. If it dumps too close to the house, the water will end up right back where it started.

Problem downspouts

Take a look in your gutters: are they plugged with leaves and debris? If so, they might spill over when it rains, dumping water right beside the foundation. If they're clear, how are the downspouts set up: some empty too close to the foundation when they should deposit water at least 6 feet away.

Changes in drainage

Have you done any landscaping recently? Changes to a patio, driveway, or garden beds might have affected drainage, which can explain why water is making its way into the basement. Proper grading is crucial to

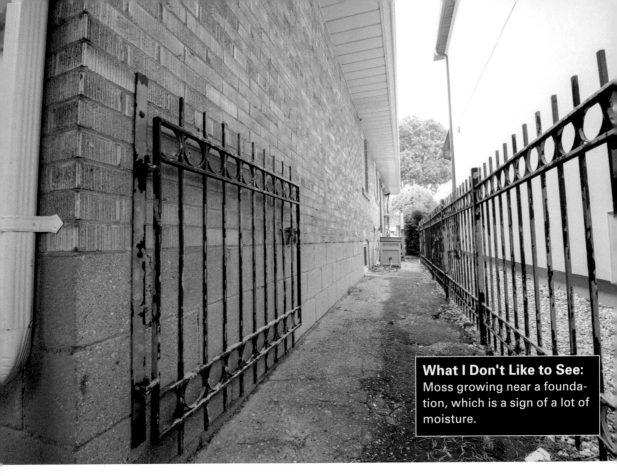

help your property handle the water around it. You should be looking at a minimum 5-degree slope away from your home on all sides—a ½-inch drop for every foot you move away from a foundation wall. Doing something as simple as mounding up soil in a flowerbed can get in the way of proper drainage.

If you adjust the downspouts and clean out the gutters and you're still seeing the same problem, it might be time to call in a foundation specialist to have a look.

Why do you say I shouldn't allow shrubs to grow beside the foundation?

Don't get me wrong: I like plants. But often, people build flowerbeds right next to the house, mounding the soil so it drops off towards the house. I suspect they have no idea that playing around with the soil this way can cause rainwater to flow back *against* the house when what they really want is for the water to drain *away*.

Landscaping can cause problems if it's done right next to the house.

Digging near the foundation walls to pull or plant shrubs disturbs the soil and leaves it less compressed. When the soil is more porous, water flows through and can seep right down to the basement walls. It's not the plants I don't like—it's the extra moisture that disturbed soil retains near the basement walls. If you don't want a wet basement, keep gardens away from the walls.

Trees are another potential problem. They're great at throwing shade in the summer, but don't plant them right up next to your house. If you have trees on your property, look at the canopy. If it's large enough for branches to overhang the house, you can be sure the tree roots have crept under the house because the roots spread out twice as wide as the canopy. Those root systems can interfere with plumbing, the waste line into municipal sewers, and even the foundation. The leaves direct water onto the roof, which wears down shingles faster.

Smart landscaping works with your home, not against it. Whatever you do outside will affect the interior, so you have to be smart. That means the best plants to have right next to your house are none at all, or at least the kind that don't need irrigation.

Materials and Finishes

I'm always telling people to educate themselves. If you take the time and look into new products on the market, you'll be better able to both choose and speak to your contractor. If you know about mold-resistant drywall, BluWood, PinkWood, Schluter Ditra, you can start asking questions. "Hey, do you use mold-resistant drywall in bathrooms? Do you use Kerdi? Do you even know what it is?" Right away this helps you with understanding whether or not your contractor knows about the new stuff. Because if yours doesn't, this means he's still working in the old times, and this is not what you want. The more you know, the better it is for communicating with contractors.

I love finding out about new products and new methods and techniques. When I first looked at the Schluter waterproofing system, I thought it was perfect for anywhere you're going to lay tiles, especially in your bathroom.

New products come out all the time that are trying to correct the way we've always done things, so we need to pay attention.

Over all the years, we've learned what works and what doesn't work. Take insulation and drywall, for example. What doesn't work is using products that will mold. As long as you have moisture penetrating the walls, and as long as mold spores in the air can find a food source—that's wood and papered drywall—you're guaranteed to get mold.

When we find products that resist mold, we should be using them as a matter of course in each and every home. It just makes sense to build with better products. Without mold, (a) you're breathing fine in your house, (b) you don't have to tear down and spend a fortune for mold abatement, and (c) you don't have to put your house back together again. We should really look at the environmental opportunity too: building mold-free means we don't have to tear it all down and throw it in the landfill.

For products to win my approval, it's really simple: I'm looking for low or zero VOCs (volatile organic compounds). I'm looking for products that just make sense in the building industry. I always loved the story of the *Three Little Pigs* when I was a kid. All we have to do is build the way they were thinking. It won't blow down, it won't fall down, it won't rot or mold, it's fireproof—that's how we should be building.

Why do you prefer using screws instead of nails? Is there a difference in screw types?

I use screws wherever possible for a simple reason: they hold better than nails, period. Canadian building code is different from code in the United States, where screws are not permitted as much. "Glue it and screw it!" That's what I say.

I can think of a few cases where screws do a much better job as a fastener. For starters, take subfloors. Most contractors use a nail gun to install a subfloor because it's faster, and time is money. But if your basement ceiling isn't finished, have a look from below and you'll see that many nails miss the joists entirely. If fewer nails are holding down the subfloor, it will pull away and squeak when someone walks on it. Perfect example of why I glue and screw subfloors instead: glue makes the connection and screws hold it in place for the long term.

Nails have a habit of loosening over time. I've seen drywall nails pop right

What I Like to See:
Treated wood products
which are mold-, insect-,
and fire-resistant.

Nails and Screws 101

Always check code when choosing the right fastener for the job. For example, you can't use just screws on load-bearing walls: you need nails too.

Wood screws are used to secure lumber. There are many different types used for different applications: you can get interior and exterior wood screws. In the case of exterior screws, you can get them specifically designed for cedar, pressure-treated wood, etc. Same with interior screws: some are for dry-wall, others for studs.

Drywall screws are manufactured to hold drywall securely, thanks to the design of the threading and head. Structural screws are manufactured for maximum strength. Tapcons are used to fasten into masonry or concrete.

Nails are just as varied in design and application as screws. There are many different types for different applications: standard wood nails, standard structural nails, roofing nails, finishing nails, etc.

The Right Fastener for the Job

Job	Fastener
Floor joists	Structural nails
Framing	Wood screws and/or structural nails depending on building code in your area
Drywall	Drywall screws
Trim	Finishing nails
Roofing	Roofing nails
Fencing	Exterior wood screws; vinyl-coated "green" wood screws for pressure-treated wood; ceramic-coated "brown" wood screws for cedar

out—it looks awful. This happens as the house shifts and settles, when wood shrinks, or because of a shoddy framing job where the crowns aren't matched (studs not lined up so all the wood curves the same direction). Banging the nails back in will only work for so long, until the hole loosens even more and won't hold the nail at all. I'd recommend pulling the nails out and putting in screws in a different spot.

I especially use screws on exteriors. Most of us probably worry about rain in a big storm, but it's the wind that's the real problem. The exterior of your house should be built to stand up to 125 mile per hour (200 kilometer per hour) winds. All you need are the right materials. I don't just nail up sheathing to the frame: I glue it and screw it to make it stronger and increase wind resistance.

Which is better: plywood or OSB sheathing?

Plywood is an engineered wood that's been around for decades. It's made of thin sheets of wood that are cross-laminated for additional strength (each layer is laid at right angles to the next layer), then bonded together under tremendous pressure using durable adhesives. It's available in more than a dozen thicknesses and twenty-plus grades,

from underlayment and wall or floor sheathing to smooth natural surfaces that can be used for finishing.

OSB stands for *oriented strand board*. Sometimes known as *chipboard*, OSB was introduced about thirty years ago and meets code for all kinds of applications.

To make OSB, layers of wood chips, or strands, are glued together under intense heat and pressure with waterproof heat-cured adhesives. Like plywood, each layer's fibers run perpendicular to the layers above and below, which helps boost the board's strength. What you get is a structural engineered wood panel that is similar to plywood. As far as I'm concerned, Weyerhaeuser makes the best OSB products.

Many applications that once used plywood—such as subfloors and sheathing for roofing and exterior walls—now use OSB. It's approved for use almost everywhere. Some OSB products are chemically treated to keep termites and other insects away, which is a good thing for homeowners. It's also less expensive than plywood for boards of the same thickness.

But OSB just isn't as strong, which is why I prefer plywood. Take subfloors: in older homes, a plywood subfloor was laid over 2 × 10 joists spaced 12 inches

apart and cross-bracketed every 4 feet. Before that, the subfloor was solid 1-inch-thick lumber that was laid perpendicular across the joists or on 45-degree angles. The finish flooring went down on top of that. The result was a seriously solid floor. Tiles didn't crack, though floorboards could still pop when nails loosened.

I think we've let construction standards slip too low, and floors are a great example. Today's new homes typically have ⅝-inch OSB sheathing as a subfloor in place of plywood. The joists are smaller (2 × 8), and they're spaced farther apart (at 16 inches), though they are doubled up for strength at stairwells and floor openings. Code also says it's OK for a 1-inch deflection, which means joists can sag up to 1 inch under weight.

That just isn't good enough for me. OK, so your floor isn't going to snap, but you'll get other problems. If you bounce in the middle of the room, I bet you'll feel the floor move. Think about it: every grout line and tile will be flexing, which can cause squeaks and cracked tiles. You need a stronger subfloor than that.

That's why I believe in building over code. Why stop at safe when you can go a little further and make your investment last? I use ⅝-inch tongue-and-grove plywood for subfloors. There are appropriate uses for OSB, but it's just not as strong as dressed solid lumber or plywood. And I don't recommend OSB for exteriors: if your contractor is using an OSB sheathing, he'd better cover it quickly with house wrap because it shouldn't be exposed to moisture for extended periods.

Do you think a product that combines paint and primer is a good thing or do you prefer two separate products?

Primer is paint that seals the surface and prepares it so the fresh paint will adhere. I get the marketing appeal of a two-for-one product—less time, less hassle, less money. But I'm old school: I prefer two separate products.

For one thing, some primers are formulated to serve different functions, such as suppressing stains or mold. You can also tint a primer to better prepare the surface to take a darker color. Tinted primer makes the finished shade appear more saturated. Without one, you may end up with a muddy look and need to apply multiple coats to get the true color. So in that sense, you'll save on material and labor costs by using a separate tinted primer. Better color, less wasted time

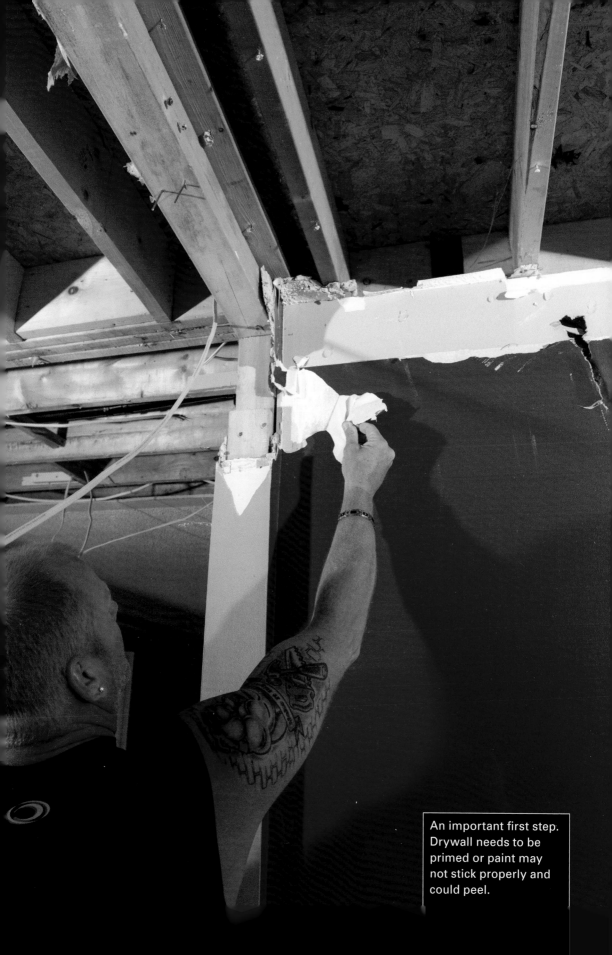

An important first step. Drywall needs to be primed or paint may not stick properly and could peel.

When Is Primer a Must?

- Transitioning from oil-based to latex paint
- Transitioning from high to low sheens
- Going from darker to lighter shades
- On drywall, raw wood, metal, or chalky surfaces
- Painting with a bargain-priced topcoat

and money: when you think about it, tinted primer is a no-brainer.

One other tip is to make sure you use the primer that was formulated for the brand of paint you're using. I've seen good-quality paint crackle after it's applied over another brand of primer. Every brand has its own chemical makeup, and mixing brands won't give you the best results.

Should I buy "green" paints?

There are a few things homeowners need to know when it comes to no- or low-VOC paint. First, VOCs are volatile organic compounds. These chemicals are released into the air in your home as the paint dries. In any paint—low-VOC or not—the chemicals keep off-gassing for years after the paint dries.

The two most popular attributes you want in paint are high adhesion and high washability. You can't get that from a no-VOC paint—yet. Keep in mind that some brands of no-VOC paint are still in the development stage. You may not get the same quality as you would get with a low-VOC or regular paint. You can get high adhesion and high washability with a low-VOC or regular paint.

Recycled paint is another option if you want to reduce your footprint. This kind of paint is usually made from end runs of manufacturers' lines, or the by-products of industrial use. A new alternative is DuRock's Green Friendly Paint. It is a recycled paint that comes straight from the factory and is LEED approved.

Bottom line: When you're looking for paint, always speak to a high-end paint retailer and ask them which one they would recommend based on your needs (where the paint is going and what you expect from the product). If you want a low- or no-VOC paint or a recycled paint, tell them why. They can guide you to the right paint for the job.

Which tile is more desirable: natural slate or porcelain?

Really, it's a matter of taste. Both come with their share of benefits and drawbacks.

Eco-friendly Tiles

Tile is always a somewhat green choice in my books because it's long-lasting, doesn't off-gas, and it can be cleaned without chemicals. Stone is natural on the one hand, which is good. But take marble, for example: it literally leaves a huge footprint on the earth when it's extracted (quarried) and then transported halfway around the world from countries like Italy or India.

So, how can you get tile with a smaller footprint?

- Source local stone—Find stone that's been quarried as close to home as you can get it. Depending on your state or province and the stone you want, you might be able to get it from within a couple hours' drive. That means you'll have to choose a stone that's quarried in North America, such as slate, limestone, or granite. You can ask at the tile store if they have any local stone tiles, or you can find out where local quarries ship their stone.
- Use recycled tiles—Various tile manufacturers are now making ceramic, porcelain, and glass tiles with recycled content. The higher the reclaimed content, the better. Post-consumer or post-industrial waste is better than pre-consumer or pre-industrial waste since it means the tile contains leftovers from a product that has had a useful lifespan and would otherwise wind up in landfill.
- Reclaim or reuse old tiles.

Slate is a natural stone. It looks great, it ages well, and it lasts forever. It's also expensive and it can be difficult to work with if it's got a rough finish. Installing slate is definitely not a simple do-it-yourself job. Natural stone is porous, so you need to seal the tile before it's installed or the grout will absorb into the tile and give the surface finish a cloudy stain that won't come out. You should also seal the tile every few years or it will get marked up with stains from everyday traffic. If you're willing to overlook those disadvantages, there's no substitute for the timeless look of nature stone.

Personally, I'd go with porcelain. Like stone, it's extremely durable. Porcelain is harder than ceramic, plus it shows the same color throughout the tile, so it won't show cracks and chips like ceramic does. It doesn't need to be sealed because it's not porous. And you can't argue with the variety: porcelain

comes in just about an unlimited number of colors, sizes, and patterns. Some tiles are even made to look like natural stone.

In both cases, tiles are heavy, so you'll need to make sure your contractor starts by building a solid, level subfloor. For strength, I like ⅝-inch plywood instead of OSB. And I recommend putting Ditra under tile whether you're using porcelain, slate, or ceramic. It's a rubber waterproof membrane that lets trapped vapor escape without damaging the tiles, and it helps prevent the tile and grout from cracking.

What is engineered lumber and why do you like it?

Engineered wood products (or EWPs for short) are manufactured by bonding together wood strands, veneers, lumber, or wood fiber to produce a composite product that is stronger and stiffer than the sum of its parts. There's a lot I like about engineered lumber.

I'm sure many homeowners are familiar with EWPs, even if they've never heard of engineered or composite wood. Particleboard, plywood, OSB (oriented strand board), MDF (medium-density fiberboard)—the kinds of products we associate with building kitchen cabinets or shelves—these are all common examples of engineered wood. Engineered wood can be used for structure, sheathing, or finishing. The truth is, more and more engineered wood products are holding up family room floors, roofs, even whole houses.

I like wood, don't get me wrong. But Mother Nature doesn't grow perfectly consistent trees. Every piece of lumber gets unique character from markings such as knots. That's a desirable feature that adds warmth and beauty when we're talking about knotty pine in a cottage family room. But in structural lumber, knots are weak spots.

Engineered lumber is strong and straight, and you can get it in lengths and dimensions that you just can't find in natural wood. One thing that makes these products superior is how they're made. Trees are broken down into pieces: strips of the best wood content are bound together using tough adhesives and pressure for maximum overall strength. Knots and voids are virtually eliminated thanks to the manufacturing process.

Products are manufactured carefully to maximize strength. For example, a header beam running horizontally has the grain running parallel with its length, so it's ideal for supporting loads from above. Managing the orientation of fibers like this makes EWPs stable, uniform, and safe, so every piece is

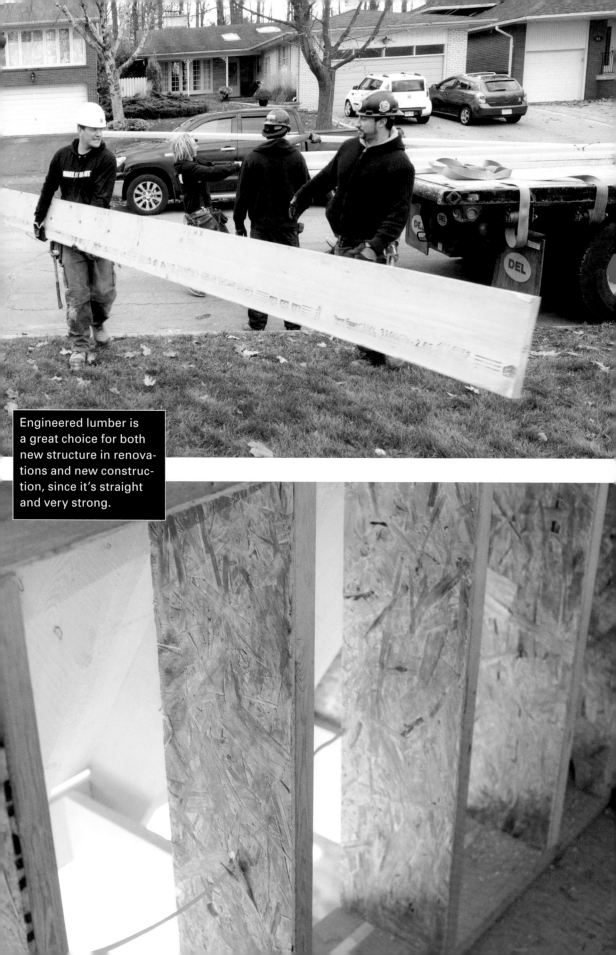

Engineered lumber is a great choice for both new structure in renovations and new construction, since it's straight and very strong.

usable. Unlike lumber, these boards resist warping and shrinking. They have certified strength ratings, so you know they're tough.

Many of these products are also environmentally smart. They're made from fast-growing softwood trees that are small in diameter—they wouldn't otherwise be valuable as solid lumber. The finished product has no relation to the size of the trees the wood comes from, so these smaller trees can be used to make large pieces of lumber. It takes the pressure off old-growth forests and puts the focus on sustainable, fast-growing trees like poplar. These are shredded into bits, so there's not much waste. You can even find some OSB that contains wood chips leftover from industry; products made from recycled content make EWPs even more eco-friendly.

In some parts of the world where there's no access to lumber, they can even engineer building products without wood. Instead, they use fibers from straw, hemp, and other grasses or vegetables.

Of course, all this processing has a drawback: it's expensive. Engineered wood costs more per linear foot than traditional sawed lumber. Fortunately, you can actually save money if your contractor uses them properly in your project.

Engineered lumber can require less material, time, and labor to install. Even though it is stronger, pound for pound, than wood or steel beams, it is also lighter. For example, TJI joists by Weyerhaeuser are often used for floors and roofs because they resist warping, twisting, and shrinking. They're light and they come in long lengths, and the additional strength means you need fewer joists: you can work with spans up to 24 inches, which saves you money during a renovation and gives you more room to run ductwork between the joists. As a bonus, the stiffness of these boards helps protect against squeaky floors. Beams and boards can be custom-sized during manufacturing, which means no cutting to fit on the job site, and less waste.

Microllam is a brand of laminated veneer lumber (LVL) that's fabricated to resist bowing, shrinking, and twisting. These are typical wood defects that can cause cracks in drywall. Microllam can be used as a header or beam that gives you superior strength with less weight.

PinkWood is another new wood product I like. Its factory-applied wood coating system helps wood resist fire and the moisture that can lead to mold and fungus growth. I'm starting to sound like a cheerleader for the EWPs industry, but these

products have their flaws. Up to 5% of every product is adhesives, which give off fumes. It's a good idea to seal the ends of cut boards to stop them from off-gassing and adding pollution to your indoor air.

Engineered lumber also has limited uses. At the moment, you can only use most products indoors. And it takes time and effort for contractors to learn how to use the products. Subcontractors need to be careful when they're routing plumbing and electrical through engineered lumber: cuts need careful planning. But learning this means they have to read about the acceptable applications of each material and it's just easier for most to default to the same old products they've always used even if they're not as environmentally friendly or durable or as versatile.

The biggest problem with these new wood products may be that they're hard to find and not available everywhere. Not many are kept in stock at building centers, which means building in extra time for ordering and extra budget for shipping. If the industry can improve distribution and supply, more homeowners will be able to benefit. I think these products are worth the extra cost and effort.

What is grout? Should you seal grout?

If my in-box is any indication, then a lot of people are confused about grout. They get stuck when it comes to the tiling stage of a bathroom or kitchen renovation. Maybe they've finished the remodel and already they're frustrated that the grout in their tile floor looks grimy in all the high-traffic zones. They're tired of cleaning it and they want a quick fix, so they're wondering about all the companies promising grout sealing or coloring as one of their services. Or they're not sure if they should pick up a product to protect and seal grout. Who wouldn't be confused?

Grout is mortar that's used for filling the gaps between tiles. Most grout is porous and it will absorb whatever is spilled on it, which is why you're guaranteed to have someone tell you to apply a sealant on the grout. It's true this will stop moisture from penetrating, but only temporarily.

I don't think you should ever seal grout. The reason is that grout needs to breathe. Eventually some water or vapor is going to come into contact with the grout and get behind your tiles. You want that moisture to be able to escape, which it can as long as the grout can breathe. If water gets behind sealed grout, how will that dampness

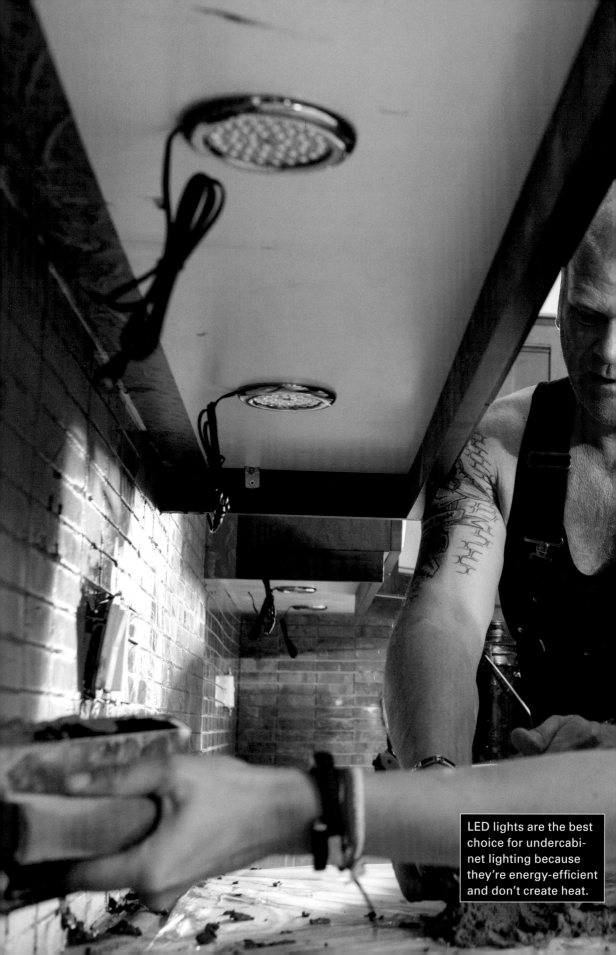

LED lights are the best choice for undercabinet lighting because they're energy-efficient and don't create heat.

be able to evaporate? The longer it stays put, the greater the odds of getting mold and rot.

Tiles are a different story: you absolutely should seal porous tiles like stone or terra cotta. (There is no need to seal porcelain or ceramic.) This should be done before the tiles come into contact with the grout or else the grout will penetrate the tile and ruin the surface of the stone. You can choose matte or glossy finishes. I love the look of matte; gloss shows every flaw. And don't go cheap: you want two coats of a good sealant that will penetrate, not just sit on top.

You definitely want to put down a waterproof system before you lay down tiles and start grouting. I like to make the floor watertight with a layer of Schluter Ditra and Kerdi against the edges of the walls. You can read more about this on pages 145–147.

People often ask me about epoxy grout. Some people say it's more durable and better at resisting stains, but I don't think it's necessary if everything is watertight underneath. I generally don't like epoxy grout because it doesn't breathe. The exception is countertops: if you're putting in a ceramic tile countertop, you're going to want epoxy grout with a watertight membrane (like Ditra) underneath.

Why do I need to use silicone caulk? What is caulk used for anyway?

Caulk is a compound used to provide an airtight, watertight, or nonporous seal. It's usually used to prevent something—air, liquids, steam—from entering or escaping between two materials. For example, I recommend adding a bead of caulk along the bottom of a kitchen backsplash where it meets the countertops to prevent spills and dirt from getting in that crevice, or along the corners of siding to make it more watertight. Just think of it this

way: caulking should be applied wherever two materials touch—like where brick walls meet wood window frame.

Caulking is engineered for different purposes: what might be great for sealing around your windows isn't what should be used around your shower door. This is one of those times where you really need to read the label. You'll find products for interior, exterior, and low and high temperature use. Some of the factors to consider when choosing the right caulk are flexibility, durability, whether it can be painted, temperature rating, water resistance, and price. Ask these questions: Will it be used inside or outside the house? And will it be used in a wet area, like a bathroom or kitchen?

Caulking has to stick to make it work. If you're sealing something on the exterior, your best bet is a special rubberized caulking that works with porous materials like exterior masonry and cement. It allows for movement; it can handle sun, rain, and melting snow; and it lasts a long time.

As for silicone caulk, this is what you want in your bathroom to seal around the tub or the glass shower enclosure. If you use a latex product, you'll get mold. You should always use silicone in a wet area because it's waterproof. There are silicone caulk products for indoors and out, and the exterior products allow for expansion and contraction due to weather.

Why should I use wood certified by the Forest Stewardship Council?

I think we should all be using the best wood products we possibly can in our renovations, and by that I mean wood that's sustainable. Sure, wood is natural because it comes from the earth, but natural and eco-friendly aren't always the same thing. Some of those exotic hardwoods may be coming from questionable harvest practices in South America. Even the lumber industry here in North America isn't perfect.

One solution is to look for wood products that are certified by the Forest Stewardship Council (FSC). FSC is recognized around the world as having the highest independent environmental standards for responsibly managed forests. It means when you buy wood that's certified by FSC, you know your purchase isn't supporting destructive forestry practices. The certification benefits us all by protecting forests and wildlife instead of just using trees to make a quick buck.

It used to be tough to find FSC products because there were only a few suppliers in North America, but it's getting easier. The FSC website has

Can Exotic Woods Be Green?

Exotic woods used to give a sense of luxury. That is, until we heard reports that the Amazon rainforest—where many exotics can be found—was shrinking. That's the thing with exotic woods: you need to be careful. If you're not, that sleek rainforest-wood deck might be contributing to the destruction of environmentally sensitive forests.

Not all exotics are destructive. In fact, there are a couple of guys from Alberta who are doing cutting-edge logging to make eco-friendly hardwood flooring (EnviroHardwood.com). They're harvesting timber that was submerged in a lake in Suriname, and they're processing it using the most energy-efficient methods possible.

If you're dead set on using exotic woods, I hope you're committed to sustainability. Do your homework to find out where the lumber came from. If you want a shortcut, make sure the wood carries one of these marks for sustainability:

FSC—Stands for Forest Stewardship Council, which is internationally respected for setting the strictest environmental standards for responsible forestry (fsc.org).

Rainforest Alliance—One of the founders of FSC, this nongovernmental organization supports the socially and environmentally responsible use of forests (rainforest-alliance.org).

a database that lists manufacturers and distributors with FSC certification (info.fsc.org). Unfortunately, they don't list retailers yet, so you'll have to ask at your building-supply store. Some national chains, such as Rona and Home Depot, carry FSC moldings, door casings, pressure-treated wood, etc. If your store doesn't offer sustainable wood, you need to ask them to start. Consumers will be the ones to drive that demand for healthy, green products.

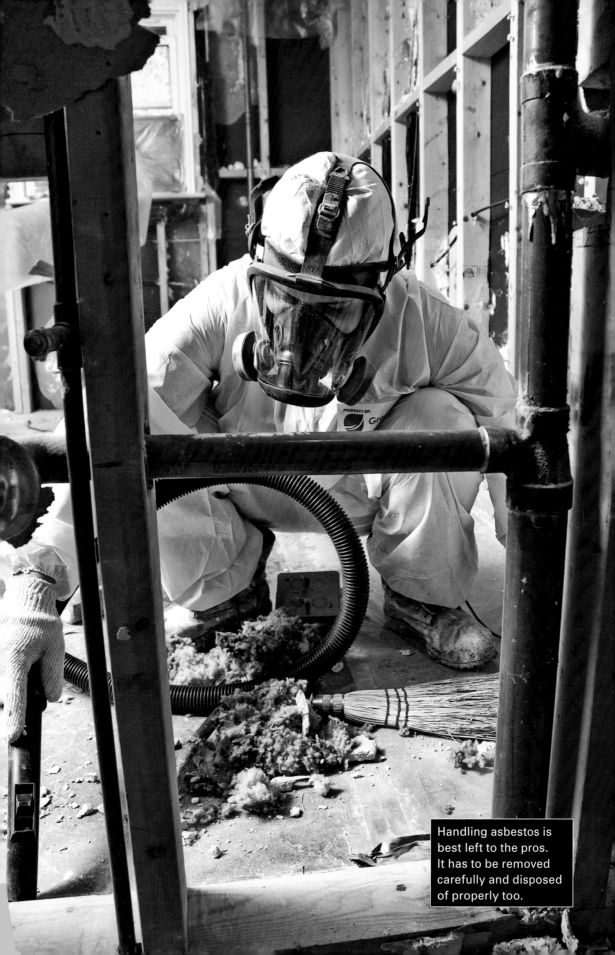

Handling asbestos is best left to the pros. It has to be removed carefully and disposed of properly too.

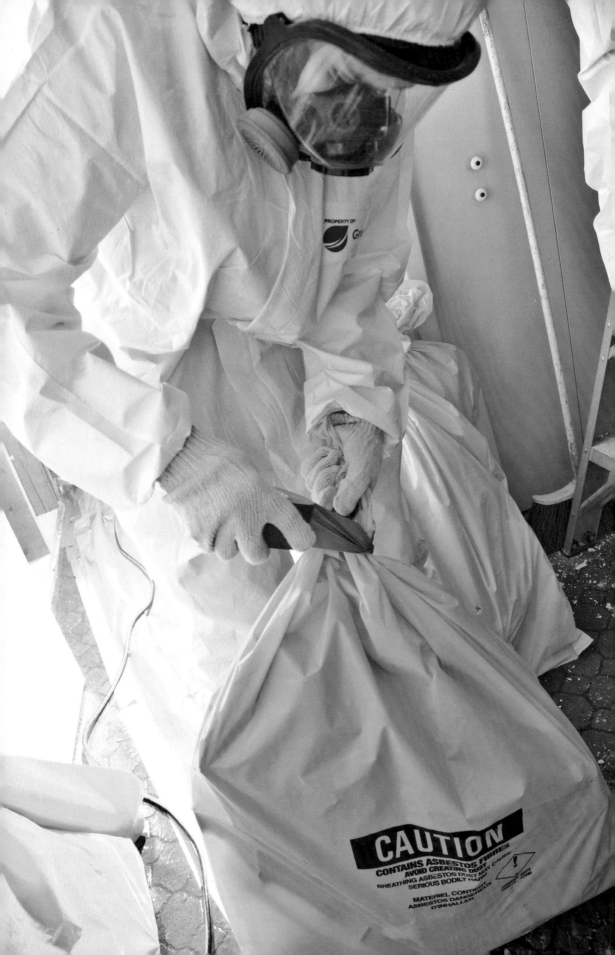

CAUTION
CONTAINS ASBESTOS FIBRES
AVOID CREATING DUST
BREATHING ASBESTOS DUST MAY CAUSE
SERIOUS BODILY HARM

MATERIEL CONTENANT
ASBESTOS DANGEREUX
D'INHALER

ASBESTOS

CANCER AND LUNG DISEASE
HAZARD

KEEP OUT

AUTHORIZED
PERSONNEL ONLY

RESPIRATORS AND
PROTECTIVE CLOTHING
ARE REQUIRED IN
THIS AREA

asbestos on the job were coming down with health problems. If the fibers are breathed into the lungs, it can lead to severe lung disease or cancer. It didn't take long for industry to phase it out of building materials, though it's still used in certain products, such as brake linings.

The thing about asbestos is it's not harmful as long as it's left in place. Both Health Canada and the Environmental Protection Agency agree on this. It's only when it is disturbed that those fibers will be released into the air. You're at risk of serious health problems if you breathe those particles into your lungs (although evidence suggests that it's people who are repeatedly exposed who are at greatest risk).

Asbestos is a concern whenever you're remodeling older homes since the process involves breaking into walls and attics where you might have asbestos. If you have asbestos in your home, it won't be hurting anyone unless you start tearing things down. If your house was drywalled before about 1980, don't start demolition until you have your walls tested to find out if there's asbestos in the compound. You can hire a specialized company to do this, or scrape off samples and send them to a lab to be tested.

The same goes for loose-fill vermiculite insulation, which was known or suspected to contain asbestos until 1990. (You can read more about this on page 187.) If you're doing renovations that might disturb the attic and you're not sure when your vermiculite insulation was installed, it's best to call a reputable asbestos removal contractor to either get rid of it or handle it safely during construction.

Don't worry about removing asbestos if you're not doing any work on your home. Asbestos is harmless as long as it's not disturbed.

What is off-gassing?

When chemicals are released into the air from artificial materials, that's called off-gassing. Some chemicals, such as formaldehyde and benzene, are known as volatile organic compounds, or VOCs. Their fumes can pollute the air you and your family breathe every day *inside* your home.

If you think these chemicals are coming from smokestacks, tailpipes, and factories, think again. I'm talking about the products in every home: furniture, candles, carpets, synthetic fabrics, cabinets, paint, varnish, wallpaper, adhesives, caulking, particleboard, insulation, cleaning products, aerosols, and air

fresheners. Sometimes you can smell VOC fumes—like in a freshly painted room or a new car—and other times they are undetectable. Odorless or not, they can still be dangerous.

These off-gassing chemicals can cause a variety of health hazards. Mild symptoms can include dizziness, stinging eyes, irritated nasal passages, headache, nausea, and asthmatic reactions. Certain chemicals are known carcinogens. Babies and children are particularly susceptible to indoor air pollution since their bodies are still developing. Every breath of polluted air has a much greater effect on them than it does on you or me. Millions of people are sensitive to chemicals, and even low levels of VOCs can make them really sick.

Some products cure quickly, such as spray-foam insulation. If it's installed properly, and the installer waits at least two hours before applying a second coat, the VOC fumes last a few days and then they are virtually gone or they're at levels so low they can't be detected. If the contractor rushes the job, the VOCs get trapped between layers and they'll continue to off-gas after you move back in. Other products off-gas for much longer—such as pressed-wood cabinets or a sofa that's been treated with flame retardants. If the materials are subjected to high temperature or moisture levels, the level of emission rises too.

Let's take carpets, for example. Most are made from petroleum- or oil-based materials like nylon, polypropylene, and polyester, woven onto a synthetic backing. Between the carpet fibers, the underpad, the backing, and adhesives, you could be inhaling VOC emissions from styrene, toluene, formaldehyde, benzenes, and many other chemicals and coatings used during manufacturing. Carpets are also a dumping ground: they collect all kinds of airborne irritants that may be spilled or tracked in from outdoors—from bacteria and mites to fungi and pesticides. It's no wonder the Lung Association warns parents not to let babies and toddlers crawl on carpets.

If you want to protect indoor air from contaminants, make sure you use products that are low in VOCs whenever possible. You can ask your contractor to use low-VOC paint, sealants, adhesives, caulking, and more. Some household items and materials don't release VOCs at all, such as ceramic tiles, glass, stone, and other hard materials.

It would be pretty expensive to remove everything from your home that may be off-gassing. That's why your best defense against off-gassing is to make sure you have a proper ventilation system to continuously exhaust contaminants and bring in fresh air.

I've heard the air quality inside our homes can be worse than outside. How can that be?

It sounds crazy but it's true. The air we breathe inside our homes can be full of biological pollutants, gases, and particulates. Indoor air can be so polluted that it can actually make you and your family sick. If your home has poor indoor air quality, you could be facing problems ranging from irritated eyes and nasal passages to nausea, headaches, and asthma attacks.

Indoor air quality is a big problem since we all spend so much of our day cooped up in offices, schools, and homes where building materials can off-gas for years. As building practices change and new homes become more airtight, forced-air heating and cooling systems recirculate dust particles, pollutants, and bacteria for years. It's one reason I keep pushing for proper ventilation: we need to move stale air outside and get fresh air circulating.

Here's what's polluting the air inside our homes.

Biological pollutants

The air we breathe is full of living organisms and their by-products: mold and mold spores, pet dander, bacteria, viruses, and dust mites (and their waste). To stay alive and grow, organisms need food and moisture. It's no wonder dust mites hang around in every home, where about 90% of household dust is skin: it's a 24-hour buffet.

Humidity

Excess moisture can lead to mold. This is not only hazardous to your health, it can attack the structure of your home. We create plenty of water vapor through showers, laundry, cooking, and even breathing. All mold needs to grow is excess moisture and organic materials, such as wood and paper— plenty of that in a house's framing and drywall.

It's one of the reasons I'm always pushing people to get the ventilation checked. If you always have condensation on the inside of your windows, or mold around the tub, it's telling you that your ventilation system may not be up to par. Excess moisture—steam from cooking or the

How to Improve Indoor Air Quality

Clear out contaminants

Clean up mold (see page 271); use nontoxic cleaners; use low- or no-VOC paint, caulk, and adhesives; and store solvents in the garage. Hire a reputable duct-cleaning company to clean furnace ducts every year or two, especially after a renovation. You'll be amazed when they show you the before-and-after shots of your ducts (make sure the company uses a camera scope to check the ductwork).

Ventilate properly

You need a sufficient air-exchange rate in your home to help extract chemicals and control humidity. Open windows or install the best exhaust fans on the market for your bathroom and kitchen (make sure you get the right size for your stove).

Filter the air

Your furnace filter traps airborne particles so you don't breathe them in. Change your furnace filter often; I'd do it once every month or two. I also recommend having an HVAC specialist install an air cleaner with a HEPA (high-efficiency particulate air) filter to remove biological and airborne contaminants.

bathroom—needs to be exhausted to the outdoors. Run your bathroom exhaust fan and range hood for twenty to thirty minutes after you've finished making dinner or taking a shower.

If your basement isn't insulated with a proper thermal break (either vapor barrier over insulation or a coating of spray-foam insulation behind the drywall), you'll need to run a dehumidifier, especially during muggy summer weather.

Off-gassing

All kinds of household items and building materials in your home release chemical vapors. They come from furniture, cabinets, candles, air fresheners, cleaning products, paint, glue, caulking, and more. Gas-fired appliances and fireplaces chip in by releasing carbon monoxide and other particles. These gases can lower indoor air quality to the point where studies have shown that, even in the countryside, the

concentration of volatile organic compounds (VOCs) inside a house is up to ten times greater than in outdoor air. You can read more about VOCs and off-gassing on pages 260–264.

The Lung Association (lung.ca) says carpets can be a real problem. The chemical emissions from the adhesives and underpad can cause everything from eye, nose, and throat irritation to allergy or flu symptoms and fatigue, especially after the installation of new carpets. Old ones trap dust, mold, pet dander, and allergens and can cause allergic reactions from mild to life-threatening (such as a severe asthma attack). I've gotten in trouble from carpet manufacturers but I still don't recommend carpets. I'd rather see hard flooring with a low-pile area rug—as long as you can and do wash the rug on a regular basis.

We're installing a gas stove in our new kitchen. What do I need to know about venting to avoid back-drafting?

It doesn't matter if your stove is electric, gas, or induction, you need to install and use an extraction fan over it when you cook. These hoods aren't just for decoration: they help control excess moisture and remove cooking fumes.

Kitchen ventilation systems have two main components. The part you see is the exterior hood. Inside the hood are the "guts" of the system— the exhaust fan and ductwork—that help extract air, smoke, and moisture. Ideally, they should be installed right over the cooking area and extend out over the surface of the stove. They have to be close enough to extract air, but not so close that you're bumping your head while you cook. I find that too many "designer" hoods are placed too high to do a good job.

Of course, the fan needs to exhaust to the outdoors. Don't even think about exhausting into the attic or soffits or a crawl space. Venting into the attic creates a whole new world of problems: the last thing you want is hot, moist air in your attic, where it can cause condensation and lead to mold, rot, or ice dams on your roof. Second, if you ever have a fire on the stove, the exhaust fan could pull the fire into the attic, where it can quickly spread throughout the house.

Make sure you get a fan that's the right size for your stove and house. One that's too big will boost your electricity bills and waste larger amounts of conditioned air, which you're paying to heat or cool.

An oversized exhaust fan can create bigger problems: depressurization (also

known as negative pressure), which can lead to back-drafting. It's what happens when an exhaust fan pushes out so much air that the air pressure in your house becomes much lower than the air pressure outside. That can pull deadly combustion gases from other, less powerful appliance exhaust systems back *inside* your house. These gases are the by-product of fireplaces, hot water heaters, gas furnaces—any combustion appliance that is vented outdoors. If you breathe in these gases, you can die.

If a professional designed and installed your HVAC system—including the kitchen exhaust fan—the ventilation will have been balanced. You'll have the right amount of air being extracted and brought in or recirculated. If you don't have enough air to replace what the fan might pull out, you risk depressurization and back-drafting.

If you're not sure about your ventilation system and kitchen exhaust, call in a qualified HVAC professional to take a look and install a CO alarm in your home. Every home needs an alarm anyway.

What is radon? Can I test for it?

Radon is the new mold. By that I mean that people are exploiting a fear of it to make money. I've heard of homeowners finding letters in their mailboxes from a so-called Radon Notification Department. The letter warns that increased radon has been found in the area, and recommends the owner get the house tested.

Radon comes from uranium, which can be found in all kinds of soil. When uranium breaks down, it produces a radioactive gas that's odorless, colorless, and tasteless—radon. When this gas is released outdoors, it gets diluted as it disperses throughout the air. If it gets into your home, it can accumulate. That's when it gets dangerous.

If you or your family is exposed to high levels of radon over time, you could get lung cancer. In fact, radon is the second leading cause of lung cancer after smoking: 10% of all cases of lung cancer in Canada are caused by radon. In total, about 2,000 Canadians and 20,000 Americans die each year due to chronic radon exposure.

In 2009–10, Health Canada surveyed homes across the country and found that 7% had radon levels that were too high. An acceptable level is considered to be 200 Bq/m³, or 200 Becquerels per cubic meter (Becquerels are used to measure radioactive concentration).

Different parts of North America have different levels of radon. Where uranium is mined, radon levels are higher.

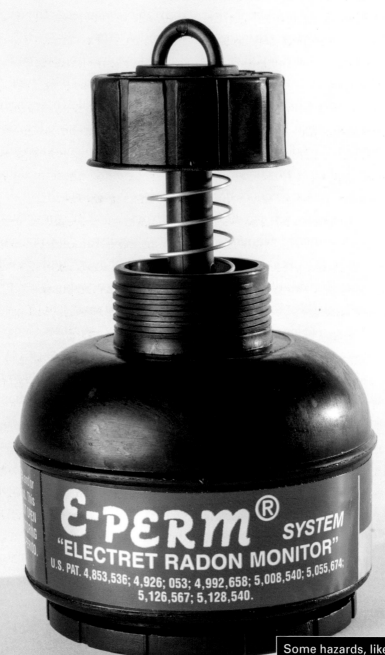

E·PERM® SYSTEM
"ELECTRET RADON MONITOR"
U.S. PAT. 4,853,536; 4,926; 053; 4,992,658; 5,008,540; 5,055,674;
5,126,567; 5,128,540.

Some hazards, like radon, are invisible. Your home might need to be tested. First, try checking with your local building department to see if radon is a potential hazard in the area where you live.

That's why the highest concentrations in Canada are found in Manitoba, New Brunswick, Saskatchewan, and Yukon. In the United States, you'll get the highest average concentrations in Iowa and the Appalachian Mountain areas of Pennsylvania.

So if radon is found in soil, how does it get inside your house? Lots of ways: through unfinished floors in basements and crawl spaces, around pipes, windows, open sump pits, cracks in foundation walls and floors, even through the foundation itself. Remember that concrete is porous and radon is a gas that can seep through tiny holes in concrete.

Radon levels fluctuate depending on the weather, humidity, home, and season. Levels tend to be higher in winter when we keep our windows and doors shut and the gas accumulates in the house. For that same reason, winter is also the best time to test for radon.

Testing is the only way to find out if you have a radon problem, no matter where you live. One house can have radon levels close to zero while the neighbors' might have levels that are off the chart.

You can take one of two routes for testing. First, you can buy radon test kits at big-box stores or from environmental organizations. These are cheaper, but testing can be tricky. For example, the lowest part of the house that's occupied for at least four hours a day is where the detector gets placed. At the same time, it can't be a room with too much humidity, like the kitchen or bathroom. It has to be away from vents and other objects, and must be set up a minimum distance from interior walls, exterior walls, the ceiling, and the ground. If you don't follow these instructions, you'll mess up the test.

That's why there are professionals who are trained to measure radon. Make sure you hire someone who is certified by the National Environmental Health Association (NEHA) or National Radon Safety Board (NRSB).

There are short-term and long-term tests for radon. Short-term is usually done over two to seven days; long-term is anywhere between one and twelve months. The longer you test, the better your results since the longer timing averages out those fluctuations you find over the seasons. Health Canada recommends a minimum of three months. But what if there is a radon issue? Should you be waiting months to find out?

Your best bet is to do a short-term radon test in closed conditions, which means keeping windows and doors shut as much as possible. You can set this

up while you're away on vacation. If the results show radon levels higher than 200 Bq/m³, that's a good time to call in a pro to confirm.

Fixing a radon problem can cost anywhere from $1,500 to $3,000. Again, you need an experienced radon mitigation pro who is certified by the National Radon Proficiency Program.

You can help reduce the risk of radon accumulation by putting a cap on sump pumps and sealing cracks in foundations. The most effective method involves drilling through the basement floor to install a pipe with a fan. This process is called depressurization. It draws the gas from the ground and exhausts it outside the home.

How do I test for lead in old paint? Should I bother or just paint over it?

Lead used to be a common ingredient in oil-based paints because of its adhesive, color, and drying qualities. Oil-based paint manufactured before the '50s contained as much as 50% lead. If you're remodeling an old house, you need to know whether or not it's got leaded paint before you start tearing it apart.

If you start sanding walls or trim where there's leaded paint, your body can absorb the lead from the dust particles. Your body thinks it's calcium and deposits the lead in your bones and organs, where it accumulates. This is especially serious for young children and pregnant women. Studies have found that even at low levels, lead concentrations in the blood are linked to a lower IQ in kids. If pregnant women are exposed to lead, it can be transferred to the baby. Higher concentrations of lead have been linked to chronic fatigue, high blood pressure, kidney damage, anemia, and problems associated with the central nervous system.

Lead paint is only a problem if you breathe in those particles. If you want to freshen up an old house with new paint, then you can just prime and paint—lead won't be an issue as long as you don't sand or scrape the old paint.

If you're planning a reno where you'll be knocking down walls or window casings, you should test the paint to see if it contains lead. You can pick up chemical test kits at hardware and building-supply stores for under $30. A positive reading tells you you've got lead but won't tell you how much. These kits aren't ideal: you have to test every layer of paint down to the bare surface and you need to do that by exposing each layer—otherwise the chemicals in the kit

won't work. Dark surfaces are hard to test since the kits themselves darken when lead is detected. You might get a false positive if the kit picks up other metals in the paint.

Your best bet is actually to send a paint chip to a lab for testing. Make sure you include every layer of paint. In a few weeks, you'll get accurate results.

If you find leaded paint, you'll have to minimize dust to reduce your risk of lead exposure. Some activities pose more of a risk than others. Obviously, laying a carpet isn't going to disturb old paint, but ripping out a wall will.

You can paint over the wall as long as the leaded surface is in good shape—you don't want to see any peeling paint—and you don't sand the leaded surface. You'll need a primer if you're transitioning from oil to latex paint.

You can get more detail on precautions to take with lead paint on the website of the Canadian Mortgage and Housing Corporation (cmhc-schl. gc.ca).

What's the best way to deal with mice? Where do they get in?

Mice find their way into our homes looking for two things: warmth and food. Cold weather often drives them indoors to find shelter, and our homes look that much more enticing if they can find a food source. They get in through cracks and anywhere there's a gap: around vents, wires, pipes, windows, and doors.

Anyone who's had mice knows they're not great houseguests. They can chew through electrical wires and cause an electrical fire. They can destroy rigid foam and fiberglass batt insulation. They can eat away at any wood in the house including furniture, trim, cabinets, doors, even the wood in your home's structure.

If you've got mice, you can try setting out traps. I don't recommend using poison to get rid of them. Poisons are not always effective, and you don't want to put the family pet at risk: pets can eat the poison or the poisoned dead mouse. Plus, when a poisoned mouse dies it's often somewhere inaccessible, like behind a wall. You'll know it when you get a foul smell. To get rid of the mouse, you'll have to damage the wall.

To stop mice from getting inside, check annually for cracks and seal them. Always get an experienced exterminator to address the problem. They can find where the mice are coming in and block their entry with mesh wiring, wood, and/or spray-foam insulation.

Other solutions include weather stripping around your doors—this also

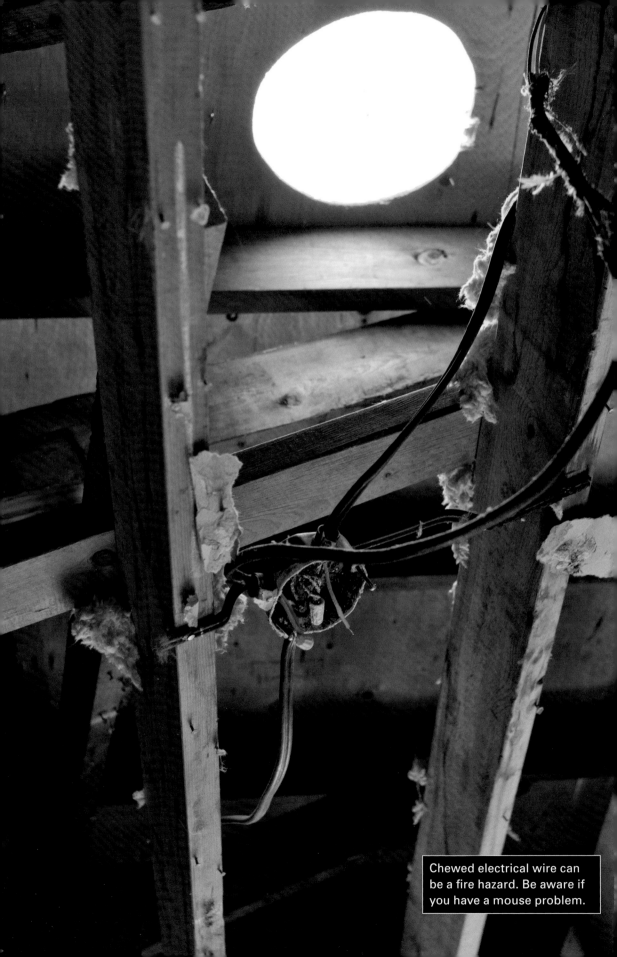

Chewed electrical wire can be a fire hazard. Be aware if you have a mouse problem.

increases energy efficiency—chimney caps on chimneys, keeping compost far away from the house, and moving firewood and mulch away from the home's exterior.

A sealed home is the only way to stop the problem. It's the most effective and humane solution.

I have an opportunity to buy a house that has been neglected. It is full of mold, but I think I can gut it and make it livable. Is it worth it?

First, you need to get a reputable mold remediation company to come in and get rid of the mold. I hope you've got some spare cash because this is going to cost you. Then, you need to find the source of the problem and fix it or you'll wind up cleaning up mold over and over.

Get a home inspector to come in so you can find out what could be causing the mold. The problem is that some issues you won't be able to see until you start to tear down the walls. By then it's too late to back out.

I wouldn't recommend buying the house. But if you love the neighborhood, the house is the exact design you're looking for, it's cheap, and you have enough money to get rid of the mold and moisture issues for good, then it might be worth the investment. The cost of mold remediation can be used as a bargaining point. But this isn't the right house for everyone.

Index

Note: Page numbers in **bold** type refer to photographs.

AFCI (arc-fault circuit interrupter), 108
air conditioning. *See also* HVAC system
 with ceiling fans, 108–10
 as dehumidification, 92
air leaks, 170–73
 in attic, 171, 183
 in ductwork, 181–82
 around windows, 81, 87, 171–73
air quality, 262–64. *See also* mold; off-gassing
appliances. *See also specific appliances*
 power needs, 106, 108, 125
 scale buildup in, 120
asbestos, 187, 254, 256–60
aspenite. *See* OSB (oriented strand board)
attic, 6. *See also* roof
 air leaks in, 171, 183
 condensation in, 27–28, 29–31, 100–101

finishing, 31–33, **162**
insulating, 31, 34, 155–62, 183–84
lighting below (recessed), 9, 100–102, 183, 184
mold in, 6, 29–31
vapor barrier in, 9, 31, 184
ventilating, 6, 8–9, 24–31, **156–57,** 158, 161

back-draft, 264–65
backflow preventers, 217
bamboo flooring, 133
basement. *See also* foundation
 bathroom in, 208–11
 carpet in, 191, 192, 193, 196
 ceiling for, 225–28
 condensation in, 192, 194, 205
 "digging out," 217–23
 drains in, 190, **209,** 210, 211, 213–17
 finishing, 189–91, 194, 203, 210, 222–23
 floors in, 191–96, 206, 211, 230–31

basement (*cont.*)

 insulating, 159, 190–91, 194, 203–6

 leaky, 40, 201–3, 228–30, 231–32

 mold in, 192, 193, 228, 255

 sump pumps, 126–27, 206–8, 231

 underpinning, 217–23

 vapor barrier in, 193, 206

 waterproofing, 191, 194, 196–200, 202, 206–8, 212, **220**

 windows in, 196, **199**

bathroom, 136–50. *See also* showers and tubs; toilets

 in basement, 208–11

 drains for, **209,** 210, 211

 floor in, 70, 130–31, 147, 148–50

 mold in, 131, 136, 142

 spa-style, 142–45

 ventilation of, 82, 140–42, 148

 walls in, 136–39, 145–47

bedroom

 electrical needs, 108, 122

 lighting in, 100–102

 over garage, 89–90, 171

 ventilation needs, 93

bench pinning, 222–23, **224**

breaker panel, 104, **105,** 106, 125

brick

 mortar repair, 40

parging, **41**

salt damage to, 65

spalling of, 49, **50**

waterproofing, 40–43

building code. *See also* building permits

 for attic, 27, 31, 34

 for basement, 205, 206, 208

 for bathroom, 136–38, 140

 for brick walls, 6

 for electrical system, 106, 108, 110, 122, 226

 for exhaust fans, 142

 for fences, 63

 for foundation, 190, 218

 for insulation, 154, 158

 for plumbing, 118

 for roof, 9, 10, 45

 and stucco, 39

 for subfloors, 69, 70, 240

 for vapor barriers, 154

building paper, 39. *See also* house wrap

building permits, 208–9. *See also* building code

 for attic, 33

 for basement, 191, 208–9

 for decks, 58

 for electrical work, 122, 126

 for foundation, 222

 for renovations, 100, 122, 208–9

 for sagging joist repair, 72

bump-outs, 136

canopies (window), 68

cantilevers, 78, 136

carbon monoxide, 163, 192–93, 265

carpet
 in basement, 191, 192, 193, 196
 as health hazard, 193, 261, 264
 subfloor for, 196

cathedral ceilings, 33, 34

caulking, 172, 249–50

cedar (as deck material), 53–54, 55–57, 59

ceiling
 for basement, 225–28
 cathedral, 33, 34
 drywall, 225–26
 plaster, 93–95
 soundproofing, 225–26
 suspended/drop, 226–28

ceiling fans, 92, 108–10

cellular PVC, 57, 59

cement board, 139
 for bathroom, **138,** 139, 145
 for siding, **35,** 36, 46

cheater (AAV) vent, 117–18

chimney, 171, 271

chipboard. *See* OSB (oriented strand board)

circuit breakers, 104, **105,** 106, 108, 125. *See also* fuses

clapboard, 36

closets, 106–7

clothes dryer
 lint trap for, 179–80
 venting, 176–80

code. *See* building code

color temperature, 113

composite wood (for decks), 57, 59

concrete (poured)
 for floors, 135, 192–93
 for foundation, 224
 sealing, 193

concrete block, 223–24

condensation. *See also* mold
 in attic, 27–28, 29–31, 100–101
 in basement, 192, 194, 205
 causes, 79–82
 HVAC system and, 79–82, 92–93
 on skylights, 92–93
 on windows, 78–82

contractors
 communicating with, 235
 hiring, 211–13, 222

cork (flooring), 132

cracks, 173
 caulking, 172
 in foundation, **201,** 203

crawl space, 165, 173–76

damp-proofing, 202. *See also* waterproofing

DaroTopp floor system, 135–36

decks
> building, 57–58
> finishing, 58–61, 64
> maintaining, 54, 55, 57, **61**
> materials for, 53–57, 59

dehumidifiers, 81, 92, 228

Ditra waterproofing membrane,
70, **146,** 147, 194, 244, 249

doors
> to basement (exterior), 218
> insulating, 173
> sticky, 88–89

downspouts, 19, 21, **23,** 190, 215.
See also gutters (roof)
> problems with, 215, **216,**
> 229, 231

drafts. *See* air leaks

drainage. *See also* downspouts;
drains; hydrostatic pressure;
weeping tile
> with brick walls, 40
> easements for, 51
> around foundation, 190, 196
> around house, 196–98, 212,
> 229, 231–33
> with stucco finishes, 38

drains
> backed-up, 213–17
> in basement, 190, 213–17
> for basement bathroom,
> **209,** 210, 211
> from house, 213–15
> inspecting, 190, 213–15
> from sink, 116–18, 150

venting, 116–18, 209–10

driveway, 196

dry rot, 186

drywall, 136, 139
> for basement, 191, 225–26
> in bathroom, 136
> for ceiling, 225–26
> installing, 95–96, 139, 238
> painting, **241**
> popped screws/nails in,
> 95–96, 97, 236–39
> as soundproofing, 183,
> 225–26

duct tape, 182

ductwork, 167, 168–70
> for additions, 165–67
> air leaks in, 181–82
> in attic, 33
> cleaning, 154, 168–70, 263
> in crawl space, 165, 175–76
> flexible, 176–79, 181
> taping, 181–82

DuRock, 93–95

easements, 49–51, 53

eaves troughs. *See* gutters (roof)

efflorescence, 201

EIFS (exterior insulating finish-
ing system), 29, **37,** 38

electrical system, 99–100, 102–6,
110–12, 120–26. *See also* wiring
> for bedroom, 108, 122
> circuit breakers, 104, **105,**
> 106, 108, 125

documenting, 100

outlets, 108, 110–12

overloaded, 104–6, 107

planning, 121–22

power available, 124–25

replacing, 120–22

surge protection for, **105,**
 123–24

energy recovery ventilator (ERV),
 177

Energy Star, 88, 115

EWPs (engineered wood prod-
 ucts), 133, 244–47

fans. *See also* ventilation

for bathroom, 82, 140–42,
 148

ceiling, 92, 108–10

exhaust, 140–42, 148, 176,
 264–65

for kitchen, 264–65

fasteners. *See also* nails

choosing, 97, 236–39

for concrete, 194

for decks, 55

for fences, 238

popped (drywall), 95–96

faucets, 118, 140

fences

building, 62–63

fasteners for, 238

finishes for, 64

and property line, 49,
 51–52

fiber cement board. *See* cement
 board

Filtrate furnace filters, 166

fire safety

dryer and, 176–79

exhaust fans and, 264

materials for, 69

for shared walls, 182

wiring and, 103, 106,
 124

floors. *See also* subfloors

for attic, 31–33

in basement, 191–96, 206,
 211, 230–31

in bathroom, 70, 130–31,
 147, 148–50

bouncy, 68–70, 97, 240

concrete, 135, 192–93

hardwood, 68, 74, 132–33

heated, 193, **195,** 230–31

jacking up, 72

joists supporting, 68–70, **71,**
 73

in kitchen, 70, 129–30,
 131–36

materials for, 68, 131–36

raised, 211

replacing, 74, 129–31

sloped, 70–74

squeaky, 74–76, 97

waterproofing, 70

footings, 217–18

Forest Stewardship Council,
 250–51

foundation. *See also* basement
 cracks in, **201,** 203
 drainage around, 190, 196
 footings for, 217–18
 materials for, 223–25
 settling of, 73
 slab (concrete), 53
 underpinning, 217–23
 waterproofing, 190, 200,
 211–13, 225
furnace
 air supply for, 185
 capacity of, 33, 163
 cleaning, 154
 dehumidifier for, 81
 exhaust for, 163
 filters for, 81, 166, 263
 heat recovery ventilator
 (HRV), 81, 93, 176, 177
fuses, 104, 106, 125. *See also* cir-
 cuit breakers

gable vents, 28, 29
garage
 door, 90, 171
 living space above, 89–90,
 171
gardens, 200, 232–33
GFCI (ground-fault circuit inter-
 rupter), 110–12
greenboard, 136–38, 139
grout
 for bathtub, 147–48
 epoxy, 147, 249

for footings, 218
 sealing, 147–48, 247–49
 for tiles, 247–49
gutters (roof), 19–24. *See also*
 downspouts
 keeping clear, 9, 20–21

heating. *See also* HVAC system
 for crawl space, 175
 in-floor (radiant), 193, **195,**
 230–31
 propane, 163
heat recovery ventilator (HRV),
 81, 93, **167,** 176, 177
HEPA filters, 263
house wrap, 46–49, 158
humidity. *See also* condensation
 and hardwood floors, 74,
 75
 problems caused by, 262–63
 removing, 81, 92, 228
HVAC system. *See also* air condi-
 tioning; heating; ventilation
 and air quality, 262–64
 air returns for, 92–93, 167,
 170, 185
 balancing, 163–68, 175, 176,
 184, 265
 checking, 153–54, 163
 cleaning, 154
 and condensation, 79–82,
 92–93
 heating/cooling vents of,
 81–82, 184

renovations and, 33, 90, 163–68

hydrostatic pressure, 201–3, 231

ice
melting, 63, 65
preventing, 10
on roof (dams), 7–8, 9, 24, 183

ICF (insulated concrete forms), 225

Improvement Location Certificate (ILC), 51

insulation, 154. *See also* spray-foam insulation
asbestos in, 187, 256, 260
in attic, 31, 34, 155–62, 183–84
for basement, 159, 190–91, 194, 203–6
batt, 159, 160, 183, 184
for crawl space, 173–76
dirty, 183
fiberglass, 159, 160
loose-fill, 159, 161–62, 184, 187, 260
over garage, 89–90
for recessed lighting, 17, 101–2, 184
rigid-board foam, 159, 160, 194, 206
R-value of, 154, 158
for soundproofing, 182–83
types, 158–61
vermiculite, 187, 260
for windows, 81, 86, 173

jack posts, 72
Jewelstone flooring, 38
joists
in basement, **71,** 73
blocking for, 74–76
under floors, 68–70, **71,** 73
materials for, 246
sagging, 72
junction boxes, 100, 122–23

Kerdi waterproofing membrane, 139, 145–47, 249
kitchen, 129–30, 131–36
bumping out, 136
floor in, 70, 129–30, 131–36
lighting for, 113, **248**
ventilating, 264–65

laminate flooring, 133
landscaping
as drainage problem, 200, 232–33
and property lines, 49, 52
lightbulbs, 106–7, 112–14. *See also* lighting
for ceiling fans, 109
CFL (compact fluorescent), 107, 109, 112, 113–14
color temperature of, 113
fixtures for, 113, 114
incandescent, 106, 112

lightbulbs (*cont.*)
 LED, 107, 109, 112–13, **248**
lighting. *See also* lightbulbs
 for bedroom, 100–102
 in closets, 106–7
 flickering, 104–6
 installing, 100, 184
 insulation-contact (IC),
 101–2, 173, 184
 under-cabinet, 113, **248**
linoleum, 135
lint traps, 179–80

MacRae, John, 218
mastic, 192–93
metal
 for decks, **58**
 for roof, 13–19
mice, 269–71
Microllam beams, 246
mold, 254–55
 in attic, 6, 29–31
 in basement, 192, 193, 228,
 255
 in bathroom, 131, 136, 142
 causes, 254–55, 271
 dry rot, 186
 preventing, 236
 removing, 186, 271
 around windows, 79
mudjacking, 53

nails, 97, 238. *See also* fasteners

off-gassing, 260–62, 263–64
 of carpet, 193, 261, 264
 of EWPs, 247
 of paints, 242
OSB (oriented strand board), 69,
 70, 74, 239–40
outlets, 108, 110–12

paint, 240–42
 leaded, 268–69
parging, **41**
particleboard. *See* OSB (oriented
 strand board)
PinkWood, 246
pipes. *See* plumbing
plaster, 93–95
plugs (electrical), 110
plumbing system, 99–100, 114–20
 documenting, 100
 galvanized steel, **151**
 life expectancy, 114–16
 pipe noise in, 150
 replacing, 118–20
plywood
 vs. OSB (oriented strand
 board), 69, 70, 74, 239–40
 as roof sheathing, 10, 11, 27,
 45
 for stairs, 93
 as stucco substrate, 39
 for subfloor, 69, 74, 135, 194,
 206, 244
pollution. *See* air quality
porches, 68

primer, 240–42

propane, 163

property line, 49–53

PRV (pressure-reducing valve), 120

PVC, cellular, 57, 59

QuietRock wallboard, 183

radon, 265–68

Rainforest Alliance, 251

Real Property Report (RPR), 51

renovations

 asbestos and, 260

 estimates for, 211–13

 and HVAC system, 33, 90, 163–68

 leaded paint and, 268, 269

resin (for decks), 57, 59

ridge vents, 28, 29

roof, 5–6. *See also* attic; shingles; skylights

 fasteners for, 238

 "hot" vs. "cold," 34

 ice problems, 7–9, 10, 24

 materials for, 17

 metal, 13–19

 slate, **16,** 17

 vents for, 24–29, 31

Rub-R-Wall waterproofing, 225

R-value, 154, 158

safety issues, 254. *See also* fire safety; mold; off-gassing

asbestos contamination, 187, 254, 256–60

carbon monoxide, 163, 192–93, 265

lead paint, 268–69

radon, 265–68

VOCs (volatile organic compounds), 242, 261, 263–64

salt (for ice), 63, 65

saunas, 142–45

sealants

 for concrete, 193

 for grout, 147–48, 247–49

 for tile, 148, 243, 249

septic system, 126–27

setback (building), 52

sewage ejection system, 211

sewer backups, 213–17

sheathing, 240

 checking condition, 44–45

 for roof, 10, 11, 27, 45

shingles, 9–13, 15. *See also* roof

 problems with, 24, **25**

 recycling, 13

 removing, 10–11, 15, 45

 types, 17

showers and tubs, 136–39. *See also* bathroom

 caulking, 250

 faucets, 140

 grouting, 147–48

 mold in, 142

 waterproofing, 139, 145–47

sidewalks
 de-icing, 63, 65
 and water problems, 196
siding, 6–7, 34–37
 aluminum, 34, 36
 cement board, **35,** 36, 46
 choosing, 6, 34–37, 44, 46
 installing, 36–37, 44
 ventilation of, 6
 vinyl, 34–36
 wood, 36
sinks
 drainage from, 116–18, 150
 faucets, 118
skylights, 33, 90–93
slab (concrete), 53
Smart Screen gutter covers, 20–21
smoke alarms, 109
snow melting, 63, 65
soffit vents, 28, 29, 31, **156–57,** 161
soundproofing, 182–83, 225–26
spa bathrooms, 142–45
spray-foam insulation, 154–55, 160–61, 168, **169,** 261
 for attic, 34, 171, 184
 for basement, 191, 194, 206
 do-it-yourself, 185–86
 over garage, 89
 for recessed lights, 102, 184
 vapor barrier with, 102, 161, 184
 for windows, 86, 173

stairs, 33, 93, **94**
 to basement (exterior), 218
steam rooms, 142–45
storm drain, 200, 215
stoves, 264–65
stucco, 37–39
studs, 95–96, 203, 205
subfloors, 69–70. *See also* floors
 for basement, 194, 196
 for bathroom, 147
 under carpet, 196
 glued and screwed, 74, 76, 97, 236
 materials for, 69, 74, 239–40
 plywood, 69, 74, 135, 194, 206, 244
 under tile, 70, 244, 249
 waterproofing, 70
sump pumps, 126, 206–8, 231
surge protector, **105,** 123–24
Surveyor's Real Property Report (SRPR), 51
surveys (property), 49

thermal break
 in attic, 184
 in basement, 194, **204,** 206, 228
tiles
 in basement, 192, 193
 ceramic/porcelain, 131–32, 193, 243–44
 choosing material, 242–44
 eco-friendly, 243

grouting, 247–49

sealing, 148, 243, 249

stone, 132, 148, 243, 249

subfloor for, 70, 244, 249

vinyl, 135

toilets

in basement, 210, 211

installing, **149**

unsteady, 148–50

water-efficient, 114–16

trees

and drainage, 190, 213, 215, 233

as lumber source, 244, 246

tuckpointing, **42–43**

turbine vents, 28–29

Tyvek. *See* house wrap

underlayment, 10

underpinning, 217–23

utility easement, 51

vapor barrier, 65, 154

in attic, 9, 31, 184

in basement, 193, 206

for recessed lighting, 102, 184

with spray-foam insulation, 102, 161, 184

for windows, 173

variance (property), 52

ventilation, 263. *See also* HVAC system

for attic, 6, 8–9, 24–31, **156–57,** 158, 161

for bathroom, 82, 140–42, 148

for bedroom, 93

cheater (AAV) vents, 117–18

energy recovery ventilator (ERV), 177

for exterior walls, 6, 40

heat recovery ventilator (HRV), 81, 93, 176, 177

for kitchen, 264–65

for plumbing system, 116–18, 209–10

for stove, 264–65

vermiculite insulation, 187, 260

vinyl flooring, 135

VOCs (volatile organic compounds), 242, 260–61, 263–64. *See also* off-gassing

walls, exterior, 6, 40. *See also* siding

walls, interior. *See also* studs

in bathroom, 136–39, 145–47

fasteners for, 238

load-bearing (structural), 73–74, 76–78

red flags, 78

removing, 73–74, 76–78, 88–89

soundproofing, 182–83

Walltite Eco spray-foam insulation, 154–55, 160

water. *See also* condensation; water pressure; waterproofing

water (*cont.*)

 hard, 120

 saving, 114–16

water pressure

 hydrostatic, 201–3, 231

 in plumbing system, 118–20

waterproofing

 for basement, 191, 194, 196–200, 202, 206–8, 212, **220**

 for brick, 40–43

 estimates for, 211–13

 for floors, 70

 for foundation, 190, 200, 211–13, 225

 for showers and tubs, 139, 145–47

WaterSense, 115

water softeners, 120

water table, 191

weeping tile

 checking, **199,** 212, 229–30

 interior, 207–8

 problems with, 40, 190, 200, 203, 229, 231

windows, 67–68

 air leaks around, 81, 87, 171–73

 in attic, 33

 in basement, 196, **199**

 condensation on, 78–82

 double-glazed, 79, 83, 88

 double-hung, 83–87

 energy-efficient, 68, 83, 88

 frame materials, 87, 88

 installing, 86, 173

 insulating, 81, 86, 173

 mold around, 79

 replacing, 82, 83–88, 173

 skylights, 33, 90–93

 styles, 83–87

 triple-glazed, 83, 88

wiring. *See also* electrical system

 aluminum, 102–4, 125–26

 and fire safety, 103, 106, 124

 junction boxes, 100, 122–23

 knob-and-tube, **121,** 125–26

 load-splitting, 106

 replacing, 120–22

wood. *See also* OSB (oriented strand board); plywood

 composite, 57, 59

 as condensation source, 82

 as deck material, 53–57, 59

 engineered, 133, 244–47

 fasteners for, 238

 as floor material, 68, 74, 132–33

 FSC-certified, 250–51

 preservatives for, 64

 pressure-treated (PT), 55, 59, 203

 problems with, 253–54

 rotting, 186

 as siding, 36

 as window material, 87

Acknowledgements

Having worked in construction for more than 30 years, I'm reminded every day that you're only as good as the people around you. I've said it before, but I feel lucky to work with the best. Thanks to Liza Drozdov, Seth Atkins, Mark Bernardi, and the rest of the great team at the Holmes Group, especially my kids, Amanda, Sherry, and Michael, who make me believe in what we do, do it right, and make the Holmes Group such a great place to work. Thanks as well to the team at HarperCollins, including Brad Wilson, Noelle Zitzer, Neil Erickson, and Sarah Salomon.

And to the many homeowners across North America who contributed questions, support the work we do, and keep us inspired to continue to educate and make it right—keep smiling.